Henri Matisse

HENRI MATISSE
Sculptor/Painter

HENRI MATISSE
Sculptor/Painter

A Formal Analysis
of Selected Works

Michael P. Mezzatesta

Kimbell Art Museum
Fort Worth
1984

This catalogue is published on the occasion
of an exhibition at the Kimbell Art Museum,
Fort Worth, Texas, May 26–September 2, 1984.

Copyright 1984
by the Kimbell Art Museum
Library of Congress Catalogue Card Number 84-80456
ISBN 0-912804-15-7 (paper)
ISBN 0-912804-16-5 (cloth)
Printed in U.S.A.

Design: James A. Ledbetter

COVER

Plaster Torso and Bouquet (1919)
Museu de Arte de São Paulo, Brazil
Catalogue, No. 37

FRONTISPIECE

Matisse Modeling *Serpentine*
Photograph by Edward Steichen, 1909
Courtesy of The Museum of Modern Art, New York

Contents

Lenders to the Exhibition

Foreword

This pioneering show, the first Matisse retrospective ever held in the Southwestern United States, focuses on the sculpture and painting of an artist widely considered one of the greatest figures in 20th-century art. The exhibition, which traces Matisse's development as both a sculptor and painter during the period 1900 to 1948, highlights the set of four monumental bronze *Backs* recently acquired by the Anne Burnett and Charles D. Tandy Foundation of Fort Worth, formerly in the Norton Simon Museum in Pasadena.

For the first time, a Matisse exhibition has been organized specifically to probe the integral relationship that existed for the artist between his work in two and three dimensions. As the exhibition reveals, Matisse turned to sculpture when he encountered difficulties or when he faced a new challenge in his painting. Matisse's sculpture is, therefore, presented here as a fundamental aspect of his art, one which helped to clarify his pictorial style and also contributed significantly to the development of modern sculpture.

Henri Matisse: Sculptor/Painter, offered exclusively in the Fort Worth/Dallas metropolitan area, was initiated by the Kimbell Art Museum as part of an ongoing series of Museum-originated, scholarly exhibits. The show includes major loans from public and private collections throughout the United States and Europe. Selected and catalogued by Michael Mezzatesta, the Kimbell's Curator of European Art, the exhibition provides an opportunity to improve our understanding of the artist's creative process and also to assess the degree to which the human figure was fundamental to Matisse's continual search for expression.

Dr. Mezzatesta curated the show with the assistance of William B. Jordan, Deputy Director, who edited the catalogue and supervised the selection. Our profound gratitude goes to both of them as well as to the numerous lenders around the world—curators and private collectors alike—whose cooperation and great generosity have ensured the success of this venture.

Edmund P. Pillsbury
Director, Kimbell Art Museum

Acknowledgements

It is not often that a specialist in European Old Master sculpture is given the opportunity to organize an exhibition on a 20th-century artist, let alone one as great as Henri Matisse. The recent acquisition of a set of the *Backs* by the Anne Burnett and Charles D. Tandy Foundation, Fort Worth, provided the occasion to celebrate the achievements of this towering figure of modern art. I am pleased to have participated in the organization of this show and hope that, in some small way, it has increased our appreciation and knowledge of Matisse as a sculptor.

Many people helped to make this exhibition possible. First, my thanks go to Dr. Edmund P. Pillsbury, Director of the Kimbell Art Museum, who provided the time necessary to acquaint myself with this new subject. Both he and Dr. William Jordan, Deputy Director, assisted in selecting the paintings and securing the loans. I am particularly grateful to Dr. Jordan for his expert editorial assistance and for his continuous encouragement and support.

In writing a catalogue outside of my area of expertise, I have, of necessity, benefitted from the advice of numerous friends and colleagues. Foremost among them are Prof. Michael Marrinan, Columbia University, and Prof. Jack D. Flam, Brooklyn College and The Graduate Center, City University of New York. Michael Marrinan read through an early draft of the manuscript and offered numerous very useful observations which significantly improved the text. Jack Flam kindly reviewed a later draft. He caught many errors of fact and generously provided a wealth of material from his own files. I am very grateful to both of them for sharing their ideas on Matisse's art. I would like to thank, as well, John Elderfield, Director of Drawings at The Museum of Modern Art, who had helpful advice concerning several loans, and Madame Wanda de Guébriant, who generously provided photographs and much useful information on Matisse. The numerous curators and private collectors who agreed to loan the works in their care are owed special thanks. Without their cooperation there could have been no exhibition.

My debt extends to a number of other people. Karen King cheerfully typed and retyped the constantly evolving text. Her patience and good humor were deeply appreciated. Erika Esau and Chia-Chun Shih, librarians at the Kimbell, kindly secured hard-to-find books and articles. My wife Anne, in addition to reading countless drafts of the manuscript, was extremely understanding and supportive during the many months of research and writing. Finally, I would like to thank my parents who provided the perfect summer environment for the early stages of work on this project. This book is for them.

M.P.M.

Henri Matisse (1869-1954), along with Picasso, is considered by many observers to be the greatest artist of this century. In the 30 years since his death, his reputation has continued to grow as the richness and diversity of his artistic legacy have won the acclaim of a new generation. Although Matisse is often thought of as painter and draftsman par excellence, this publication focuses on another aspect of his legacy, his sculpture. Forty bronzes have been selected, including all of Matisse's major pieces. They are studied beside a selected group of paintings that provide the opportunity to assess the relationship of his art in two and three dimensions.

The works considered here span almost fifty years of Matisse's career, 1900-1948, a career which saw him rise to international prominence slowly and in the face of great difficulties. Born in 1869 into a middle class family from the town of Le Cateau-Cambrésis in the north of France, Matisse had little reason to aspire to an artistic career. His father, a grain merchant, directed him toward the legal profession and, in 1889, Matisse began work as a law clerk. The following year, bedridden while recovering from appendicitis, his mother presented him with a box of colors, and he began to paint. The experience was a revelation. "I was completely free,"[1] he said later, and he decided to become an artist, despite parental opposition.

Matisse moved to Paris in 1892 and began his studies at the Académie Julian, a private school taught by the painters of the École des Beaux Arts, including the academic painter Adolphe William Bouguereau (1825-1905). However, he found the atmosphere there too stifling and switched to the more liberal studio of Gustave Moreau (1826-1898), where he remained for the next five years. Moreau offered what Matisse later called "intelligent encouragement," neither imposing his own rich, orientalized, romantic style on his students (Fig. 1), nor insisting on the mechanically perfect drawing that Bouguereau demanded.[2] This open and sympathetic attitude attracted a number of students, including Georges Rouault, Albert Marquet, and Henri Manguin — among others — who flourished under Moreau's constructive tutelage.[3] Matisse won official honors and recognition from the Salon de la Société Nationale des Beaux Arts in 1896, and a bright future seemed to await him. But after meeting Camille Pissarro (1830-1903) and discovering Impressionism in 1897, he abandoned his promising career as

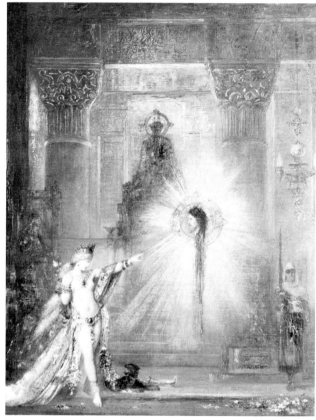

Fig. 1 Gustave Moreau, *The Apparition*, ca. 1876.
Courtesy of the Fogg Art Museum, Harvard University.

an officially recognized artist and joined the avant-garde.[4]

Matisse married Amélie Payrayre in 1898 and began raising a family. The succeeding years were difficult. He struggled financially and artistically as he sought to come to grips with the advanced styles of painting. An indication of his direction at this time is provided by his purchase of Paul Cézanne's *Three Bathers* (Fig. 2).[5] Its acquisition represented a considerable financial sacrifice, but one readily born, for the painting had a tremendous artistic and spiritual influence. "It has sustained me morally in the critical moments of my venture as an artist," Matisse later wrote.[6] His figure paintings of the next several years were strongly influenced by the solid structure of Cézanne's art, and he would return to it repeatedly throughout his career.

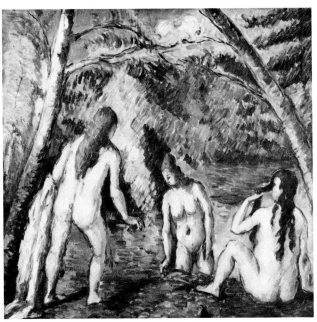

Fig. 2 Paul Cézanne, *Three Bathers*, 1879-1882.
Musée du Petit Palais, Paris.

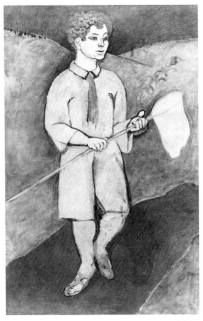

Fig. 3 Matisse, *Boy with a Butterfly Net*, 1907.
The Minneapolis Institute of Arts.

During the summer of 1904, spent at St. Tropez, Matisse's palette brightened considerably under the influence of Paul Signac, one of the leading figures of Neo-Impressionism.[7] *Luxe, calme et volupté* (Fig. 26) was the most notable example of his use of the divisionist color technique; however, it was his subsequent chromatic development which brought him wide public attention. At the Salon d'Automne of 1905, the strident, seemingly arbitrary colors of his paintings earned him and his followers the sobriquet "Les Fauves," (the wild beasts).[8] Fauvism freed the artist from one aspect of naturalistic representation by liberating color from its descriptive function and elevating it to an expressive role linked not to the subject but to the artist's sensibilities.

But by 1907, Matisse was concerned with Fauvism's inherent lack of structure and he began to look for other expressive modes. The light and color Matisse experienced in North Africa, the bold patterns of Islamic art, and the formal purity of African sculpture contributed to the reformulation of his art. The "wild beast" was, as Apollinaire noted in 1909, "*un artiste cartesien*," rationally exploring all possibilities.[9]

However, it was to the traditions of European art that Matisse was most indebted.[10] His trip to Italy in 1907 and his study of Giotto, the Sienese primitives, and Piero della Francesca led him to the monumental, simplified figure style first seen in such paintings as *Boy with a Butterfly Net* (Fig. 3, No. 12) and *Bathers with Turtle* (Fig. 39).

Drawing on all these sources, Matisse began to attain from 1907 a synthesis of the life-sized figure clearly and simply drawn in a flattened, abstract space with broad, bold planes of color. The culminating works in this development were *Dance* and *Music* (Figs. 4, 5), the great murals for the Russian collector Sergei Shchukin completed in 1910. The next seven years witnessed a series of major canvases including *The Red Studio* (1911, Fig. 6), the *Arab Café* (1912-13), *Portrait of Yvonne Landsberg* (1914), *Bathers by a River* (1916), and *The Piano Lesson* (1917, Fig. 7). His paintings of these years grew increasingly austere and experimental and displayed the spatial and structural influences of Cubism, though recast by Matisse in an original way.[11]

The impulse toward abstraction waned from 1917 to about

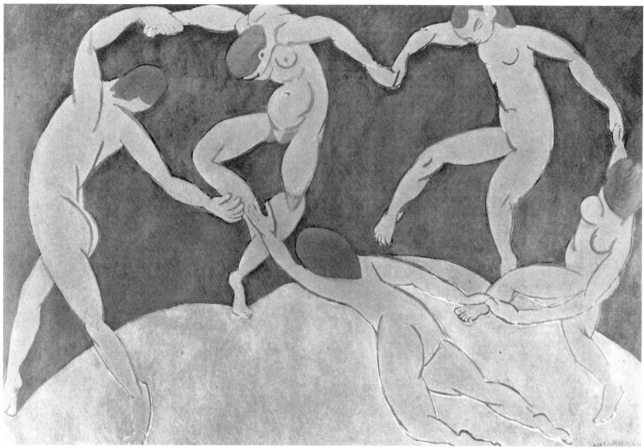

Fig. 4 Matisse, *Dance II*, 1910. The Hermitage, Leningrad.

1929. During these years, spent largely in Nice, Matisse's art became naturalistic and was centered on the odalisque. By the late 1920's, his production of paintings had fallen sharply, for Matisse found himself at an artistic impasse. Trips to Tahiti and New York in 1930 helped to resolve the crisis, and he resumed work in 1930 with an important mural commission on the theme of the dance from Dr. Albert C. Barnes for the central hall of his foundation building in Merion, Pennsylvania.[12]

During the 1930's and 1940's, Matisse continued to paint, produced book illustrations, theatrical designs, some of his most impressive prints and drawings, and even served as architect for the Chapelle du Rosaire of the Dominican nuns of Vence (1948-51). One of his greatest achievements was developed over the last decade of his life — the *papiers*

découpés or cut-outs. These large, decorative compositions were composed of freely-formed shapes swiftly carved with scissors out of pre-colored paper and arranged on a white or colored ground (Fig. 8).[13] Matisse's life-long search for purity and simplicity of expression and for an idyllic art in which one could find repose and peace found its most complete expression here. The cut-outs represent the final flowering of Matisse's art before his death in 1954.

Matisse first took up sculpture in 1899 when he enrolled in an evening course at the École Communale de la Ville de Paris. This sudden interest was not a mere diversion but a serious study in which he even sought the advice of Rodin and Bourdelle. It also occurred at a difficult moment in Matisse's life. Under severe financial pressure, he was forced to paint

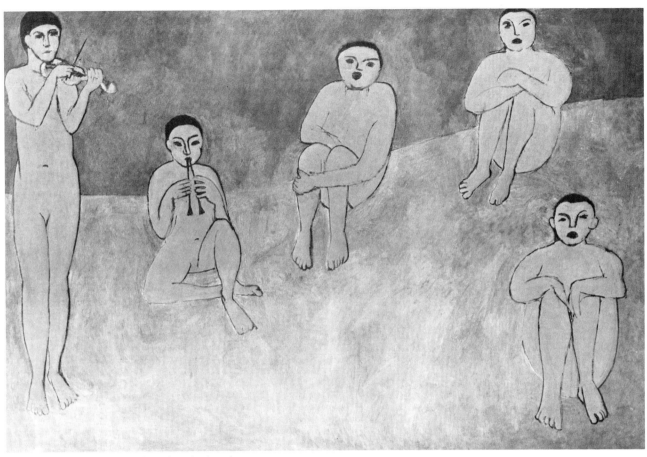

Fig. 5 Matisse, *Music*, 1910. The Hermitage, Leningrad.

decorative laurel leaves on the cornice of the newly constructed Grand Palais, which was tedious and exhausting work. Yet, after laboring all day, he spent the hours from eight to ten modeling at the École Communale. His first effort was a study after Barye's *Jaguar Devouring a Hare* (Fig. 9), a work on which he spent two years, even securing a dissected cat to analyze the anatomy of the back.[14]

Any artist in Paris at the turn of the century interested in sculpture had to confront the challenge of Rodin's work. Matisse had an encounter with the master, probably in 1898, which was brief but of pivotal importance. He visited Rodin's studio to show him some drawings. The old master advised Matisse to make more detailed drawings. Matisse demurred, sensing that what he sought was mastery of the overall

concept in order to achieve his ultimate goal, "the realization of my own sensations." Matisse noted:

> I could not understand how Rodin could work on his St. John by cutting off the hand and holding it on a peg; he worked on the details holding it in his left hand, it seems, anyhow keeping it detached from the whole, then replacing it on the end of the arm; then he tried to find its direction in accord with his general movement. Already I could only envisage the general architecture of a work of mine, replacing explanatory details by a living and suggestive synthesis.[15]

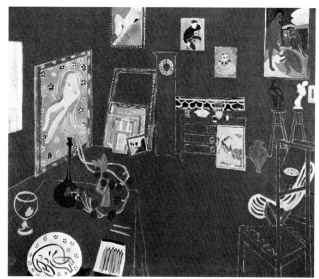

Fig. 6 Matisse, *The Red Studio*, 1911.
The Museum of Modern Art, New York.

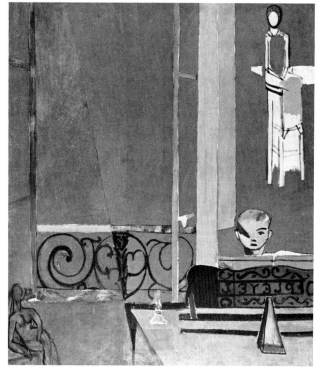

Fig. 7 Matisse, *Piano Lesson*, 1916.
The Museum of Modern Art, New York.

These comments provide a key to understanding both Matisse's sculpture and his painting. To Matisse, Rodin's practice of amputating a hand to work on it apart from the rest of the body was unthinkable. He could only imagine the human form in its entirety — the parts subsumed to a new and vital whole conceived in the artist's mind. This reformulation, though ordered by the intellect, was guided by his own sensations.

> I want to reach that state of condensation of sensations which makes a painting.[16] . . . Suppose I want to paint a woman's body: first of all I imbue it with grace and charm, but I know that I must give something more. I will condense the meaning of this body by seeking its essential lines. The charm will be less apparent at first glance, but it must eventually emerge from the new image which will have a broader meaning, one more fully human.[17]

The intensity of Matisse's early training was characteristic of the artist who, by his own admission, worked every day for more than 50 years.[18] It is also characteristic of the deliberate use of sculpture throughout his career. Matisse's initial interest in sculpture was part of a total rethinking of his art which saw him abandon his Impressionist style of the 1890's. The change was accompanied by a shift in subject matter from still lifes, interiors, and landscapes to the human figure. *The Serf* and *Madeleine I* (Nos. 1, 3), sculptures for which there are painted studies of the same models in identical poses, laid the groundwork for Matisse's first serious figure paintings and established the pattern for his use of sculpture.

A review of the development of Matisse's sculpture indicates that, in general, periods of sculptural activity coincided with moments of stylistic transition or crisis, or with major pictorial commissions. The bronzes of 1904-1906 seem to have grown or developed from the expressive challenges of *Luxe, calme, et volupté* (1904-05) and *Bonheur de vivre* (1906), Matisse's first multi-figured compositions.

The liberation of color from its descriptive role during the fauve years of 1905-07 met a post-fauve reaction, Barr's so-called "Crisis of 1907-08."[19] Matisse reacted against the excessive color and flimsy design of fauvism by seeking to endow the figure with a greater expressive weight. *Reclining Nude I* (Fig. 10) led the way in this effort, preceding *Blue Nude*, the almost life-sized painting of a nude in the same pose.

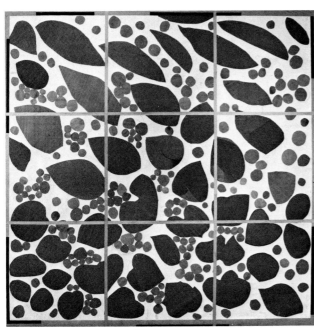

Fig. 8 Matisse, *Ivy in Flowers*, 1953.
Dallas Museum of Art.

The assertive physicality of this bronze is indicative of an increased interest in the human figure that developed in many artistic circles, impelled by an intense study of Cézanne. The year 1907 also witnessed the debut of Picasso's *Demoiselles d'Avignon*, a painting initiating the revolution of Cubism which would soon reshape the history of western art. The dramatic fracturing and geometrizing of the human form developed by Picasso and Braque in 1907 and 1908 was answered by Matisse in two sculptures, *Decorative Figure* and *Two Negresses* of 1908 (Nos. 16, 17), works which maintained the integrity and unity of the body while still exploring its weight, solidity, and architectonic structure. Nothing in Matisse's painting at this point was as advanced as these sculptures, and the confidence he gained through their realization helped him to use the figure as the main feature of his compositions.[20]

Sergei Shchukin's 1909 commission of two large decorative panels on the themes of dance and music, and a third work, a bathing theme which Matisse sought to incorporate in the project, led to a number of sculptures. *Study of a Foot* (1909, No. 20), the *Serpentine* (1909, No. 18), the first three *Backs*

(1909-13, Nos. 19, 27, 30), *Torso without Arms or Head* (1909, No. 21), and *Dance* (1911, No. 26) can be related to Matisse's study for or after these panels, although only the first is an actual modello.[21]

From about 1913 to 1917, Matisse's art grew more severe and formal. The austere, architetonic quality of his art during this period of experiment was the result of a renewed confrontation with Cubism. The last three heads in the Jeanette series and *Back III* bear witness to the constructive strength and abstract discipline now underlying Matisse's sculpture. Yet Matisse's sculpture was not always engaged in the experimental issues which occupied his painting. Sometimes, as with the *Head of Marguerite* (1915, Fig. 11), it provided him a respite, an opportunity to refamiliarize himself with the motif in three dimensions at the same time that it was being flattened and abstracted on the canvas.

As we have seen, Matisse's move to the south of France in 1917 initiated the so-called "Nice period," which lasted for over a decade. As Matisse turned from the rigorous figural abstractions of the earlier years, he developed new themes inspired by the sunny Mediterranean ambience (Fig. 12) and by the exotic odalisques of the Middle East. The recumbent nude, frequently depicted in oriental garb and in lavishly decorated settings, became the focus of a kind of dream world whose indolent eroticism fulfilled, for the time being, Matisse's desire for soothing art "devoid of troubling or depressing subject matter."[22] To express these new feelings, Matisse developed a different expressive mode, one more naturalistic and inspired by the linear purity of Ingres and the equilibrium of ancient sculpture, ideals embodied in *Reclining Nude with Bolster* (1918, No. 36) and *Venus* (1918, Fig. 71).

The largest and most ambitious sculpture of the Nice period, *Large Seated Nude* (1923-25, No. 39), provides an initial indication of the dissatisfaction Matisse felt with the Nice style in its reassertion of the more severe formal impulses and structural imperatives which had informed his pre-1918 bronzes. His experimentation continued in *Henriette II* (1927, No. 42), in which he stressed the almost pure mass and volume of the head, and in *Henriette III* (1929, No. 43), in which he reoriented his sensations, pulling back from abstract sculptural purity through the actively modeled surface. *Reclining Nude II* (1927, No. 44), which on the one hand embodies the balance and harmony inherent in all of Matisse's nudes, also has been endowed with tremendous

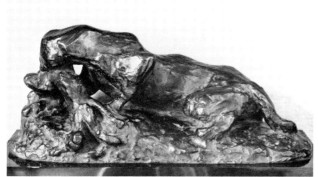

Fig. 9 Matisse, Copy after Barye's *Jaguar Devouring a Hare*,
1899-1901.

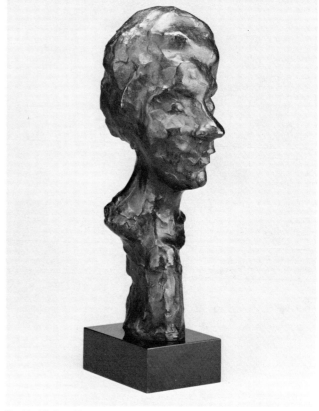

Fig. 11 Matisse, *Head of Marguerite*, 1915.
The Minneapolis Institute of Arts.

Fig. 10 Matisse, *Reclining Nude I*, 1906-1907.
Albright-Knox Art Gallery, Buffalo.

bulk and an aggressive physical presence which would seem to
be a reaction against his svelte painted odalisques. *Venus on a
Shell I* (1930, No. 49) and *Venus on a Shell II* (1932, No. 52),
display an elegant formalism and geometry which would soon
be reinfused into his painting.

Matisse's last great sculpture, *Back IV* (1931, No. 51) was
probably undertaken in 1931 in response to the mural
commission from Dr. Albert Barnes.[23] In returning to the
dance theme, Matisse resumed his study of the back, which
had earlier served him for Shchukin's *Dance* and *Music*. In a
way, Matisse had come full circle, concluding his sculptural

career with the same theme with which he first worked on a
monumental scale. Moreover, the weight and mass of *Back
IV*, its broad form and nuanced surface, recall Matisse's own
painting by Cézanne, *The Three Bathers*, purchased over 30
years before (Fig. 2). Matisse had, in essence, rediscovered
Cézanne in attaining the simplification and purification of
form he had been seeking.

Back IV was a harbinger of the order and symmetry of
Matisse's later paintings, such as *Lady in Blue* (1937, Fig. 13).[24]
It also looked forward to the cut-outs, not so much
technically as conceptually. The broad proportions of *Back IV*

were adopted for the dancers of the Barnes murals. Matisse also prepared cut-outs of those figures—paper maquettes—which then served as models for the final canvas. This was the first use of the process which would gradually become an end in itself.[25]

In a way, the cut-outs brought Matisse to a new sculptural dimension, for the process involved in their formation was similar to sculpting. Matisse used the scissors like a chisel, carving the paper with the open blades rather than clipping it.[26] "Cutting straight into color reminds me of the direct carving of the sculptor," Matisse wrote in 1947 of the cut-and-pasted designs for his book *Jazz*.[27] The cut-outs are like reliefs in their vivid separation from the ground; the cut edges and nuanced surfaces impart volume to the figure or form. Yet volume and relief have been distilled to their most economical state.[28] Matisse condensed his sculptural sensations from a three dimensional relief plane to a sheet of heavy paper. The cut-outs combined painting, sculpture, and drawing in the final, most purified synthesis of Matisse's career.

Matisse's extraordinary career has been the subject of countless studies. The thought of yet another investigation, therefore, might seem superfluous. But many questions remain to be considered about Matisse's life and art. Although he is the subject of a vast literature, Matisse is, in some significant ways, poorly understood. An indication of the present status of the literature is the fact that Alfred Barr's book, *Matisse and His Public*, published in 1951, remains the most authoritative source.[29] One of the major handicaps for the student interested in Matisse is the lack of a catalogue raisonné.[30] There is also no standard biography, so important details of his personal life are shrouded in mystery, their possible influence on his art unknown. For an artist as complex as Matisse, these are serious lacunae, especially given that critics have only begun to decipher his personal iconography.[31]

Even Matisse's extensive activity as a sculptor is relatively underappreciated, although it began early and was sustained for over thirty years. Matisse produced some 70 sculptures — predominantly bronzes based on terra cotta models — most executed between 1899 and 1932. Several of those sculptures occupied him for years, so there can be little doubt about their importance to him: no artist would lavish so much time and thought on an activity that was of secondary

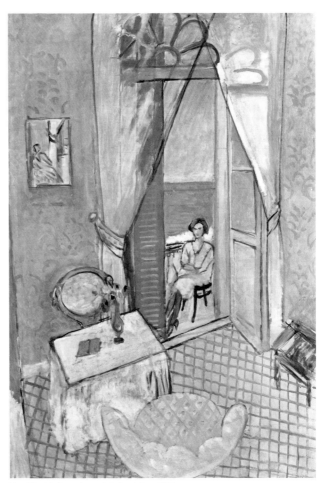

Fig. 12 Matisse, *Large Interior, Nice*, 1921. The Art Institute of Chicago.

interest. Nevertheless, many of Matisse's bronzes have been studied only in a general way.

In some respects this is not surprising. The bronzes are for the most part small. Only *The Serf*, *Decorative Figure*, the *Backs*, and *Large Seated Nude* are over two feet in height. They are also fairly uniform in handling and are seemingly distant from the principal sculptural issues of the day. Matisse himself said he "made sculpture as a painter, not as a sculptor,"[32] a fact which has led some critics to label his sculpture as "painter's sculpture," and to see it as a dalliance apart from the major issues which concerned his art.[33] These

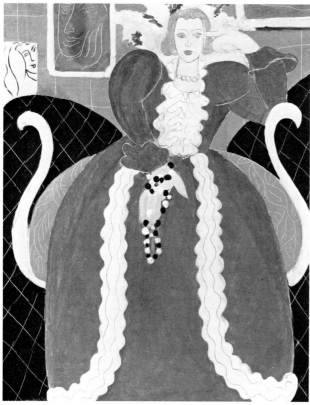

Fig. 13 Matisse, *Lady in Blue*, 1937.
Philadelphia Museum of Art.

facts illustrate the difficulty of assessing Matisse's sculpture.

Part of the unfamiliarity with his work in three dimensions also derives from its function as a private medium of study closely tied to his work as a painter. It should be noted, however, that, unlike Degas, whose sculptures were largely unknown during his lifetime, Matisse exhibited his work as early as the Salon d'Automne of 1904.[34] When his bronzes or plasters were seen, however, they appeared sporadically over the long course of his career. More than half of the bronzes were only exhibited between twenty and fifty years after they were conceived.[35] *Standing Nude, Arms on Head* (No. 8), *Venus II* (No. 52), and *Back II* (No. 27), which lay forgotten in a Nice warehouse until 1955, were never seen during Matisse's lifetime. His two most famous sculptural works, the five *Jeanette Heads* (1910-1913, Fig. 14) and the

Backs (1909-1931, Fig. 15) were not exhibited as complete series until 1950 and 1956 respectively.[36] The *Backs*, indeed would seem on first glance to embody the ambition Matisse frequently held for his painting — the desire to create a major public masterpiece — yet they were never exhibited together during the artist's lifetime and, as far as we know, were never meant to be shown as a series. This peculiar situation illustrates the ambiguous position which Matisse's sculpture has occupied in the public eye. In addition, the cataloguing and exhibition of the sculpture has only occured relatively recently. The first exhibition to include almost all of Matisse's sculpture opened in Zurich as late as 1959, five years after his death.[37] An American retrospective was not mounted until 1972 at The Museum of Modern Art.[38] In 1975, the complete sculptural oeuvre was seen in France for the first time, concluding the great centenary celebration initiated with the historic 1970 exhibition of his paintings in Paris.

Inevitably, the lag between completion and exhibition delayed a careful consideration of his work. Although the catalogue of the 1975 Paris show offered full exhibition histories and references, it did not, like the previous catalogues devoted to Matisse's sculpture, provide detailed critical entries. The first comprehensive analysis of Matisse's sculpture was Albert Elsen's pioneering book, *The Sculpture of Henri Matisse*, published in 1972.[39] Elsen considered Matisse's sculpture as the work of a sculptor, for as he said, ''we gain nothing from approaching Matisse's work as a painter's view of sculpture or as sculpture aspiring to the effects of painting.''[40] He provides a perceptive and sensitive analysis of Matisse's work, its relationship to the academic tradition and to contemporary masters of modern sculpture. If this excellent book has one shortcoming, however, it is the tendency to consider the sculpture apart from Matisse's painting, an approach that isolates the sculpture from the mainstream of his art and gives it a curiously self-sufficient quality.[41]

The integral relationship between Matisse's sculpture and painting was first discussed by William Tucker in the introduction to the catalogue of a Matisse sculpture show seen at the Victor Waddington Gallery in London in 1969.[42] This essay, reprinted in that summer's issue of *Studio International*, identified the basic functions of Matisse's sculpture: it provided continuity and stability during moments of pictorial experimentation; it allowed him ''to recapture

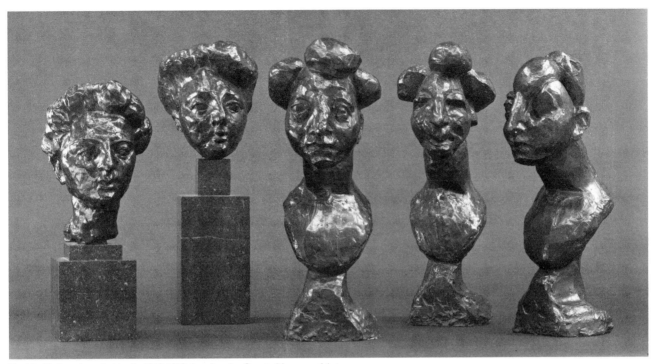

Fig. 14 Matisse, *Jeanette Heads*, 1910-1913. Los Angeles County Museum of Art.

the sensuous experience of volume that was increasingly denied him by the demands of the flat surface''; and it provided the confidence to structure his canvases around the figure.[43] These points were further developed with an analysis of the innovative qualities of Matisse's sculpture in Tucker's 1974 book, *The Language of Sculpture*, and in an article in *Art in America* the following year.[44] Similarly, both Pierre Schneider and John Elderfield, in articles published in 1972, discussed the character of Matisse's sculpture in general and the nature of its modernity achieved through its separation from the subject and self-affirmation as an object.[45]

Although there is general agreement about the nature and function of Matisse's sculpture, few of his bronzes have actually been studied within the larger context of his art. Jack Flam's 1970 article on the *Backs* analyzed the specific formal and conceptual issues which tied these monumental reliefs to Matisse's contemporary pictorial projects, thereby freeing them from their anomalous position in his oeuvre.[46] John

Elderfield's 1978 catalogue, *Matisse in the Collection of the Museum of Modern Art*, sets a new standard for Matisse scholarship and is the most important study of Matisse since Alfred Barr's book was published 33 years ago.[47] Each painting and sculpture is considered in detail as part of a thorough investigation of the sources and issues which concerned Matisse's art.

While analyzing each bronze individually — its date and sources, as well as its formal and expressive characteristics — the present catalogue is not a monographic study of Matisse's sculpture. Rather, its focus is somewhat wider. For the first time, Matisse's sculpture and painting have been shown together for the express purpose of analyzing the symbiotic relationship of his work in two and three dimensions. The 40 bronzes span the most fertile period of Matisse's sculptural activity, 1900-1932, including all of his familiar works — *The Serf*, the two *Madeleines*, *Reclining Nudes I, II,* and *III*, *Decorative Figure*, *Two Negresses*, the *Serpentine*, the *Jeanette Heads*, the *Backs*, *Large Seated Nude*, and *Venus on a Shell I*,

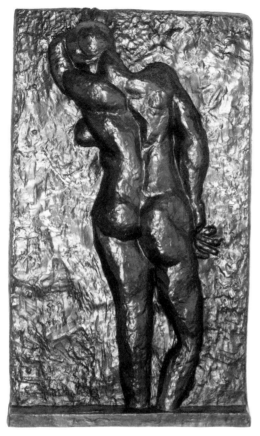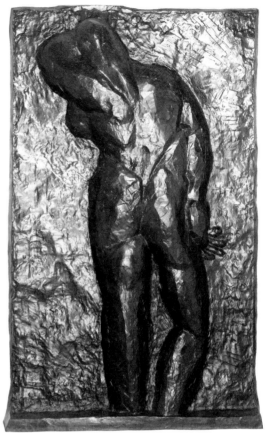

Fig. 15 Matisse, *Backs*, 1909-1931. The Anne Burnett and Charles D. Tandy Foundation, Fort Worth.

and *II* — as well as lesser known but equally interesting examples. With the exception of the bronzes studied in Elderfield's catalogue, Matisse's sculpture has generally been dated to a year or range of years. In the present study, an attempt has been made to date the bronzes as precisely as possible — where that has not already been done — if not to specific months, then to seasons. This has helped to clarify their position and role in Matisse's oeuvre.

Moreover, many of the bronzes have been linked for the first time to Matisse's activity as a painter. The bronzes of 1904-1906 are related to his work on *Luxe, calme, et volupté* and *Bonheur de vivre*, while *Torso without Arms or Head* (1909, No. 21) and *Dance* (1911, No. 26) are here seen as part of Matisse's continually evolving ideas on the Shchukin commission,

one of his most important projects. In general, the emphasis placed on examining Matisse's sculpture in context demonstrates, perhaps more fully than before, how integral a part of his creative process it was and how it served to direct his thoughts as he developed new pictorial strategies.

The paintings selected for the exhibition relate directly to individual bronzes, such as the Tate's *Nude Study in Blue* to *Madeleine I*, Yale's *Still Life with Statuette* to *Standing Nude*, São Paulo's *Plaster Torso and Bouquet* to the *Venus*, and the Baltimore Museum's *Girl in a Yellow Dress* to *Venus on a Shell I*; others represent important moments in Matisse's career and address a second theme of this study, the general development of Matisse's art and the principles which informed it.

Gustave Moreau predicted early in Matisse's career that he

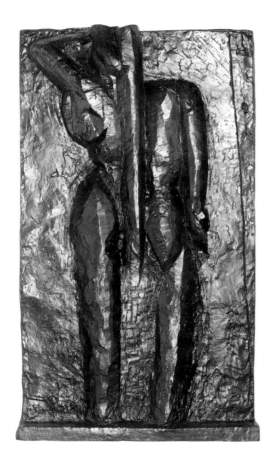

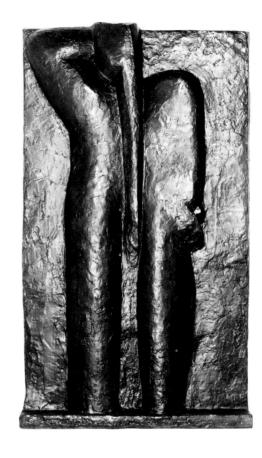

would "simplify painting."[48] The "simplifications" he achieved at various points throughout his career differ widely in style but were all achieved through a rigorous intellectual process. Matisse wrote and spoke eloquently about his art, and, reading through his comments, one can hardly fail to be struck by the recurrence of certain key words — stability, order, clarity, condensation — words which betray the underlying intellectual discipline of his ambitions. Matisse was firmly grounded in the basics and similarly insisted that his students at the shortlived "Academy Matisse" master the essential skills of drawing and modeling from the figure and plaster casts, an approach which came as a shock to the fledgling painters. The high degree of order and structure displayed by Matisse's art perhaps seems incongruous for a painter frequently thought of for his voluptuous nudes and luxurious, decorative subjects and who envisioned an art as comfortable and relaxing as a good armchair. Yet, as it has been aptly noted by John Golding: "the sensuous side of Matisse is in fact always balanced by and at times, indeed, superimposed onto a disciplined, highly reasoned substructure: it is this side of his art that has never been sufficiently analyzed and explored and that gives his work at best its enormous strength and often a knife-like, almost surgical precision of balance."[49]

Sculpture was frequently an essential factor in attaining that balance, for it was both a supplementary and a parallel mode of expression to his painting. In 1912 he remarked to an American journalist: "I like to model as much as to paint — I

have no preference. If the search is the same when I tire of some medium, then I turn to the other — and I often make *pour me nourrir* (in order to nourish myself), a copy in clay of an anatomical figure."[50] Sculpture helped Matisse refresh and refine his sensations in the search for expression:

> I took up sculpture because what interested me in painting was a clarification of my ideas. I changed my method, and worked in clay in order to have a rest from painting where I had done all I could for the time being. That is to say that it was done for the purposes of organization, to put order into my feelings, and find a style to suit me. When I found it in sculpture, it helped me in my painting. It was always in view of a complete possession of my mind, a sort of hierarchy of all my sensations, that I kept working in the hope of finding an ultimate method.[51]

Matisse noted that artistic means in themselves did not have great importance:

> In admitting that there exists a richness in certain of my paintings, I would not hesitate to abandon painting if my supreme expression had to realize itself in another way. Thus in order to express form, I devote myself sometimes to sculpture, which permits me, in lieu of being placed before a flat surface, to go around the object to know it better.[52]

Sculpture provided a link to the materiality of the world. It has often been noted that Matisse turned to sculpture at moments when his painting was abstract and flat.[53] Working in clay allowed him to maintain contact with the physicality of the figure when volume was being eliminated from his painting. Sculpture's weight and mass could also be used to counterbalance the flattening effect of the all-over, decorative patterns seen in many paintings. Matisse often introduced images of his bronzes or plasters into his still lifes to ground the composition through the implied substance of the figural form.

Indeed, the fundamental connection between Matisse's painting and sculpture is the figure as subject, and the clarification he sought through sculpture concerned the representation of the human form. Throughout Matisse's career, the figure was the touchstone of his art, serving as both an anchor and a probe. Except for a few early works, all of Matisse's bronzes are based on the human subject, specifically the female nude. "What interests me most is neither still life nor landscape, but the human figure," Matisse wrote in 1908, "It is that which best permits me to express my almost religious awe towards life."[54] Matisse, like the mythological giant Anteus who grew more powerful when in contact with the earth, derived strength and intellectual sustenance by modeling the figure in clay. The weight and density of the material opened to him the tactile and volumetric sensations not available in painting. This allowed him to get closer to his subject — to know it on the most intimate of terms. Matisse once spoke of his reactions before the model as he sculpted: "She was a pretty girl, a perfect model. I touched her body, my hands enveloped her forms, and I transmitted into clay the equivalent of my sensations."[55]

Like the early Italian Renaissance sculptor, Matisse attained a kind of magic in his creation of a simulacrum of the human body. Unlike his Renaissance colleagues, however, Matisse was not bound to a classical canon. Rather, he established new criteria for his sculpture and painting, affirming the autonomy of his own sensibilities and opening, in the process, new horizons for art.

Notes

1. As quoted by Pierre Schneider in the Introduction to the catalogue, *Henri Matisse: Exposition du Centenaire* (Grand Palais, Avril-Septembre 1970), Paris, 1970, 12.

2. Alfred Barr, *Matisse, His Art and His Public*, New York, 1951, 15.

3. *Ibid.*, 16.

4. *Ibid.*, 35-37.

5. The painting was purchased from the dealer Amboise Vollard in 1899 for 1300 francs, along with a plaster bust of Henri Rochefort by Rodin, see Barr, *Matisse*, 38-39.

6. Matisse made this statement in a letter dated November 10, 1936, to Raymond Escholier, Director of the Museum of the City of Paris, in which he donated the painting to the Museum. For the complete text, see Jack Flam, *Matisse on Art*, New York, 1973, 75.

7. Barr, *Matisse*, 53 ff. For a detailed study of Matisse's relationship to Neo-Impressionism, see Catherine C. Bock, *Henri Matisse and Neo-Impressionism 1898-1908*, Ann Arbor, Michigan, 1981.

8. The literature on Fauvism is extensive. For general background as it pertains to Matisse, see Barr, *Matisse*, 54 ff. The most thorough analysis of the movement and of Matisse's role in it, is John Elderfield's book, *The "Wild Beasts:" Fauvism and its Affinities*, New York, 1976.

9. As quoted by Nello Ponente, in "Matisse," *Encyclopedia of World Art*, New York, 1964, IX, col. 588.

10. As noted by Apollinaire in his interview with Matisse in *La Phalange*, no. 2, December, 1907, 15-18, reprinted in Dominique Fourcade, *Henri Matisse, Écrits et propos sur l'art*, Paris, 1972, 57-58, and n. 26.

11. Barr, *Matisse*, 88 ff.

12. *Ibid.*, 195 ff.

13. The cut-outs have been the subject of two recent studies: Jack Cowart, Jack D. Flam, Dominique Fourcade, John Hallmark Neff, *Henri Matisse, Paper Cut-Outs* (The St. Louis Art Museum and The Detroit Institute of Arts), 1977; and John Elderfield, *The Cut-Outs of Henri Matisse*, New York, 1978.

14. Barr, *Matisse*, 40, 51.

15. Raymond Escholier, *Matisse from the Life*, London, 1956, 138.

16. "Notes of a Painter, 1908," as quoted by Flam, *Matisse on Art*, 36.

17. *Ibid.*

18. Fourcade, *Écrits*, 78, n. 4.

19. Barr, *Matisse*, 86 f.

20. William Tucker, "The Sculpture of Matisse," *Studio International*, vol. 178, no. 913, July/August 1969, 26.

21. For the background of this commission, see Barr, *Matisse*, 132 ff. Additional references are found in the entries cited above.

22. "Notes of a Painter, 1908," as quoted by Flam, *Matisse on Art*, 38.

23. For which, see Barr, *Matisse*, 241 ff.

24. See No. 51.

25. Elderfield, *The Cut-Outs*, 8.

26. *Ibid.*, 7.

27. Matisse, *Jazz*, Paris, 1947. See also, Flam, *Matisse on Art*, 112; and Elderfield, *The Cut-Outs*, 7.

28. Elderfield, *The Cut-Outs*, 7-8.

29. Reprinted in 1966 without color plates.

30. This project had long been the responsibility of Marguerite Duthuit, Matisse's daughter. Her recent death has indefinitely delayed the appearance of the catalogue raisonné.

31. A book on Matisse's iconography by Jack Flam is scheduled for publication in 1985. A number of articles have addressed various aspects of Matisse's personal imagery, among which are, Jack D. Flam, "Some Observations on Matisse's Self-Portraits," *Arts*, v. 49, no. 9, 1975, 50-52; Albert Kostenevich, "*La Danse* and *La Musique* by Henri Matisse: A New Interpretation," *Apollo*, v. 100, 1974, 504-513; Frank Trapp, "Form and Symbol in the Art of Matisse," *Arts*, v. 49, no. 9, 1975, 56-58; Pierre Schneider, "The Striped Pajama Icon," *Art in America*, v. 63, July/August 1975, 76-82; Theodore Reff, "Meditations on a Statuette and Goldfish," *Arts Magazine*, LI, November 1976, 109-115; Kate Linker, "Meditations on a Goldfish Bowl: Autonomy and Analogy in Matisse," *Artforum*, v. 19, October, 1980, 64-73; and Pierre Schneider's review of Lawrence Gowing, *Matisse*, London, 1980, in *The Burlington Magazine*, CXXII, 1980, 510.

32. Fourcade, *Écrits*, 70, n. 45.

33. Hilton Kramer, "Matisse's Sculpture," *Bulletin of the Boston Museum of Fine Art*, 1966, 49-65.

34. Matisse exhibited two sculptures; see Paris 1975, 29. However, the works are not specified and are not listed in the entries. His first major showing was at the Salon d'Automne of 1908, when he exhibited thirteen sculptures.

35. Compare the exhibition histories listed in Paris 1975.

36. Paris 1975, nos. 204-208; nos. 202, 210, 212, 225.

37. *Henri Matisse. Das plastische Werk* (Kunsthaus, Zurich), 14 July to 12 August, 1959.

38. For which see, Alicia Legg, *The Sculpture of Matisse*, The Museum of Modern Art, New York, 1972.

39. This book was based on a series of articles which appeared in *Artforum*, v. VII, September-December, 1968.

40. Elsen, *The Sculpture of Henri Matisse*, New York, 1972, 11.

41. See the review by Carl Goldstein in *Art Quarterly*, v. 36, 1973, 420-421.

42. *Henri Matisse 1869-1954. Sculpture* (Victor Waddington Gallery, London, 12 June-12 July 1969).

43. Tucker, ''The Sculpture of Matisse,'' 25-27.

44. Tucker, *The Language of Sculpture*, London, 1974, 85-106; Tucker, ''Matisse's Sculpture: The Grasped and the Seen,'' *Art in America*, July/August, 1975, 62-66.

45. Pierre Schneider, ''Matisse's Sculpture: The Invisible 'Revolution','' *Art News*, v. 71, March, 1972, 22-25, 68-70; John Elderfield, ''Matisse's Drawings and Sculpture,'' *Artforum*, v. X, September, 1972, 77-85.

46. Jack D. Flam, ''Matisse's *Backs* and the Development of His Painting,'' *Art Journal*, XXX, 1970/71, 352-361.

47. John Elderfield, *Matisse in the Collection of The Museum of Modern Art*, New York, 1978.

48. Barr, *Matisse*, 36.

49. John Golding, ''Matisse and Cubism'' (W. A. Cargill Memorial Lectures in Fine Art), University of Glasgow Press, 1978, 7-8.

50. Interview granted to Clara T. MacChesney in 1912, published in the *New York Times Magazine* in 1913, as quoted by Flam, *Matisse on Art*, 51-52.

51. Jean Guichard-Meili, *Matisse*, New York, 1967, 168.

52. Fourcade, *Écrits*, 70, n. 45.

53. Tucker, ''The Sculpture of Matisse,'' 26.

54. ''Notes of a Painter, 1908,'' as quoted by Flam, *Matisse on Art*, 38.

55. Schneider, ''Matisse's Sculpture,'' 22.

Colorplates

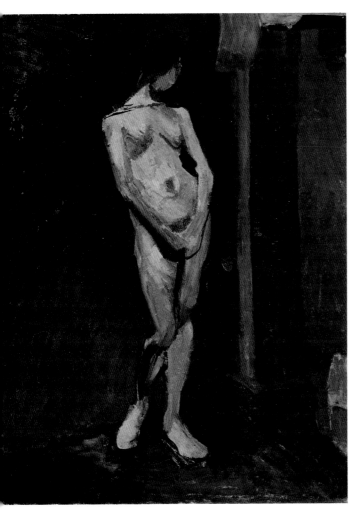

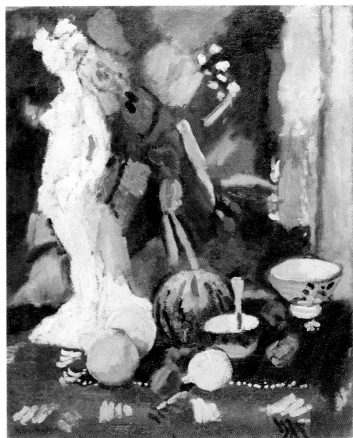

Nude Study in Blue, 1900. The Tate Gallery, London (No. 2).

Still Life with Plaster Figure, 1906. Yale University Art Gallery (No. 10).

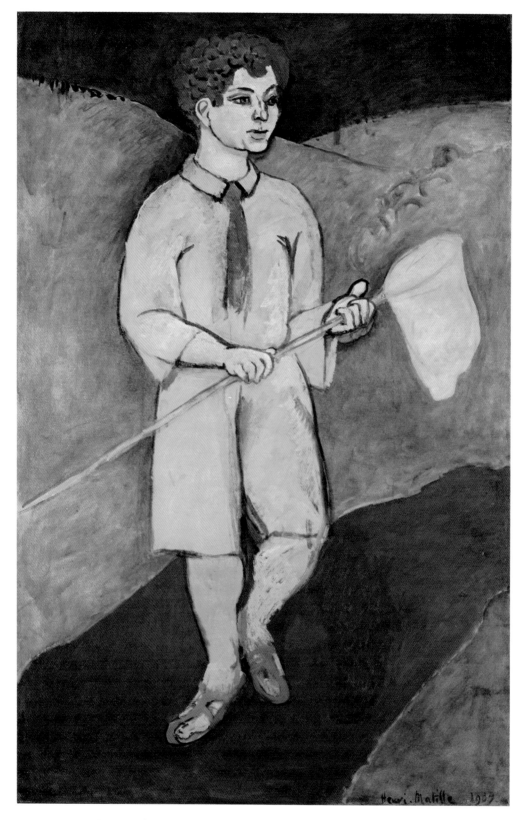

Boy with a Butterfly Net, 1907. The Minneapolis Institute of Arts (No. 12).

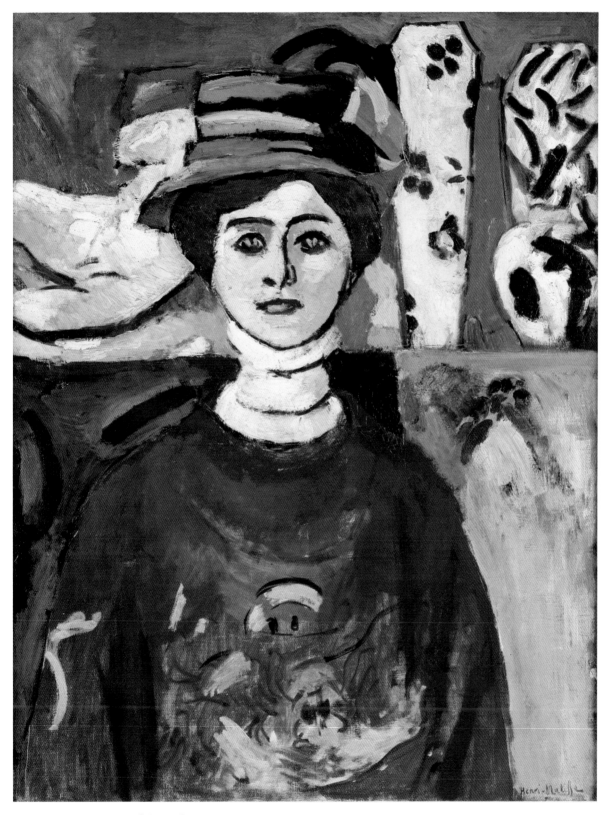

Girl with Green Eyes, 1908. San Francisco Museum of Modern Art (No. 14).

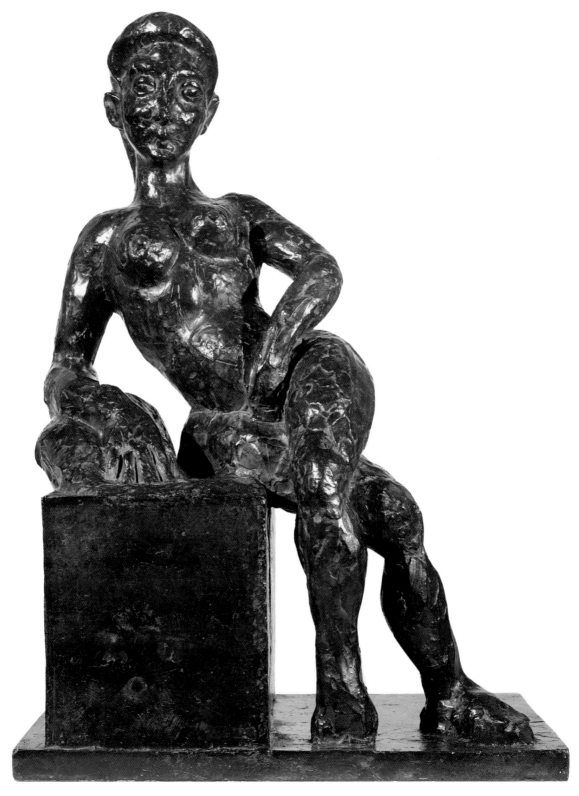

Decorative Figure, 1908. Mr. and Mrs. Wilfred P. Cohen, New York (No. 16).

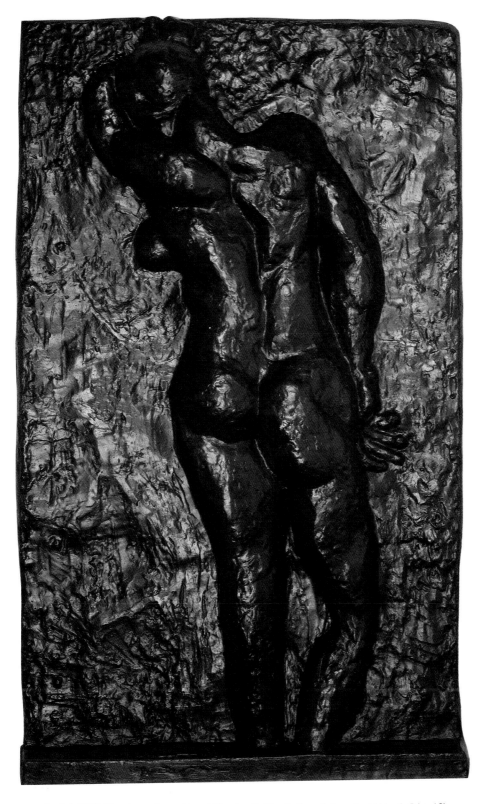

Back I, 1909. The Anne Burnett and Charles D. Tandy Foundation, Fort Worth (No. 19).

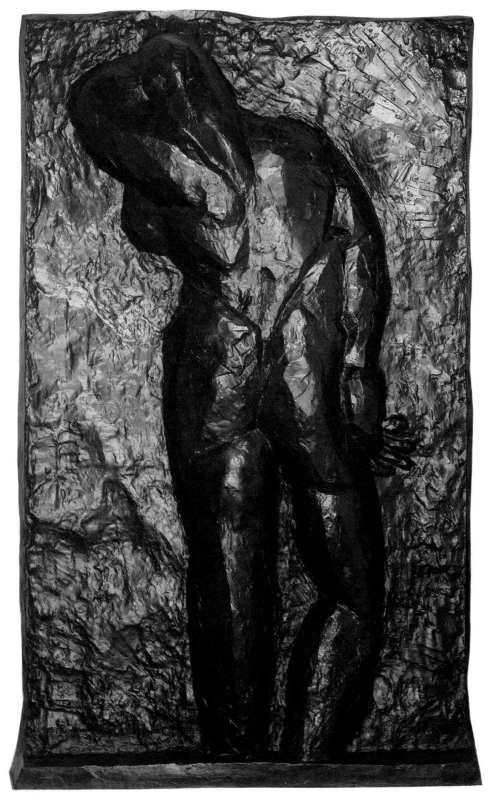

Back II, 1913. The Anne Burnett and Charles D. Tandy Foundation, Fort Worth (No. 27).

Still Life with Lemons, 1914. Rhode Island School of Design (No. 28).

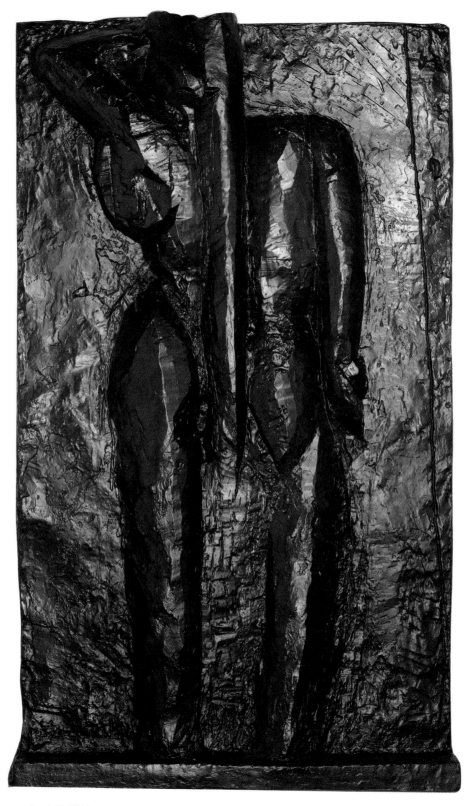

Back III, 1916. The Anne Burnett and Charles D. Tandy Foundation, Fort Worth (No. 30).

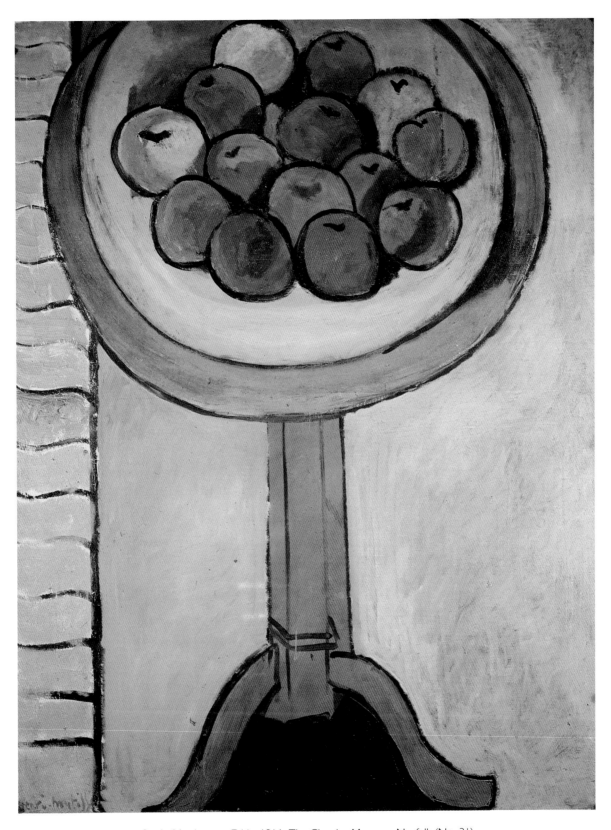

Bowl of Apples on a Table, 1916. The Chrysler Museum, Norfolk (No. 31).

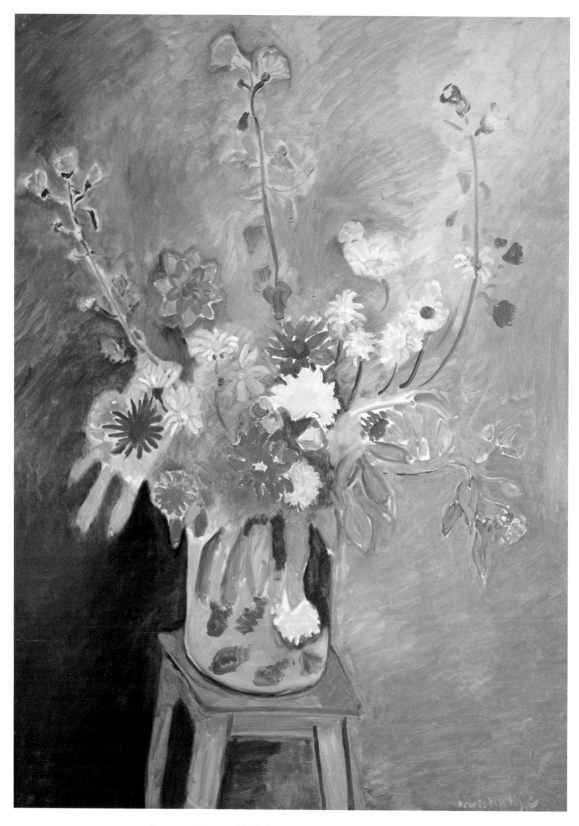

Bouquet of Flowers, 1917. San Diego Museum of Art (No. 32).

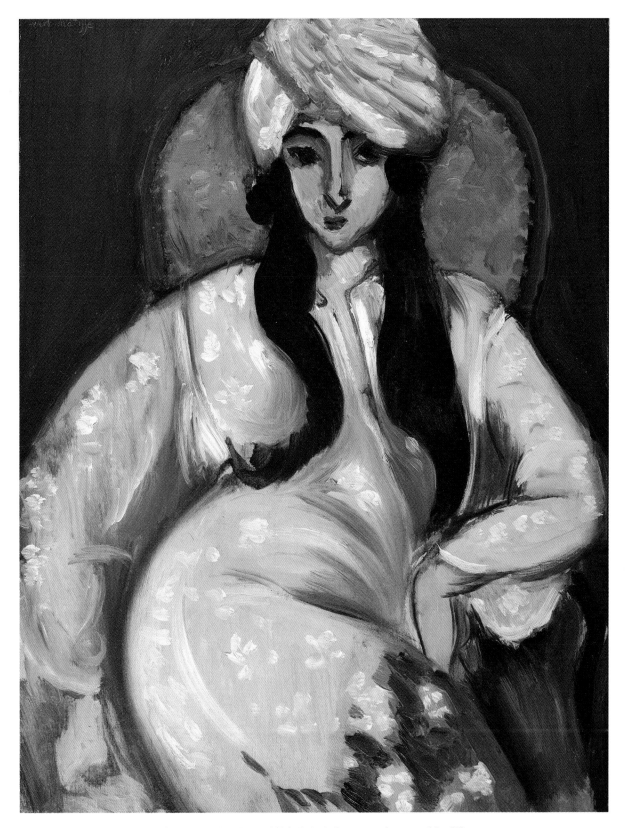

Laurette, turban blanc, 1916. Galerie Rosengart, Lucerne (No. 33).

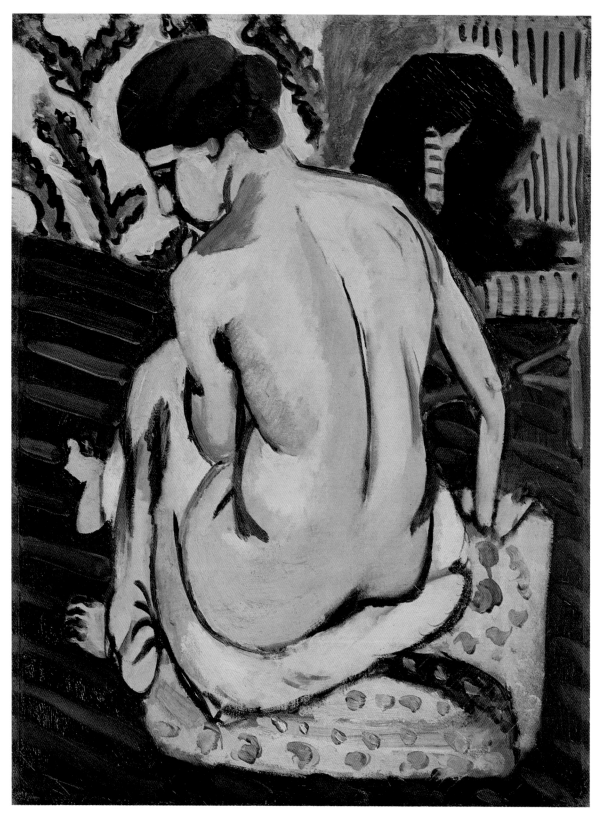

Seated Nude, Back Turned, 1918. Philadelphia Museum of Art (No. 35).

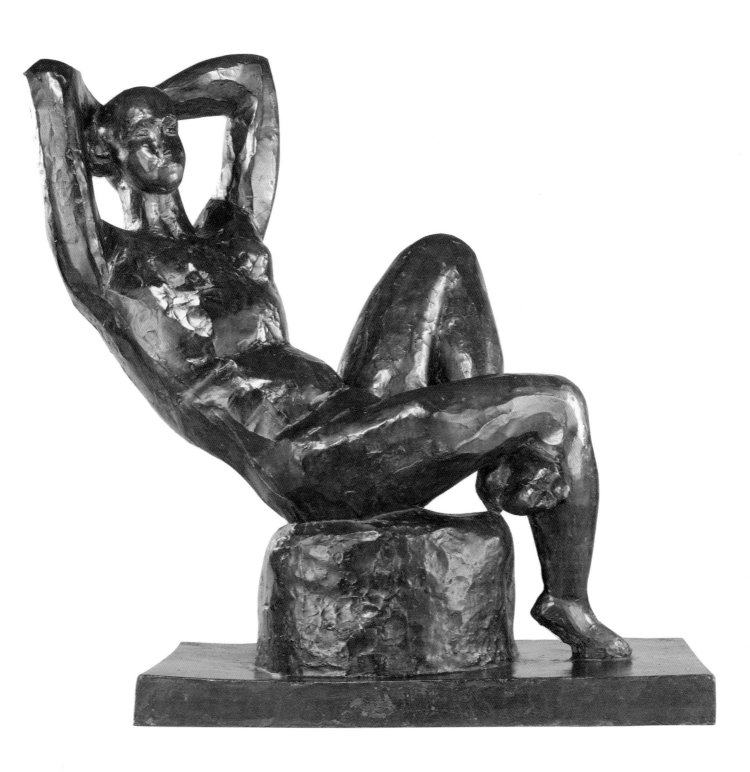

Large Seated Nude, 1923-25. Mr. and Mrs. Raymond D. Nasher, Dallas (No. 39).

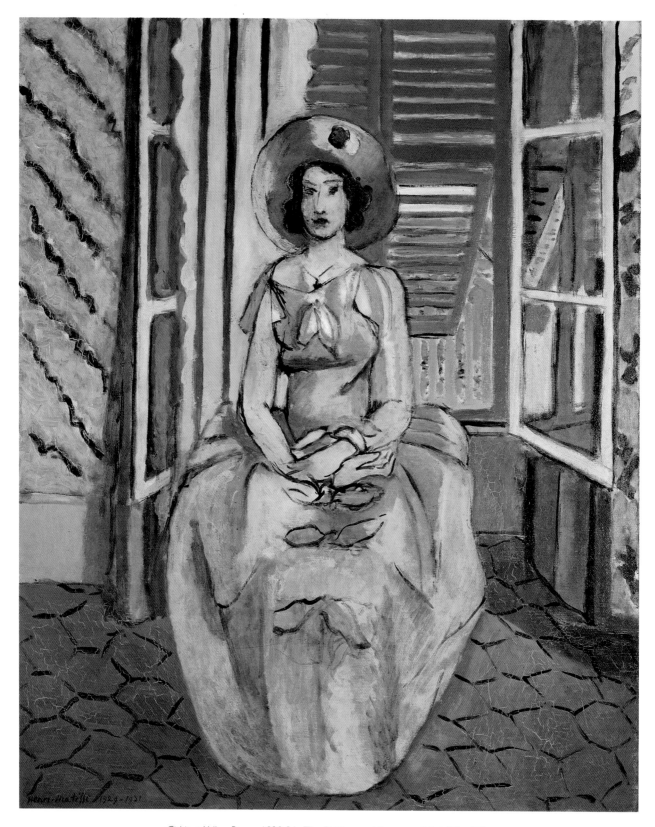

Girl in a Yellow Dress, 1929-31. The Baltimore Museum of Art (No. 50).

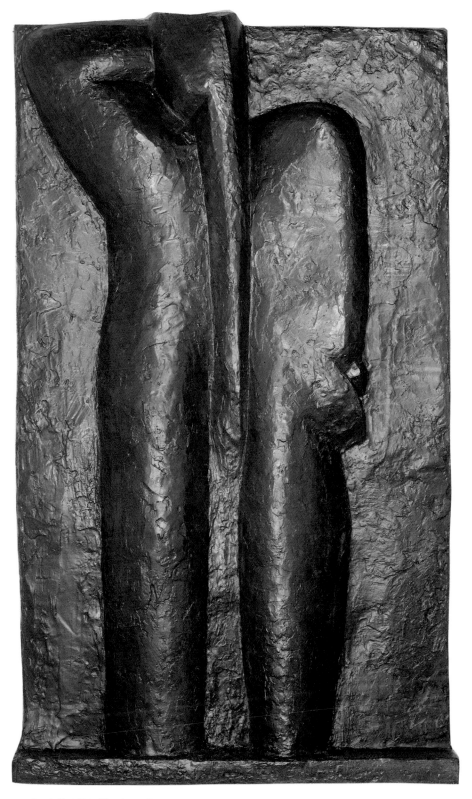

Back IV, 1931. The Anne Burnett and Charles D. Tandy Foundation, Fort Worth (No. 51).

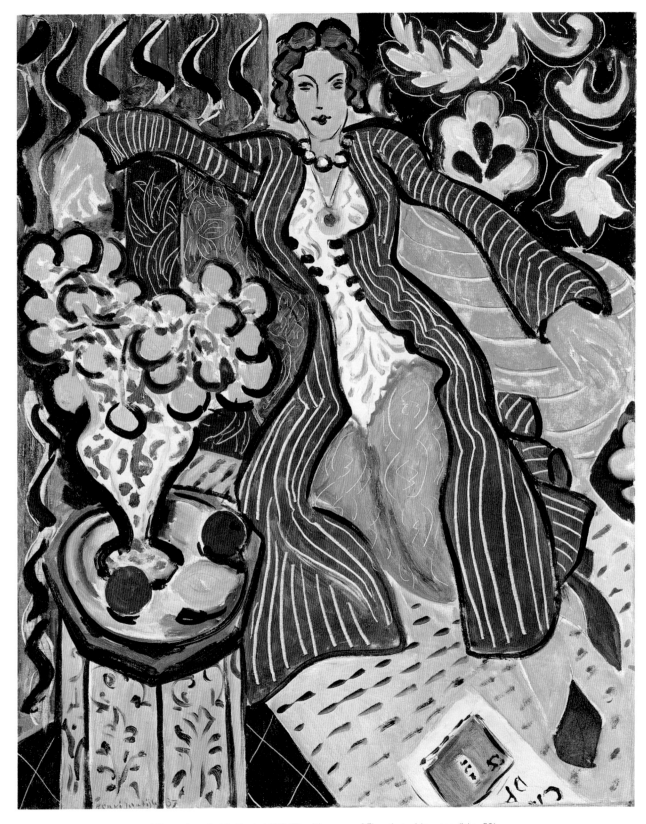

Woman in a Purple Coat, 1937. The Museum of Fine Arts, Houston (No. 53).

Catalogue

Notes to the Reader

Catalogue entries for the individual bronzes do not include a heading for exhibition history and references. For this material, the reader is directed to the corresponding entry in the 1975 Paris catalogue, *Henri Matisse Dessins et Sculpture* (Musée National d'Art Moderne, 29 Mai-7 Septembre 1975), where full listings will be found for the same composition. For the paintings, references have been given either to the catalogue of the 1970 Paris exhibition, *Henri Matisse, Exposition du Centenaire* (Grand Palais, Avril-Septembre 1970), or, when available, to the catalogue of the lending institution. An effort has been made, however, to include the most important post 1970 and 1975 references in the text or footnotes for both the paintings and bronzes.

The casts of the bronzes are Valsuani, unless otherwise indicated.

Abbreviations have been employed for the following exhibitions:

Zurich 1959: Henri Matisse, *Das plastische Werke* (Kunsthaus, Zurich, 14 Juli-12 August 1959).

Paris 1970: *Henri Matisse, Exposition du Centenaire* (Grand Palais, Avril-Septembre 1970).

Paris 1975: *Henri Matisse, Dessins et Sculpture* (Musée Nationale d'Art Moderne, 29 Mai-7 Septemre 1975).

Zurich 1983: *Henri Matisse* (Kunsthaus, Zurich, 15 Oktober 1982-16 Januar 1983).

The dates of the bronzes follow, for the most part, those given in Zurich 1959; Alicia Legg, *Matisse*, 1972; and Paris 1975, which were largely based on information supplied by the Matisse family.

1. THE SERF (1900-1908)

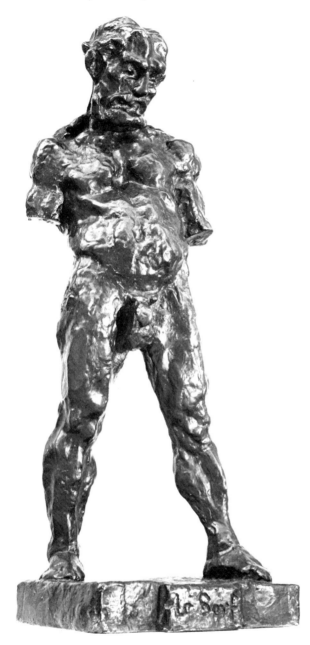

Bronze, HM 6/10, Le Serf, 36⅛ x 14⅞ x 13 in.
San Francisco Museum of Modern Art
Bequest of Harriet Lane Levy.

The Serf was Matisse's first original sculpture and his first study of the full figure. It has generally been assumed that Matisse finished *The Serf* in 1903.[1] However, new evidence discussed below suggests that he continued to work on it beyond that date.

Matisse began work on *The Serf* at the École Communale during the winter of 1900 and over the next three years used hundreds of sessions with the model.[2] The extraordinary amount of time Matisse devoted to this sculpture was clearly the result of his determination to master the figure in all its aspects and volumes. It may also have represented a kind of exorcism of Rodin, the greatest sculptor of the day. Even though *The Serf* was a studio exercise, Matisse had to confront Rodin's example in terms of material and the figure as subject.[3] He accepted the challenge and even employed the Italian model, Bevilacqua, who had earlier become famous by posing for the legs of Rodin's *Walking Man* (1877 or 1878) and the *St. John the Baptist* (1878, Figs. 16, 17).[4]

A connection between the *Walking Man*, the related *St. John the Baptist* and *The Serf* has been suggested, specifically in terms of the stance.[5] Yet the poses are quite different — Rodin presenting a figure in motion, Matisse a figure firmly rooted to the ground. In this sense, Matisse was reacting against the illusion of movement that Rodin's statues conveyed, an illusion Matisse felt inappropriate for sculpture.[6]

The differences between Matisse and Rodin were, however, much more fundamental. What Matisse sought above all was ''the realization of my own reactions.''[7] Matisse was certainly building on Rodin's innovations, but he eventually transcended Rodin by locating the work's meaning in his reaction to the model rather than in the heroic subject matter, mimetic surface, or the audacity of the partial figure. His treatment of *The Serf*'s body is as far from the miraculously modeled, integral form of *John the Baptist* as it is from the gouged torso of *Walking Man*. Matisse reformulated the anatomy of Bevilacqua according to his own feelings, striving, as he said, to envisage ''the general architecture'' of the figure and ''replacing explanatory details by a living and suggestive synthesis.''[8] He felt in Bevilacqua a powerful series of internal forces. The left side of the torso swells upward in response to the forward thrust of the left leg. The large abdomen, accentuated by the slouched pose, sweeps downward and outward. It is counterbalanced, however, by the right shoulderblade, a massive mound jutting aggressively

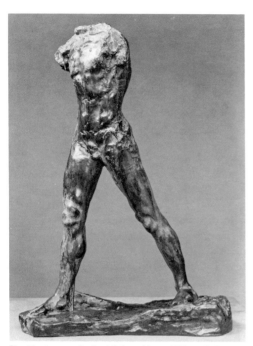

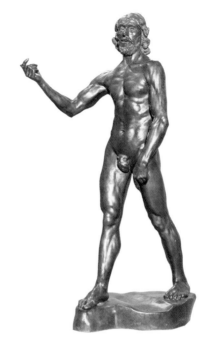

Fig. 16 Auguste Rodin, *Walking Man*, 1877 or 1878
The Metropolitan Museum of Art, New York.

Fig. 17 Auguste Rodin, *St. John the Baptist*, 1878.
Philadelphia Museum of Art, Rodin Museum.

into space. This bulging form seems to exert an equally potent force which collapses the chest at the breastbone in a deep concavity (Fig. 18). In recreating the model's anatomy, Matisse sought, however, not just expressive distortion. He advised his students in 1908: "I do not say that you should not exaggerate, but I do say that your exaggeration should be in accordance with the character of the model — not a meaningless exaggeration which only carries you away from the particular expression that you are seeking to establish."[9] It was the "essential qualities" of his subject that Matisse sought to capture. In *Notes of a Painter* of 1908 he wrote: "If I have an Italian model [probably referring to Bevilacqua] who at first appearance suggests nothing but a purely animal existence, I nevertheless discover his essential qualities. I penetrate amid the lines of the face those which suggest the deep gravity which persists in every human being."[10] Bevilacqua's powerful physique and primal force obviously had a profound impact on Matisse. Yet *The Serf* is not a grotesquerie, for the anatomical distortions assert the

autonomy of Matisse's own sensations without violating the dignity of the model.

While working on *The Serf*, Matisse undertook a painted study of Bevilacqua entitled *Male Nude* (1900, Fig. 19). The relationship between the painting and sculpture reveal Matisse's unity of purpose. In both cases the pose struck by Bevilacqua was the same. Although the anatomical distortions are somewhat less exaggerated in the painting, *Male Nude*, with color richly applied in broad, flat strokes inspired by the brushwork of Cezanne, is as sculptural in its own way as *The Serf*. Planes of color are abruptly juxtaposed in the arms and torso to define forms, while the legs are more freely brushed and bounded by bold, black contours. The parts of the body are individualized in their treatment of color and texture yet are related to the body's overall form to present a solid, architectonic image. While it would be misleading to label *The Serf* painterly — it is after all concerned with mass, volume, and the existence of the figure in space — it is important to note that unlike the smoothly finished

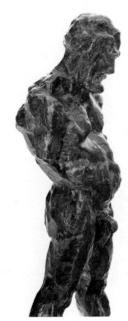

Fig. 18 Matisse, Detail of *The Serf*.

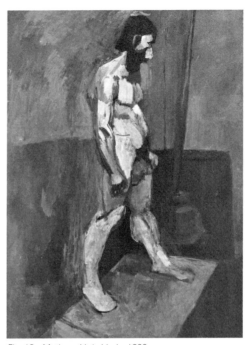

Fig. 19 Matisse, *Male Nude*, 1900.
The Museum of Modern Art, New York.

surface of *St. John the Baptist* or the distressed torso of *Walking Man*, *The Serf*'s agitated surface has been built up with small lumps of clay continuously reworked with fingers and thumbs to create a constantly undulating, variegated surface. This gestural modeling and the use of the sculptor's knife on the back and thighs to create broad, flat planes finds an equivalent in the loose brushwork and planar faceting of the *Male Nude*.[11]

A photograph of Matisse standing beside a plaster or clay version of *The Serf* provides a record of the work before it was cast in bronze and shows the arms still present. The date of this photograph can now be established with some precision on the basis of new information.[12] On the wall, behind *The Serf*, is Marquet's portrait of Madame Matisse of ca. 1900,[13] and, to Matisse's right, his *Bust of a Woman* of 1900 seen from behind. The presence of these works might seem to indicate that the photograph was taken about 1900 were it not for the painting on the floor to Matisse's left. This little known work entitled *Monk in Meditation* was painted by

Matisse between late 1903 and 1904.[14] Since the painting appears to be finished, the photograph should be dated no earlier than 1904.

This fact has significant consequences, as the date for the completion of *The Serf* traditionally has been given as 1903. However, *The Serf* in Figure 20 differs considerably from the bronze, not only because it has arms but also because of its profusion of muscle piled on muscle.[15] In order to achieve the final version, Matisse heavily reworked the figure seen in the photograph. He diminished the proportions and the knobby quality of the musculature by paring with the knife and smoothing the surface, changes especially evident in the outer edge of the left leg where the hand was attached to the thigh. The head also appears to have been reshaped, with the features of the face flattened and generalized.

Exactly when the arms were removed and the figure was reworked is difficult to say. According to Marguerite Duthuit, Matisse's daughter, the arms were lost in an accident before the work was cast.[16] Unfortunately, we do not yet know

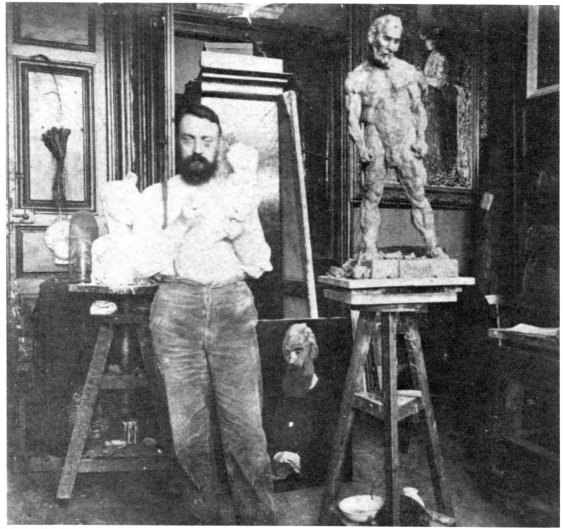

Fig. 20 Henri Matisse in his studio with *The Serf*, ca. 1904. Courtesy of The Museum of Modern Art, New York.

precisely when *The Serf* was first cast in bronze, or even if the accident occured in connection with the casting process, as Marquerite Duthuit seemed to imply. A definitive *terminus ante quem* for final work on *The Serf* is, therefore, presently unavailable.[17]

Matisse exhibited a plaster version of *The Serf* at the Galerie Druet in March and April of 1906.[18] Whether it was shown with arms is unknown. Matisse may have continued to work on *The Serf* from 1904 to 1906, arriving at a state close to the bronze. The fact that he showed a plaster version, however, suggests that it did have arms and that it had not yet been cast in bronze.

The first bronze version of *The Serf* was seen at the Salon d'Automne of 1908, indicating that the piece may have been cast in that year.[19] Hans Purrmann, who met Matisse late in 1905 or early 1906, and who in 1908 served as the

"manager" of Matisse's Academy, recalled that the arms were broken while *The Serf* was in transit,[20] perhaps on the way to the foundry. The recollections of Madame Duthuit and Hans Purrmann should not be lightly dismissed, for they were eyewitnesses. It may well be that the arms were damaged just prior to casting and that Matisse then decided to remove them, a decision leading to a figure thinner and less assertive in its surface. At the very least, the removal of the arms required the trueing of the stumps and the planing of the left thigh where the arm was attached.

Unless a photograph of the 1906 plaster version of *The Serf* comes to light and its date of casting can be found, it will be difficult to determine the exact chronological and stylistic evolution of Matisse's first major bronze. It is clear, however, that Matisse worked on *The Serf* beyond the long accepted terminal date of 1903.

Notes

1. Paris 1975, no. 166; Elsen, *Matise*, 25-39.

2. Paris 1975, no. 166. Estimates on the time spent vary from 100 sittings, as reported by Leo Stein and quoted by Barr, *Matisse*, 48, to 2000 hours, Aragon, *Matisse in France*, 1943, unpaged.

3. Tucker, *Language of Sculpture*, 87.

4. Elsen has noted that Matisse was aware of Bevilacqua's connection with Rodin and even talked with him concerning Rodin's working methods; Elsen, *Matisse*, 29. Matisse declared in 1907, "I have never avoided the influence of others, I would have considered it a cowardice and a lack of sincerity toward myself. I believe that the personality of the artist develops and asserts itself through the struggles it has to go through when pitted against other personalities. If the fight is fatal and the personality succumbs, it means that this was bound to be its fate;" Flam, *Matisse on Art*, 21. See also Fourcade, *Écrits*, 56 and n. 24. Rodin's *Walking Man* was seen in its original small format in June of 1900 during his historic retrospective and so it would have been known to Matisse; Elsen, *Matisse*, 28.

5. "This stance is exactly the same as Rodin's *St. John the Baptist . . .,"* Herbert Read, "The Sculpture of Matisse," in *Henri Matisse*, Berkeley and Los Angeles, 1966, 20. Henry Geldzahler made the connection with the *Walking Man* in "Two Early Drawings by Henri Matisse," *Gazette de Beaux Arts*, v. 60, 1962, 497-505, as

did George H. Hamilton, *Painting and Sculpture in Europe, 1880-1940*, Baltimore, 1967, 109. Both Elsen, *Matisse*, 27, and Tucker, "The Sculpture of Matisse," 82-83, have noted the differences.

6. Elsen, *Matisse*, 29.

7. Escholier, *Matisse*, 138.

8. *Ibid.*

9. "Sarah Stein's Notes, 1908," as quoted by Flam, *Matisse on Art*, 43.

10. Flam, *Matisse on Art*, 38.

11. Elderfield, *Matisse*, 32.

12. Elsen, *Matisse*, 29-30, fig. 32, dates the photograph to ca. 1908 and asserts that it was taken by Hans Purrmann. Purrmann arrived in Paris for the first time late in 1905 to see the Manet retrospective; Purrmann, *Leben und Meinungen des Malers Hans Purrmann*, Wiesbaden, 1961, 58, 91. He was soon introduced to Matisse by Leo Stein and the two artists became close friends, with Purrmann later acting as the manager of Matisse's 'Academy' which opened early in 1908; Barr, *Matisse*, 59. If Purrmann actually took this photograph, it would date between 1906 and 1908 and imply a major reworking of *The Serf* at this late date.

There is, however, little evidence to indicate that Purrmann took the photograph, or even owned it. Although it is reproduced in his book, it is not dated or credited to him; Purrmann, *Leben*, Fig. 26, opposite page 97. The original photograph is contained in an album in the Special Collections of the Library of the Museum of Modern Art. This small book was the property of Erich S. Herrmann who presented it to the museum in 1954. Research undertaken by the library staff in 1970 concluded that the photograph should be dated to 1900. I would like to thank Clive Phillpot, Director of the Library of the Museum of Modern Art, for helping to track down the origins of this photograph.

13. Jack Flam identified the painting in a conversation in December, 1983.

14. The identification of this painting was kindly supplied by Wanda de Guébriant in a telephone conversation on February 22, 1984. She noted that this work, now in a private collection in the United States, was once owned by Vollard and is mentioned in an unpublished letter from Matisse to Biette dated 1903.

15. *The Serf,* as seen in Fig. 20, brings to mind the muscular abundance of Goltzius' engraving, *The Large Hercules* of 1589, for which see Walter L. Strauss (ed.), *Hendrick Goltzius 1558-1617: The Complete Engravings and Woodcuts,* 2 vols., New York, 1977, II, n. 283.

16. Barr, *Matisse,* 52; Elsen, *Matisse,* 217, n. 23. More recently, scholars have doubted the possibility of an accident, suggesting that the arms were intentionally removed by the artist since they were firmly attached to the sides, see Elsen, *Matisse,* 30.

17. The casting records of Matisse's sculpture are unpublished. Madame Wanda de Guébriant has indicated in a letter to the author that Matisse's sculpture, usually issued in an edition of 10, with one or two artist's proofs, was neither cast in numerical order nor necessarily at the same time. According to Madame de Guébriant, Matisse only began using Valsuani as a founder in 1925. Many aspects of Matisse's casting practice remain to be clarified.

18. Paris 1975, no. 166.

19. *Ibid.* This is the most probable scenario, as it is difficult to imagine that Matisse would have gone to the trouble and expense of casting the piece in 1906 or 1907. Matisse showed thirteen bronzes at the Salon d'Automne of 1908, his largest exhibition of sculpture up to that date. He was undoubtedly busy preparing for that show in the preceding months. A photograph of the apartment of Michael and Sarah Stein shows the bronze verion; *Four Americans in Paris: the Collections of Gertrude Stein and her Family,* New York, 1970, 45 The photograph is dated early 1908, but the reasons for assigning the photograph this date are unclear.

20. Purrmann, *Leben,* 413.

2. NUDE STUDY IN BLUE (1900)

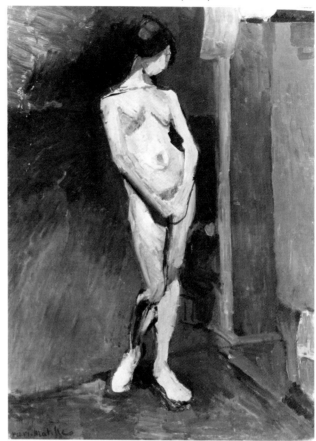

Oil on canvas, *Henri Matisse,* 23¾ x 21⅜ in., The Tate Gallery, London. Colorplate on page 21

In February of 1899, Matisse and his wife returned to Paris from a year in Corsica and Toulouse.[1] He began to sketch at the École des Beaux Arts in the studio of his late teacher, Gustave Moreau, but left as the new professor, the academic painter Fernand Cormon, was unsympathetic. He soon found a studio where he could work undisturbed even by the master, Eugène Carrière, who came once a week to correct the drawings. It was here that he met a number of artists including Jean Puy, Lapade, Biette, and Derain. Later, after the "Academie Carrière" closed for lack of students,[2] they all relocated to Biette's studio, hiring models and continuing their work.

It was during this period that Matisse began his study of the figure. The *Male Nude* and related studies of Bevilacqua (see No. 1) were among the first paintings Matisse undertook in his new mode. About the same time he also began working from the female model. One of those early efforts is *Nude Study in Blue* (1900) in the Tate Gallery (No. 2). Here, Matisse has produced another *académie* or study of a studio pose. Like the *Male Nude*, *Nude Study in Blue* is dominated by the dark blue and brown tonalities of the background.[3] Matisse painted freely, applying colors in broad, diagonal strokes on the torso and long, sweeping strokes on the limbs.

Unlike *Male Nude*, however, this figure is without the strong planar faceting found in Bevilacqua's torso. The more fluid and consistent handling of paint evident throughout the figure would seem to be partly the result of what Matisse called the "essential qualities" of the model. In fact, *Nude Study in Blue* may be seen as a complementary contrast to *Male Nude*: feminine grace versus masculine power; supple, flowing lines versus bold, angular contours and assertive internal modeling; a graceful *contrapposto* versus a stolid earthbound pose; the sex of the female model demurely concealed versus that of Bevilacqua unhesitatingly revealed. From this point on, Matisse almost totally abandoned the male physique, concerning himself with the more tranquil and harmonious potential of the female form.[4]

Notes

1. Barr, *Matisse*, 37.

2. Barr, *Matisse*, 38.

3. Barr, *Matisse*, 48.

4. John Jacobus, *Matisse*, 54.

3. MADELEINE I (1901)

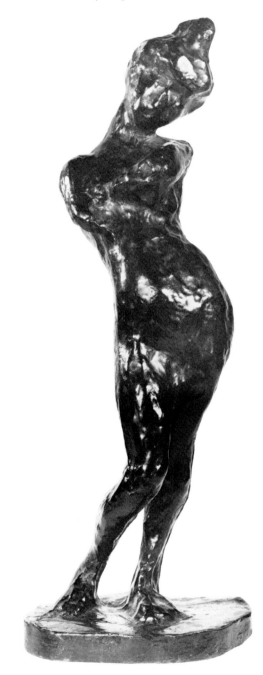

Bronze, *HM 4/10*, Height: 23⅜ in., Private Collection, New York.

Fig. 21 Matisse, Study for *Madeleine I*, pencil, ca. 1901.
The Museum of Modern Art, New York.

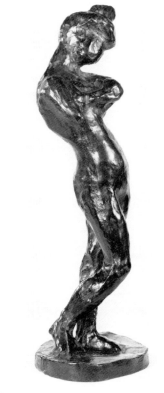

Fig. 22 Matisse, *Madeleine I*, side view.

Madeleine I, though begun after *The Serf*, was the first important bronze Matisse completed. It differs markedly from *The Serf* in stance and execution and represents the first stages of a new direction in Matisse's art, one which would concern him for the remainder of his career — the exploration of the decorative arabesque.

Nude Study in Blue (No. 2) may be seen as a parallel effort if not an actual preparatory study for the bronze.[1] In the painting, the arms of the model are drawn forward over the pubic area, a pose which tended to complicate and obscure the body's contours. Matisse addressed this problem in a subsequent pencil sketch executed about 1901 (Fig. 21).[2] Here the arms are folded over the breasts on a sharp diagonal, with the right elbow projecting sharply outward into space.

Matisse adopted this placement of the arms in the bronze but cut the right arm just above the elbow, blending the stump into the body. The left arm has also been modeled so that it appears to meld into the breast at the wrist. Matisse was clearly interested in presenting an uninterrupted contour, a smooth undulating outline undisturbed by angular projections or the kind of blunt appendages which characterize *The Serf*. The pencil drawing, basically a study of the figure's contours, shows Matisse working toward the fluid lines of *Madeleine I*. By folding the arms across the chest and by exaggerating the hipshot pose employed in the painting, Matisse intensified the graceful, curving forms of the sculpture with an elegant sweep evident from all sides (Fig. 22). The *figura serpentinata* pose also calls to mind Leonardo da Vinci's lost *Leda* composition. A drawing formerly attributed to

Fig. 23 Matisse, *La Coiffure*, 1901.
National Gallery of Art, Washington, D.C.

Leonardo is in the Louvre, and it is not inconceivable that Matisse referred to the type, modifying and reversing the pose.[3]

The more decorative and lithesome quality of this bronze is reinforced by its facture. Matisse must have wet the clay and then worked the surfaces with his fingers, smoothing and rubbing, to obtain an evenly modulated quality. All the forms blend together without great variation in relief and with no abrupt transitions to interrupt the continuous flow of the surface. The overall effect is of an evenness of execution much more homogeneous than *The Serf* and not unlike that of *Nude Study in Blue*.

Madeleine I is contemporary with *La Coiffure* (1901) in the National Gallery of Art, Washington (Fig. 23). This work, one of Matisse's first figure paintings other than an *académie*, was indicative of his increased confidence in the handling of the human body.[4]

Notes

1. Barr, *Matisse*, 48.

2. In the collection of the Museum of Modern Art; see Elderfield, *Matisse*, 32.

3. L. Ettlinger, *The Complete Paintings of Leonardo*, Milan, 1967, 107. The S-curve of the figure has also been related to Art Nouveau, see Kramer, ''Matisse's Sculpture,'' 53.

4. Barr, *Matisse*, 49.

4. MADELEINE II (1903)

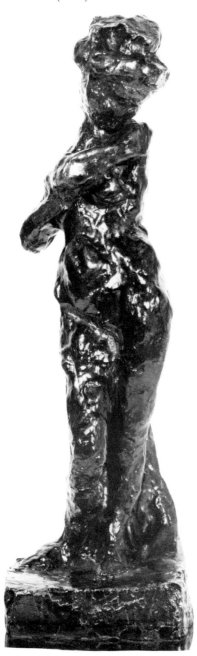

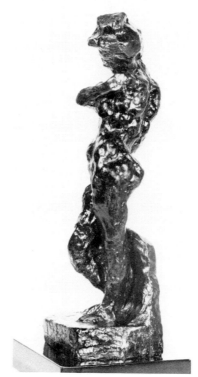

Fig. 24 Matisse, *Madeleine II*, side view.

Bronze, *HM 3/10*, Height: 23¼ in.
Collection Marion and Nathan Smooke, Los Angeles.

It would appear that *Madeleine II* is based on a plaster cast of *Madeleine I*. Matisse radically altered the form by slicing away the top of the coiffure and placing a support behind the left leg, undoubtedly to steady the cast as he worked on it. The right shoulder has been considerably modified by a strong backward thrust which increases the spatial torsion, while the arms folded across the chest are now complete with the right elbow protruding sharply as in the drawing of 1901 (Fig. 21). The most noticeable difference between *Madeleine I* and *Madeleine II* is in the handling of the surface, which in the latter is vigorously worked with an agitated touch. Matisse added large lumps of clay which were then punched and pinched, forming a restless surface which catches the light and accentuates the roughness of the modeling, an effect far removed from the smooth skin of *Madeleine I*. The side views reveal an exaggerated anatomy, especially the large buttocks (Fig. 24). This bold and assertive

Fig. 25 Matisse, *Carmelina*, 1903.
Museum of Fine Arts, Boston.

work is far more experimental than Matisse's contemporary
painted figure studies such as the *Carmelina* of 1903 (Fig. 25).[1]
Madeleine I is, in fact, much closer to *The Serf*. The rougher,
aggressive quality may have been motivated by his work on
The Serf. Matisse may have found the surface of *Madeleine I*
too tame, especially in light of his current sculptural
sensations, and so created a more vigorous second version.

This is the earliest example in the sculpture of Matisse in
which he developed a composition in multiples, a practice
which soon became a familiar aspect of his art. By working
from the plaster cast of *Madeleine I*, Matisse was able to
distance himself from the live model, thereby allowing his
sensations greater freedom to react to the motif.

Notes

1. Compare also *Nude with White Towel* of 1903, a study of the
same model who posed for *Madeleine I*; Paris 1970, no. 53.

5. SEATED NUDE WITH ARMS ON HEAD (1904)

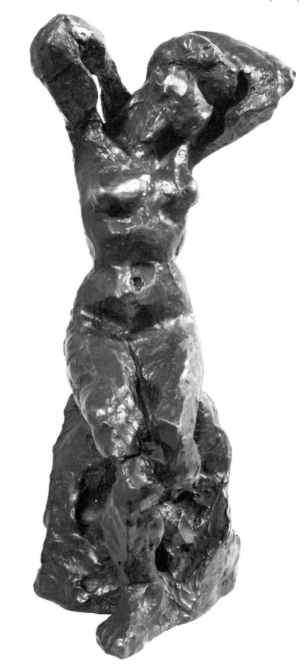

Bronze, *HM 5/10*, Height: 13¾ in., Private Collection, New York.

6. UPRIGHT NUDE WITH ARCHED BACK (1904)

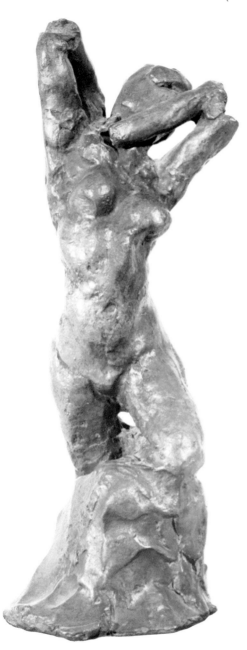

Bronze, *HM 9/10,* Height: 7⅛ in.
Collection Beatrice S. Kolliner, Los Angeles.

After the relatively small sculptural production of 1903 (*Madeleine II* and a 5 inch high profile relief of his daughter Marguerite),[1] the following year saw the beginning of a significant period of Matisse's sculptural work which lasted for more than a decade. Two bronzes heralded this period of activity — *Seated Nude with Arms on Head* and *Upright Nude with Arched Back.*

In both cases Matisse explored a familiar studio pose — the arched back and arms raised arranging the hair. The stretching posture increases the vertical accent of the figures by liberating the contours of the body. Elsen has noted that Matisse infused these voluptuous bronzes with an energy far exceeding that found in the almost inert poses usually contrived by academic sculptors.[2] *Seated Nude with Arms on Head,* with its pinched waist and breasts thrust outward in response to the straight back, is extremely sensuous, an effect heightened by the contrast established between the smoothly modeled torso and the rougher, more schematic treatment of head, arms, and legs. There is also an intimate, langourous quality conveyed by the nestling of the head against the left arm, an intimacy reinforced by the private act of adjusting the hair while nude. *Upright Nude* is equally appealing as she stretches upward, braiding the hair lying on her right shoulder.[3]

Matisse was fascinated by the expressive potential inherent in a woman arranging her hair. He utilized the motif several times in his sculpture and paintings, most immediately in *Luxe, calme, et volupté* of 1904-05 (Fig. 26).[4] The bronzes of 1904 certainly reflect Matisse's interest in investigating the motif and may possibly have been inspired by his work on this important picture.

Luxe, calme, et volupté was a key work in which Matisse temporarily resumed a Neo-Impressionist style under the influence of Signac.[5] The picture was a milestone inasmuch as it was his first multi-figured composition with a group of nudes in various poses — sitting, reclining, and standing. Matisse was venturing into a new genre, the idyllic landscape, and in so doing faced the same challenge as had Giorgione, Claude and Poussin, the population of this environment with figures in an interesting variety of poses.

Work on *Luxe, calme, et volupté* began in St. Tropez during the summer of 1904. The image evolved from a painting of his wife and son Jean seated at the seaside.[6] This composition was expanded by the addition of nude bathers. These figures

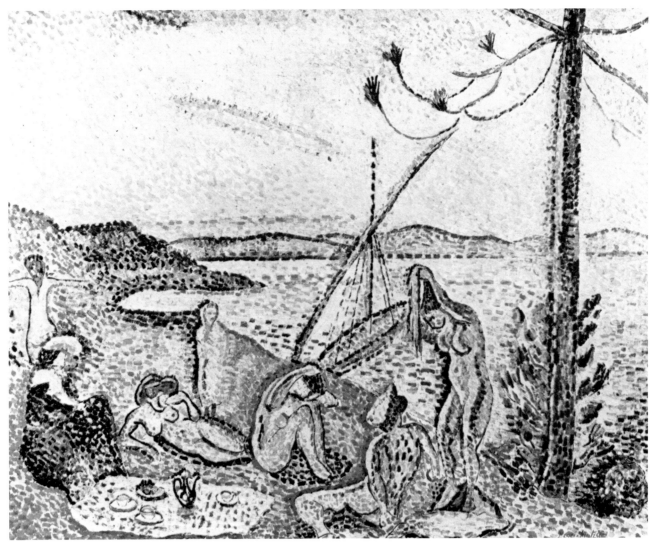

Fig. 26 Matisse, *Luxe, calme, et volupté*, 1904-1905. Private Collection, Paris.

were first studied in a series of sketches from the model.[7] By the end of the summer, Matisse had finished the oil sketch now in the Whitney collection. The painting was then completed in Paris during the winter of 1904-05.[8]

There is no indication that Matisse did any modeling in clay at St. Tropez. If any was done at all in connection with this work, it would most likely have been after his return to Paris in early October.[9] The multi-figured composition was new territory for Matisse, and it is not improbable that he sought reassurance through sculpting the figure. We know he felt that a conflict existed between the solidity of the figures' forms and integrity of contours and the color, a problem deriving from the Neo-Impressionist technique. In 1929 Matisse discussed with the critic Tériade the weaknesses of

Neo-Impressionism: "The breaking up of color led to the breaking up of form, of contour. Result: a jumpy surface."[10] He sought to regain the identity of the figure by outlining, then only to worry about the resultant conflict between drawing and color.[11] In a letter to Signac of July 14, 1905, Matisse expressed his opinion about the painting's problems directly: "Have you found in my picture of the *Bathers* a perfect accord between the character of the drawing and the character of the painting? In my opinion they seem totally different, one from the other, absolutely contradictory. The one, drawing, depends on linear or sculptural plasticity; the other, painting, depends on colored plasticity."[12] Although we cannot be sure, these two bronzes may have been undertaken simultaneously with work on *Luxe, calme, et volupté* as a complementary and necessary assertion of the "sculptural plasticity" displayed by the painting's nudes. The handling of *Seated Nude with Arms on Head* would seem to address these concerns directly. Matisse planed the arms and the upper thighs which emphasizes the linear contours. Yet, at various points, he returned and added small lumps of clay over those flattened areas, working material into the surface to build up volume.

The curious sexual aura of the painting is certainly echoed in the bronzes. The rock-like base which supports both figures implies an outdoor setting and removes them from the confines of the studio to an imaginary environment not unlike the idyllic world of the nude bathers in *Luxe, calme, et volupté*.

Notes

1. Legg, *Sculpture of Matisse*, 14.

2. Elsen, *Matisse*, 58.

3. The arms of this figure originally extended upward over the head. They have been broken at the elbow and bent down to the right shoulder. In a forthcoming article Jack Flam redates this bronze to 1906 and reidentifies the subject as well as the source of the pose.

4. For a related use in sculpture, see No. 8.

5. For a detailed discussion of the picture, see Elderfield, *Matisse*, 36-39.

6. This painting is now in the collection of the Indiana Foundation.

7. M. T. Lemoyne de Forges, *Signac* (Paris, Musée du Louvre, 1964), 102. For the oil sketch, see Elderfield, *Matisse*, 36-39.

8. Elderfield, *Matisse*, 36. It is possible that the oil sketch was begun in Paris in the fall; oral communication from Jack Flam.

9. Matisse returned to Paris shortly before the opening of the Salon d'Automne on October 15; Elderfield, *Matisse*, 36. Barr gives no indication of Matisse's activities during the first six months of 1904. It is not impossible that the bronzes were created sometime during that period. Matisse did produce drawn studies of the nude in 1902 and 1903; see Elderfield, *Matisse*, 35. As far as I know, however, none relate as directly to the figures in *Luxe, calme, et volupté* as these two bronzes, a fact which argues for a later date.

10. Flam, *Matisse on Art*, 58.

11. Elderfield, *Matisse*, 38.

12. As quoted in Elderfield, *Matisse*, 38.

7. WOMAN LEANING ON HER HANDS (1905)

Bronze, *HM 6/10*, Height: 5¼ in., Weatherspoon Art Gallery, Cone Collection, University of North Carolina at Greensboro.

In 1905, Matisse produced four sculptures — three small heads and *Woman Leaning on Her Hands*.[1] It seems possible that this bronze is related to his work on *Luxe, calme, et volupté*. When viewed from the back, *Woman Leaning on Her Hands* is close enough to the reclining figure at the right, especially in the positioning of the legs and left arm and in the interest in the body's torsion, to suggest a more than casual relationship (Fig. 26). We know that while in St. Tropez Matisse prepared sketches from the model for the nude bathers.[2] He may well have continued such sketches as he worked on the final version of *Luxe, calme, et volupté* during the winter of 1904-05. It is easy to imagine the bronze as an outgrowth of those studies; all the more so because from the summer of 1905 Matisse was moving in a new direction, producing his first "pure and characteristic fauve canvases,"[3] including *The Woman with the Hat* and *The Green Line*. Whether *Woman Leaning on Her Hands* was coeval with *Luxe, calme, et volupté* or immediately followed it is impossible to say but, in either case, the bronze undoubtedly should be dated to the early months of 1905.

A contour drawing of the model in this complex pose presumably done at this time, if not an actual study for the bronze, may have alerted Matisse to the pose's sculptural possibilities.[4] The bronze's sprawling posture is ordered by a

counterbalanced thrust of arms and legs. The body undulates through space, the contrapuntal torsion of its parts impelling us to move around the figure or, more accurately, to turn it in our hands in order to appreciate a composition in perfect equilibrium. In 1908, Matisse told his students that "a sculpture must invite us to handle it as an object — just so the sculptor must feel, in making it, the particular demand for volume and mass."[5] Matisse's tactile imperative for the sensation of mass and volume is remarkably achieved in this little figure which embodies the essence of form with a minimum of descriptive detail. This quality recalls Matisse's comment: "The smaller the bit of sculpture the more the essentials of form must exist."[6] This small sculpture, so smoothly and simply modeled, also shares the sensuousness of the 1904 bronzes, as her shift is pulled up above the waist and hangs low over her shoulders and breasts. A terra cotta version of this figure appears in two paintings, *Pink Onions* (1906) and *Still Life with Geraniums* (1907).[7]

Notes

1. For the heads, see Legg, *Sculpture*, 14-15.

2. See Nos. 5, 6

3. Barr, *Matisse*, 54.

4. Elsen, *Matisse*, 61.

5. Flam, *Matisse on Art*, 45.

6. *Ibid.*

7. For illustrations, see Barr, *Matisse*, 76; and Zurich 1983, no. 21.

8. STANDING NUDE, ARMS ON HEAD (1906)

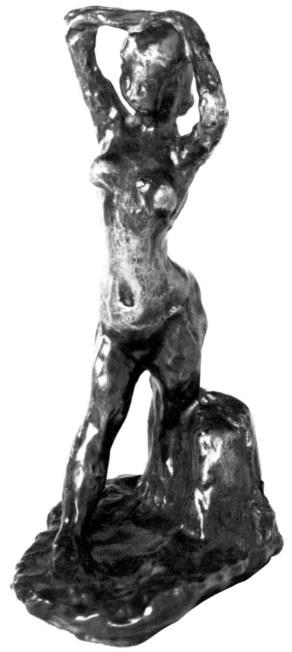

Bronze, *Henri Matisse 4/10*, Height: 10¼ in.
The Rosenbach Museum and Library, Philadelphia.

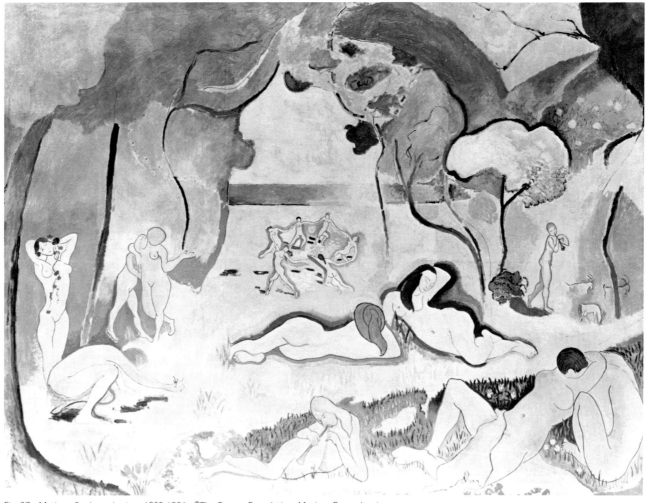

Fig. 27 Matisse, *Bonheur de vivre*, 1905-1906. ©The Barnes Foundation, Merion, Pennsylvania.

When the Salon des Indépendants opened on March 20, 1906, Matisse exhibited but one work, the *Bonheur de vivre* (Fig. 27). It was, as Barr noted, "a grand composition, a definitive statement,"[1] a conscious masterwork demanding all of Matisse's art. The subject matter was developed from the imaginary, idyllic world presented in *Luxe, calme, et volupté*, but the technique sought to rectify the conflict between color and form generated by the earlier work's Neo-Impressionist style. It was also Matisse's most ambitious figure painting with sixteen figures presented in a wide variety of poses and activities.

Matisse drew on the rich tradition of classical figure types found in the Golden Age theme to populate his picture.[2] The painting is a landmark in its conscious historicism and in the importance with which Matisse endowed the figure.[3] Not surprisingly, *Bonheur de vivre* became a rich source of motifs for Matisse; the crouching figure at the left, the reclining nudes in the middle ground, and the dancers in the

54

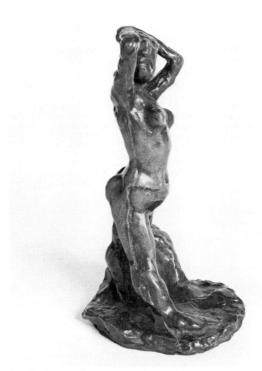

Fig. 28 Matisse, *Standing Nude, Arms on Head*, side view.

Fig. 29 Matisse, *Seated Nude*, woodcut, 1906.
The Museum of Modern Art, New York.

background, all soon reappeared in various manifestations in Matisse's painting and sculpture.[4]

One other figure, the girl with ivy in her hair at the far left, may have served as a point of departure for another work, the bronze *Standing Nude, Arms on Head*. Matisse was fascinated with the motif of the upraised arms, treating it earlier in the two bronzes of 1904.[5] *Standing Nude, Arms on Head* shares the sensuous pose with arched back and protruding breasts of the earlier statuettes but also exhibits a new interest in an expressive, undulating contour, as seen in the sharp curve of the back and the dimpled outline of the buttocks in the *Bonheur de vivre's* girl with ivy (No. 8, Fig. 27).

These affinities might suggest a date early in 1906 for the bronze, were it not for its most remarkable feature, the exaggerated anatomy which, when seen from the side, seems to set it apart from the mellifluous forms in the *Bonheur de vivre* (Fig. 28). Yet, as Matisse was completing work on the

painting, he produced a series of prints and drawings which study the figure in a wide range of techniques and style.[6] Most pertinent here are a series of three woodcuts, "the only prints by Matisse that are dynamically in the Fauve manner."[7] All share a simplified treatment of the body, drastically reshaped and defined through bold, strong lines.[8] *Seated Nude* — with her protruding shoulder blades and buttocks, paunchy stomach and squat legs — shows an expressive distortion of forms for which one finds a parallel in *Standing Nude, Arms on Head* (Figs. 28, 29). According to Madame Duthuit, Matisse usually executed these prints at the end of a long day of painting: "The clarity of line and the special luminosity emanating from the plates that were produced in this manner constitute in a way the direct profit from the periods of sustained effort that preceded them and offer delightful variations on the theme preoccupying him at the moment."[9] We know that Matisse frequently moved

from one medium to another in order to investigate a problem.[10] He used sculpture in a similar way. It seems possible that *Standing Nude, Arms on Head*, exploring in three dimensions the exaggerated anatomical distortions advanced in the prints and drawings, may have been produced along with them during the final stages of work on the *Bonheur de vivre*.[11]

Notes

1. Barr, *Matisse*, 82.

2. On the *Bonheur de vivre*, see Barr, *Matisse*, 88-92; Elderfield, *The "Wild Beasts," Fauvism and Its Affinities*, New York, 1976, 97ff.; and Elderfield, "The Garden and the City: Allegorical Painting and Early Modernism," *Bulletin, The Museum of Fine Arts, Houston*, Summer, 1979, 10f.

3. An interesting connection between the *Bonheur de vivre* and Agostino Carracci's print, *Reciprico Amore*, was advanced by James B. Cuno, "Matisse and Agostino Carracci: A Source for the 'Bonheur de Vivre,'" *Burlington Magazine*, CXXII, 1980, 503-504.

4. See Nos. 11, 15.

5. See Nos. 5, 6.

6. Elderfield, *Matisse*, 48-50.

7. *Ibid.*, 48.

8. For illustrations of all three, see William S. Lieberman, *Matisse 50 Years of His Graphic Art*, New York, 1956, 65-67.

9. As quoted in Elderfield, *Matisse*, 50.

10. Paris 1975, 12. Two studies of the nude model datable to 1906 would also appear to reflect Matisse's interest in the expressive distortion of the figure and may be contemporary with the woodcuts, see Paris 1975, nos. 23, 24.

11. Elderfield, *Matisse*, 51, has proposed a date late in 1906 based on the distortions seen in *Reclining Nude I*. The small bronze *Torso with Head (La Vie)* is stylistically related to No. 8 and, in all likelihood, was produced at the same moment, see Legg, *Matisse*, 13 for an illustration.

9. STANDING NUDE (1906)

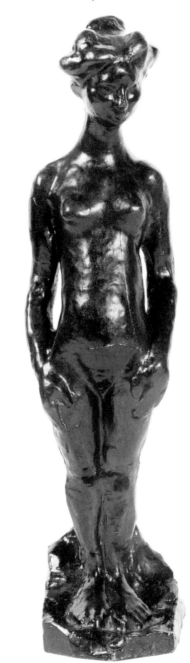

Bronze, *HM 9/10*, Height: 19 in., Collection Miriam and Bernard West.

Shortly after the opening of the Salon des Indépendants and his second one man show at the Galerie Druet, Matisse left on his first trip to North Africa. He returned via Collioure where he spent a fruitful spring and summer producing a large body of work. *Standing Nude* is datable to those summer months.

The paintings done at Collioure show Matisse working in a wide variety of styles and genres — still lifes, portraits, landscapes, and figure studies. He appears to have been unsure of his next step and unwilling to follow immediately the direction indicated by the *Bonheur de vivre*, and so experimented freely, testing a number of stylistic options in search of a new direction for his art. One of those summer paintings was *Marguerite Reading*, a portrait of his daughter (Fig. 30).[2] This work demonstrates a direct connection between Matisse's painting and sculpture. For the preparation of the painting, Marguerite sat to her father during the afternoon and then, at the onset of evening, posed for *Standing Nude*.[3] At first glance, there might appear to be little to connect the sculpture and painting other than the model. But when viewed in the broader context of Matisse's work, the relationship becomes clearer. *Marguerite Reading* is a reinterpretation of *Girl Reading (La Lecture)*, the portrait of his daughter reading, done during the winter of 1905-06.[4] This painting is executed in the "mixed-technique style of Fauvism" in which the color is loosely and freely applied in a wide variety of brushstrokes, producing an active, agitated surface.[5] *Marguerite Reading*, on the other hand, has a more consistent brushwork. The uniform touch and the neutralization of the background imparts a sense of order and calm which enhances, rather than detracts from, the intimate quality of the subject.

Standing Nude shows a similarly restrained treatment and, when compared to his earlier sculpture, represents a significant stylistic and formal departure. The pose is no longer so obviously derived from the studio, and the surface evinces an allover smoothness and a degree of finish distinct from the rougher touch and more summarily formed limbs of his most recent bronzes (see Nos. 5, 6, 8). The self-contained pose and unexaggerated anatomy also distinguish it from the assertive *Standing Nude, Arms on Head*, just as its quiet introspective mood finds a parallel in *Marguerite Reading*. In fact, the tranquility and order expressed by painting and bronze are reminiscent of the *Bonheur de vivre*.[6] *Standing*

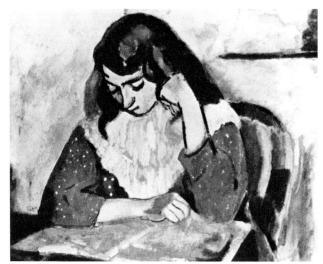

Fig. 30 Matisse, *Marguerite Reading*, 1906.
Musée de Peinture et de Sculpture, Grenoble.

Nude with her closed-legged stance, flowing outline, and the kind of ideal stasis achieved through a simplified mode of expression evokes in particular the girl with ivy in her hair at the left (Fig. 27).

In conceiving this bronze, Matisse was obviously influenced by his daughter's tender age and youthful figure. Unlike the more mature women of the earlier bronzes, this piece is demure, even chaste by comparison. Yet, though modeled after Marguerite, *Standing Nude* is hardly a portrait. For the first time in Matisse's sculpture, a bronze assumed the status of a totem or icon, rather than just a studio study. This quality betrays its sources, for when posing Marguerite, Matisse was drawing on his knowledge of ancient and primitive sculpture. The near frontal stance, erect posture with arms placed on the thighs and legs pressed together, the elongated neck and narrow eyes would seem to be a synthesis of archaic Greek and Egyptian sculpture, especially of the Amarna period.[7] The realism and proportions of the body, though derived from direct observation, are also linked to these two sculptural traditions, while the figure's hieratic formality gives it the independent presence of an African statuette.[8]

Whether Matisse saw tribal wood carvings during his sojourn in North Africa is unknown. His first purchase of

African art occured in the fall of 1906,[9] but its earlier influence should not be precluded. At the very least, Matisse's visit to exotic North Africa may have triggered this sculptural response as he strove to infuse his sculpture with a clearer form and fuller volume. In fact, the figure's distended stomach and the smooth, bulging arc of the abdomen evoke a vase or pitcher with the arms as handles. The comparison is not gratuitous. Matisse remarked to his students in 1908 while discussing the study of the model: "This pelvis fits into the thighs and suggests an amphora."[10] Matisse was sensitive to such formal relationships, and one can imagine him identifying this feature and developing the expressive parallel much as he did in his still lifes when he was touched by "the tear-like quality of this slender, fat-bellied vase," or "the generous volume of this copper . . ."[11]

In *Standing Nude* Matisse was combining one aspect of the *Bonheur de vivre*'s figure style — its "classical" quality of repose and restraint — with the elegant formalism of early Greek and Egyptian statuary. The converse, seen in the woodcuts of early 1906 and in *Standing Nude, Arms on Head*, was exploited again at the end of the year in *Reclining Nude I*.[12]

Notes

1. Barr, *Matisse*, 82; Elderfield, *Matisse*, 183, n. 1.

2. Paris 1970, no. 77.

3. Schneider, "Matisse's Sculpture," 22; and Paris 1975, nos. 22, 179.

4. Elderfield, *Matisse*, 44-47, reproduced in color on page 45.

5. *Ibid.*, 44.

6. The preparatory drawing for *Marguerite Reading* "shows that he was taking up again the condensed, synthetic approach initiated in the *Bonheur de vivre* and applying it to the test of recording the observed, not the invented world"; Elderfield, *Matisse*, 47.

7. Picasso noted that when Matisse first introduced him to African sculpture he also discussed Egyptian art; Malraux, *Picasso's Mask*, New York, 1976, 10-11. Matisse seems to have been particularly interested in Egyptian sculpture, as his comments in, "Notes of a Painter" indicate, for which see Flam, *Matisse on Art*, 37. Compare, for example, nos. 22, 52 in Cyril Aldred, *Akhenaten and Nefertiti*, New York, 1973.

8. Jack Flam makes the connection to African sculpture in his article "Matisse and The Fauves," to be included in the forthcoming catalogue of the exhibition, *'Primitivism' in 20th Century Art: Affinity of the Tribal and the Modern*, opening at the Museum of Modern Art in September 1984. I would like to thank Prof. Flam for allowing me to see the typescript of his article.

9. *Ibid.*

10. "Sarah Stein's Notes, 1908," as quoted by Flam, *Matisse on Art*, 42.

11. *Ibid.*, 45.

12. See No. 11.

10. STILL LIFE WITH PLASTER FIGURE (1906)

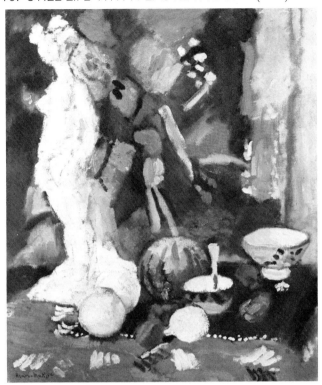

Fig. 31 Matisse, *Flowers*, ca. 1906.
Private Collection, England.

Oil on canvas, *Henri Matisse*, 21¼ x 17¾ in.
Yale University Art Gallery, Bequest of Mrs. Kate Lancaster Brewster.
Colorplate on page 21

Matisse's experimental mood during the summer of 1906 is also evident in his still lifes. These ranged from the Fauve modeling and spatial definition of the Cézannesque *Oriental Rugs* to the unaccented, flat, almost child-like *Pink Onions*.[1] *Still Life with Plaster Figure* falls between these two extremes and shows Matisse trying to resolve the implications of both.[2]

The picture has struck some observers as "retrospective,"[3] or even as a "curious regression" from his earlier Fauve pictures.[4] As a "study in the tonal values of forms in light and depth," *Still Life with Plaster Figure* would seem to be somewhat conservative and "modestly Fauve," especially when compared to the strident colors in the portraits of Madame Matisse.[5] Neither the picture's more somber palette nor its dependence on Cézanne in the handling of still

life elements make the work retrogressive. Indeed, here, as in the other summer still lifes, Matisse was struggling to resolve the spatial implications of the *Bonheur de vivre* with the Cézannesque facture he loved.

Arrayed across the foreground on a red Moroccan rug with a dark brown-black central field are a selection of fruits, ceramics obtained on his recent trip to Algeria, and a plaster cast of the *Standing Nude* (No. 9). In the background Matisse introduced another of his works, a still life entitled *Flowers* probably done at this time (Fig. 31).[6] Matisse defined the foreground plane by the rug-covered table top whose edges are visible at each side. On this ground he carefully arranged the bowls, fruit, and plaster.

Still Life with Plaster Figure is an early example of Matisse's

use of sculpture in his paintings, a device with which he often introduced a human note in the otherwise inanimate world of objects.[7] The figure is thinly painted in some areas with bare canvas visible, while the head, breasts, and legs have a rich impasto that gives a strong tactile quality. The statuette acts as a foil for carefully placed fruits and bowls providing a play of contours and rounded forms.

The plaster figure also catapults our eye upward into the background. Here is perhaps the most unusual aspect of the painting, for Matisse has contrasted the flat, almost abstract background created by *Flowers* with the more three dimensional objects in the foreground; at the same time he has bound the two together through the interrelationship of form and color. The swatch of orange between the elbow and side of *Standing Nude* may be read as a view through to *Flowers*, but it appears to lie directly on the surface and, with other scattered patches of orange, compresses space, forcing the background up to the picture plane. Similarly, the turquoise blended along the right side of the statuette is carried into the figure in a "V" shape on the lower abdomen, while dabs of turquoise across the background likewise force the rear plane forward. The shapes and colors of fruits and bowls are echoed in the forms of *Flowers*; the diagonal stroke of paint above the melon even seems to serve as its stem.

A tension is therefore established between the tactile objects in the foreground and the flat, abstract background which is drawn forward and even melds with the foreground at certain points. This flattening of space reflects the influence of the *Bonheur de vivre*, while the linkage of front and rear planes through a decorative and painterly intermingling of forms looks forward to such works as *Harmony in Red* of 1908, the flatness of which is asserted through its uniform color and the overall motif of vine and flower basket.[8]

Notes

1. Barr, *Matisse*, 77, 92, 329.

2. For this work, see E. C. Carlson, "*Still Life with Statuette*, by Henri Matisse," *Bulletin*, Yale University Art Gallery, Spring, 1967, 4-13; and Francóise Forster-Hahn, *French and School of Paris Paintings in the Yale University Art Gallery*, New Haven and London, 1968, 17. The dating to 1906 was confirmed by Mdm. Duthuit, see Carlson, "*Still Life*," 7.

3. Barr, *Matisse*, 92.

4. Jean Leymarie, *Fauvism*, Lausanne, 1959, 94.

5. Barr, *Matisse*, 92.

6. Carlson, "*Still Life*," 6-7.

7. On this aspect of Matisse's work, see Theodore Reff, "Matisse—Meditations on a Statuette and Goldfish," *Arts Magazine*, LI, 1976, 109ff.

8. For an illustration, see Jacobus, *Matisse*, colorplate 18.

11. RECLINING NUDE I (1906-07)

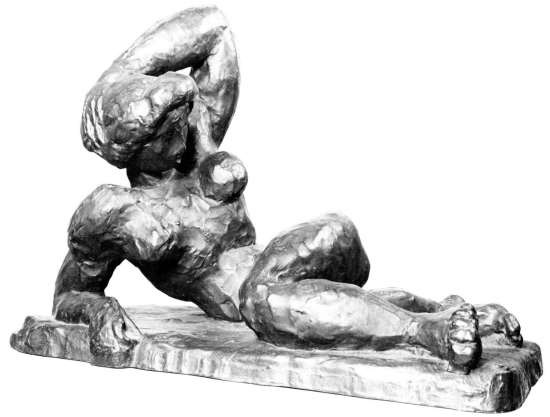

Bronze, *Henri Matisse 4/10, F. Castenoble Fondeur, Paris*, 13-11/16 x 19¾ x 11 in., Albright-Knox Art Gallery, Buffalo.

During the early months of 1907 at Collioure, Matisse produced one of his most famous paintings, *Blue Nude-Souvenir of Biskra* (Fig. 32). This remarkable life-sized nude was unprecedented in its scale and physicality.[1] The pose had antecedents in *Luxe, calme et volupté* and *Bonheur de vivre* and was immediately preceded by two sculptural interpretations, *Reclining Nude with Chemise* of 1906 (Fig. 33),[2] and a first version of *Reclining Nude I* which was ruined when it accidentally fell off the modeling stand onto its head. In frustration, Matisse abandoned the sculpture and painted *Blue Nude*, salvaging the statuette after the completion of the painting.[3]

That Matisse initiated the reinvestigation of this pose in

sculpture indicates his interest in volume and its expressive manipulation in three dimensions. This development was part of a broader movement toward ''sculptural'' painting which also involved Derain and Picasso.[4] The change within Matisse's art is apparent when *Reclining Nude I* is contrasted with *Reclining Nude with Chemise* (Fig. 33). In the latter work, although we can see the roots of *Reclining Nude's* expressive pose,[5] Matisse was most concerned with establishing a subdued, ideal quality. The allusion to antique sculpture created by the flowing *all'antica* drapery echoed the ''harmonious classical ambiance of the *Bonheur de vivre*.''[6]

The relaxed pose of the earlier bronze was considerably transformed in *Reclining Nude I*. The left leg is pulled high

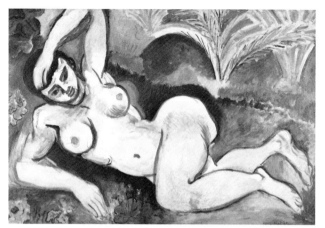

Fig. 32 Matisse, *Blue Nude*, 1907.
The Baltimore Museum of Art.

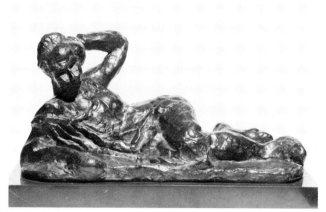

Fig. 33 Matisse, *Reclining Nude with Chemise*, 1906.
The Baltimore Museum of Art.

toward the waist, the thigh forming a line almost parallel to the shoulders; the arm, projecting straight outward in the earlier bronze, is now directly over the head, while the torso has been elevated with the bracing right arm positioned further away from the body, thus intensifying the pose's tectonic tension. These features, presumably seen in the damaged version of *Reclining Nude*, were recreated in the painting where Matisse gave free reign to the expressive play of the body's shapes and volumes, developing the exaggerated proportions and physical distortions on a monumental scale.[7]

The repaired version of *Reclining Nude I* showed additional refinements. The extraordinary physique which caused one critic to dub *Blue Nude* a "masculine nymph,"[8] has been made more assertive. Her upper body and arms have grown even larger, taking on the look of a body builder's torso. Matisse exaggerated the right shoulder in response to the physical strain of supporting the body's weight.[9] The breasts look like projectiles attached to the chest, while the narrowed waist accents the dominant mass of chest and arms. In *Blue Nude* the body is turned toward the picture plane, while in the bronze Matisse rotated the torso and placed the head in profile. Matisse worked on several viewpoints for the statuette. He asked Druet to photograph the completed work from the front and the feet (Figs. 10, 34),[10] views which make the powerful physical distortions

most evident. Elbow, breasts, hip, and buttock jab aggressively into space, while the dynamically counter-balanced arrangement of vertical and horizontal thrusts channel the explosive energy of the limbs upward and outward.

The remarkable transformation of the female anatomy from the classicism of *Reclining Nude with Chemise* to the primitivism of *Reclining Nude I* is difficult to explain solely in terms of his earlier work. The figural distortions Matisse developed in his woodcuts of early 1906, as he was completing the *Bonheur de vivre*, certainly prepared the way. However, the large buttocks and abstract breasts and, above all, the exaggerated volumes and proportions, would seem to express Matisse's growing interest in African sculpture. To be sure, the influence of African art is often subtle and at times so fully assimilated by Matisse that it is difficult to identify, but there can be little doubt that the freedom of organization which African art offered here opened the way to a reformulation of the human anatomy.[11]

The exotic quality of the bronze and of the painting, especially the latter's setting in a lush oasis, coupled with the traditional associations of the recumbent nude in western art, combine to charge both with an untamed primal force, a feminine, sensual urgency which, in a way, makes it a counterpoint to the masculine power of *The Serf*. Matisse has created in this piece an answer to the academic nude whose

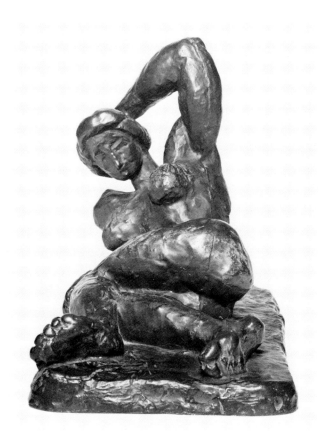

Fig. 34 Matisse, *Reclining Nude I*, view from feet.

chic eroticism was tuned to the civilized eyes of the Salon audience. This powerfully evocative bronze appeared in many subsequent paintings, symbolizing the pleasures of the sensual world.[12]

Notes

1. Barr, *Matisse*, 94.

2. The exact date of *Reclining Nude with Chemise* is unknown. It could have been produced during the summer of 1906 along with *Standing Nude* or during the winter when Matisse returned to Collioure after the opening of the Salon d'Automne.

3. Barr, *Matisse*, 94.

4. Elderfield, *Fauvism*, 119.

5. Elsen, *Matisse*, 69.

6. Elderfield, *Matisse*, 51. Whether Matisse had in mind the *Sleeping Ariadne* or some other ancient work is unknown; see Elsen, *Matisse*, 218, n. 51 on possible antique prototypes. We do know, however, that Matisse was greatly interested in classical sculpture for, as he said, it helped ''to realize the fullness of form.'' ''In the antique,'' Matisse noted, ''all the parts have been equally considered. The result was unity and repose of the spirit,'' ''Sarah Stein's Notes, 1908,'' as quoted by Flam, *Matisse on Art*, 42.

7. Matisse's comments in ''Notes of a Painter, 1908,'' regarding the enlargement of compositions seem relevant here: ''An artist who wants to transpose a composition from one canvas to another larger one must conceive it anew in order to preserve its expression,'' as quoted by Flam, *Matise on Art*, 36.

8. Louis Vauxcelles, *Gil Bas*, March 20, 1907, as quoted in Elderfield, *Matisse*, 51.

9. Matisse told his students in 1908 about the making of sculpture: ''The joints, like wrists, ankles, knees, and elbows must show that they can support the limbs — especially when the limbs are supporting the body. And in cases of poses resting upon a special limb, arm or leg, the joint is better when exaggerated than underexpressed,'' ''Sarah Stein's Notes, 1908,'' as quoted by Flam, *Matisse on Art*, 44.

10. Elsen, *Matisse*, 75.

11. A masterful analysis of *Blue Nude* and *Reclining Nude I* and their relationship to African art is found in Jack Flam's forthcoming article for the Museum of Modern Art show; see No. 9, n. 8.

12. Reff, ''Matisse—Meditations on a Statuette,'' 109ff.

12. BOY WITH A BUTTERFLY NET (1907)

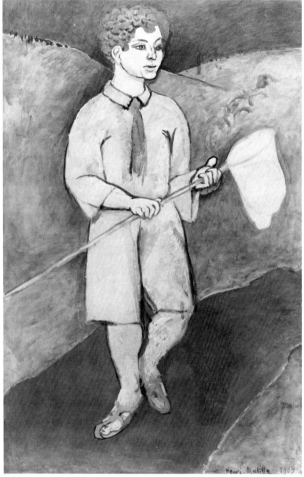

Oil on fabric, *Henri Matisse 1907*, 69¾ × 45⁵/₁₆ in.
The Minneapolis Institute of Arts
The Ethel Morrison Van Derlip Fund.
Colorplate on page 22

Blue Nude-Souvenir of Biskra initiated a series of important figure paintings, works symptomatic of a crisis in Matisse's art. This "Crisis of 1907-08," as Barr has called it,[1] arose from a reaction against Fauvism and from a desire to endow his paintings with a greater sense of order and structure. The return to the figure was not limited to Matisse but was widespread among artists around 1907, accelerated by a renewed interest in Cézanne, whose works were seen in two major exhibitions of 1907.[2] Most prominent among those concentrating on the figure was Picasso, who in 1907 began work on the landmark *Les Demoiselles d'Avignon* (Fig. 35). This painting had a profound impact on the Parisian art world, effectively killing Fauvism and catapulting Picasso into the role of leader of the avant garde.[3]

Matisse was not immune to the *Demoiselles'* powerful force. *Standing Nude* (1907, Fig. 36), a work so unusual in its sombre tonality, squat proportions, and heavy, angular faceting of the body, that it has been seen as an anomaly in Matisse's oeuvre at this point,[4] may have been painted as a direct result of a visit to Picasso's studio.[5] Two other paintings from the first half of 1907, *Three Bathers* and *The Hairdresser (La Coiffure)* (Fig. 42),[6] also exhibit a bold figural style with heavy, simplified contours and, in the latter, a vigorous interior modeling stressing the volumes of the body, much like *Blue Nude*. These three paintings are united by their forceful redefinition of the nude.

The widely varied treatment, however, hints at the impasse Matisse had reached. As he would do later in his life when he was similarly stalled, Matisse dealt with the problem by traveling, in this instance to Italy.[7] He was away for a month — from July 14 to about August 14 — visiting Venice, Padua, Florence, Siena, and Arezzo.[8] While in Florence, he stayed with Michael and Sarah Stein at their villa in Fiesole. From there, he made excursions to study the work of Duccio, Piero della Francesca and Giotto. The trip proved crucial in helping to clarify his ideas. Upon his return to Collioure, he began two paintings — *Le Luxe I* and *Boy with a Butterfly Net*.[9]

Boy with a Butterfly Net is a portrait of Allan Stein, the young son of Michael and Sarah Stein.[10] The subject probably reflects a recollection of one of the boy's activities in Fiesole, while the style clearly embodies Matisse's Italian experiences. The high horizon, the reduction of the background to the red path and schematic green hills, and the intense blue sky evoke the simplified topography of trecento frescoes. However, it is especially the figure of the young Allan Stein, filling the large canvas from top to bottom, which is reminiscent of the monumental, sober figures of Giotto. "Giotto is for me the summit of my desires,"[11] wrote Matisse. The frescoes of the Arena Chapel in Padua and the Peruzzi Chapel in Florence conveyed the sense of gravity, dignity, and quiet stasis that he sought (Fig. 37).

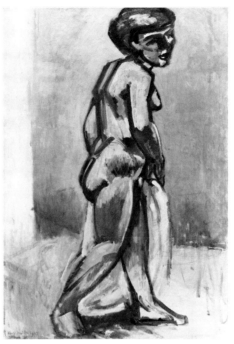

Fig. 35 Pablo Picasso, *Les Demoiselles d'Avignon*, 1907.
The Museum of Modern Art, New York.

Fig. 36 Matisse, *Standing Nude*, 1907.
The Tate Gallery, London.

Matisse's initial conception for the painting, however, showed Allan Stein in motion, walking down the path. An x-ray clearly shows the left leg in a walking attitude, a pentimento also visible to the naked eye (Fig. 38). Matisse painted out the leg below the knee and sketched in a new leg. The simple change had rather dramatic consequences, for the boy no longer turns sharply at the waist as he proceeds down the path but confronts the spectator almost frontally. The pose is, in fact, identical to that of the standing nude in *Le Luxe I* and *II*, a fact which may indicate that Matisse adopted it for *Boy with a Butterfly Net* (Figs. 40, 41).

This painting has not received much attention in the scholarly literature. Yet along with *Le Luxe*, it was Matisse's first confident answer to the challenge of Picasso's *Demoiselles*. The primitivism of that painting was countered by Matisse through a return to the Italian "primitives," the first masters of the Renaissance.[12] Matisse thus reformulated his art within the traditional context of western painting to achieve "a revived classicism, a timeless, monumental and ideal art."[13]

Notes

1. Barr, *Matisse*, 86.

2. *Ibid.*; Elderfield, *Fauvism*, 117 ff.

3. Golding, "Matisse and Cubism," 4.

4. Jacobus, *Matisse*, 114.

5. Golding, "Matisse and Cubism," 5. The painting was probably done in Paris before June, when Matisse went to Collioure; Elderfield, *Matisse*, 52.

6. Both of these pictures and *Standing Nude* were delivered to Matisse's dealer on July 13, 1907, the day before his departure for Italy; Elderfield, *Matisse*, 51.

7. See No. 50.

Fig. 37 Giotto, Detail of Violin Player.
Peruzzi Chapel, S. Croce, Florence.

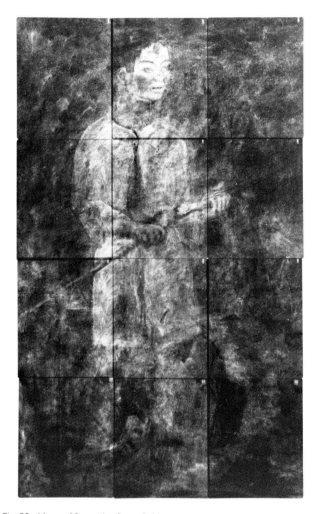

Fig. 38 X-ray of *Boy with a Butterfly Net*.

8. Barr, *Matisse*, 83.

9. Elderfield, *Matisse*, 53, dates *Le Luxe I* after Matisse's return from Italy. Barr, *Matisse*, 95, places it early in 1907. For a discussion of the issues surrounding the dating of the picture, see Elderfield, *Fauvism*, 159, n. 137. The Minneapolis catalogue asserts that *Boy with a Butterfly Net* was done in Italy. There is, however, no reason to assume that this is true; see *Catalogue of European Paintings in the Minneapolis Institute of Arts*, Minneapolis, 1970, no. 168, 319-320.

10. *Ibid.*, 320.

11. Fourcade, *Écrits*, 49, n. 15.

12. Golding, "Matisse and Cubism," 6.

13. Elderfield, *Fauvism*, 132.

13. HEAD WITH NECKLACE (1907)

Bronze, *HM 9/10*, Height: 6⅛ in., Collection Mr. and Mrs. Raymond D. Nasher, Dallas.

Between 1905 and 1907, Matisse modeled nine small heads. These works were predominantly portraits, none of them much larger than six inches in height.[1] Matisse explored a variety of expressive modes in these heads, ranging from naturalistic renderings of his young children, to the schematic representation of the sitter in *Head with Necklace*.

This small head, perhaps the most impressive of the nine, was not modeled in connection with a painted portrait. It is an independent creation in which Matisse sought a different approach to the sculpted portrait. The small scale of the head favored experimentation as well as the quick and economical exploration of his ideas. The simplicity of the overall form and the informality of the modeling give it the freshness of a child's work. This quality is especially evident in the necklace draped over the shoulders, a piece of clay rolled thin, just as one of Matisse's children might have done. At this

time, Matisse was particularly interested in the simplicity and directness of children's art. His 1907 painted portrait of Marguerite is one of the most striking examples of his ingenuous style.[2] Picasso, who selected this painting when the two artists exchanged works in 1908, was aware of its source: "Well, the influence on Matisse when he painted this work was his children, who had just started to draw. Their naïve drawings fascinated him and completely changed his style. Nobody realizes this, and yet it's one of the keys to Matisse."[3]

Despite its diminutive size, *Head with Necklace* embodies one of Matisse's fundamental artistic tenets. As mentioned above in relation to *The Serf*, Matisse sought to comprehend the overall form of his subject rather than master the details which comprised it.[4] "Already I could only envisage the general architecture of a work of mine, replacing explanatory

details by a living and suggestive synthesis."[5] In *Head with Necklace*, Matisse concentrated on the major forms and stressed the relationships and rhythms of masses — hair to head and head to shoulders. He focused on a few elements: the exaggerated coiffure which crowns the head like a broad and bulbous hat, the enlarged eyes and forceful nose, and the simple necklace. Matisse was impressed by these aspects of the model and made them the dominant motifs. It is unlikely that any of these features in the bust mirrored their original proportions in the model. Indeed, such a correspondence was unnecessary. For Matisse, proportion according to measure meant nothing unless, as he said, "confirmed by sentiment and expressive of the particular physical character of the model.... Note the essential characteristics of the model carefully: they must exist in the complete work, otherwise you have lost your conception on the way."[6]

The exaggerations and simplifications which Matisse undertook were not, of course, solely guided by his own perceptions. Matisse reconstructed the sitter's features at a moment when the influence of ancient and primitive art was at its peak.[7] The prominent eyes, mask-like face, and the iconic quality of the bust reflect these sources and endow the head with an almost archaic simplicity. Matisse combined in this work the essential characteristics of children's art and primitive art in a new expressive synthesis in which he sought to find an alternative to the traditions of western art.

Notes

1. For illustrations, see Legg, *Matisse*, 14-15.

2. Flam, "Matisse and The Fauves," n. 79.

3. Dore Ashton, *Picasso on Art*, New York, 1972, 164.

4. See No. 1.

5. Escholier, *Matisse*, 138.

6. "Sarah Stein's Notes, 1908," as quoted by Flam, *Matisse on Art*, 43.

7. Flam, "Matisse and The Fauves."

14. GIRL WITH GREEN EYES (1908)

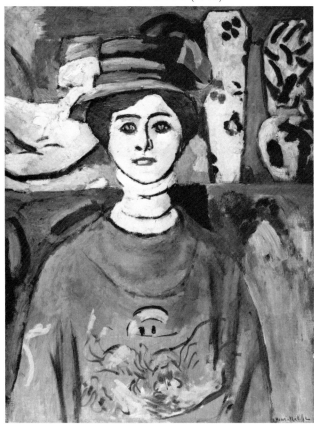

Oil on canvas, *Henri Matisse*, 26 × 20 in.
San Francisco Museum of Modern Art, Bequest of Harriet Lane Levy.
Colorplate on page 23

Girl with Green Eyes was probably painted sometime during the summer or fall of 1908.[1] It is the latest of a number of portraits of that year, including *Red Madras Headdress* and *Greta Moll*, which became increasingly structured in organization.[2]

In fact, *Girl with Green Eyes* is not a portrait in the strictest sense but rather an analysis of formal interrelationships. Matisse noted to an interviewer in 1912, "No, I seldom paint portraits, and if I do only in a decorative manner. I can see them in no other way."[3] It is perhaps the only "portrait" Matisse had painted up to that date which included a still life, a fact which provides a clue to his intentions.

The model is posed frontally, arms at her side under the orange Chinese robe. The gently sloping shoulders merge with the arms, forming a smooth, even silhouette. The figure itself is clearly divided into sections — torso, neck, head, and hat. On the shelf behind are placed three vases and a reduced plaster cast of the river god Ilissus, one of the Parthenon statues.[4] The head is set off by a high, curving white collar which looks and acts like a sculpted pedestal for a bust. In fact, the model's head seems to sit on the shelf like one more vase. Its position and shape were carefully calculated to relate it to the full form of the short vase at the right. Similarly, Matisse suggested on the hat the flat top and raking upper edges of the large vertical vases. He was playing with the interrelationships between inanimate and animate forms. ''To copy the objects in a still life is nothing,'' Matisse told his students in 1908, ''one must render the emotion they awaken in him. The emotion of the ensemble, the interrelation of the objects, the specific character of every object modified by its relation to the others — all interlaced like a cord or a serpent.''[5]

Notes

1. The original bill of sale from the Bernheim Jeune Gallery in Paris is dated November 23, 1908; *Catalog of the Permanent Collection of Painting and Sculpture: San Francisco Museum of Art*, San Francisco, 1970, 109. This entry also includes exhibition history and references.

2. For these works, see Barr, *Matisse*, 350, 351.

3. Clara T. MacChesney: ''A Talk with Matisse, 1912,'' as quoted by Flam, *Matisse on Art*, 52.

4. This cast also appeared in *Still Life with Greek Torso* of 1908, see Barr, *Matisse*, 342.

5. ''Sarah Stein's Notes, 1908,'' as quoted by Flam, *Matisse on Art*, 45.

15. SMALL CROUCHING TORSO (1908)

Bronze, *HM 6/10*, Height: 3⅛ in., Private Collection, New York.

Small Crouching Torso, a work little more than three inches high, was probably modeled in 1908.[1] The pose was not a new one in Matisse's art, having appeared previously in *Bonheur de vivre* (1905-06), *Three Bathers* (1907), and both versions of *Le Luxe* (1907, 1908).[2] The compression of legs against torso and the compact, enclosed form it generated obviously appealed to Matisse, for he used the pose again in the large *Bathers with Turtle* (1908), now in the City Art Museum of St. Louis (Fig. 39).

Though the arms have been cut, their outward extension relates the piece most closely to the crouching attendant in *Le Luxe I* and *Le Luxe II* (Figs. 40, 41). If this sculpture was modeled in relation to a painting, then it would probably have been done during the course of work on *Le Luxe II*: that is, early in 1908.[3] Compared to the first version of the composition, the women of *Le Luxe II* are visually more coherent. Inflected contours have been regularized and extended around the perimeter of each figure, while the

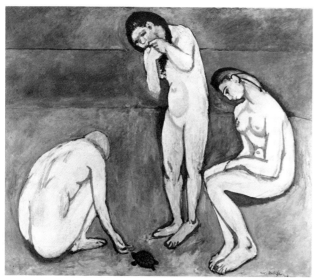

Fig. 39 Matisse, *Bathers with Turtle*, 1908.
The St. Louis Art Museum.

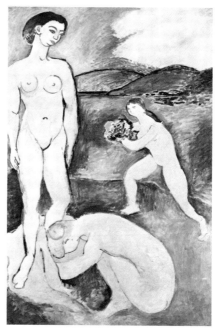

Fig. 40 Matisse, *Le Luxe I*, 1907.
Musée National d'Art Moderne, Paris.

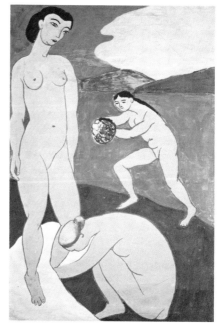

Fig. 41 Matisse, *Le Luxe II*, 1908.
Statens Museum for Kunst, Copenhagen.

mixed brushwork and varied color was eliminated in favor of a smooth, flat application of paint. The figures thus gained in clarity and monumentality.

This evolutionary process evident in the two paintings may have been aided by modeling. It is not unlikely, indeed, that, as the figures in the paintings were flattened and volume drained away, Matisse felt the need to explore the crouching pose in three dimensions in order to maintain contact with the postural dynamics and to rediscover the body's mass. The tactile quality of Matisse's small sculpture is especially evident here. This work, modeled without a base, is meant to be handled.

Notes

1. The bronze has been dated to 1929 by the Matisse family, but most scholars believe it was modeled in 1908; Legg, *Matisse*, 21; Elsen, *Matisse*, 107-108; Paris 1975, no. 194.

2. For *Three Bathers*, see Barr, *Matisse*, 338.

3. On the dating of *Le Luxe II*, see No. 12, n. 9.

16. DECORATIVE FIGURE (1908)

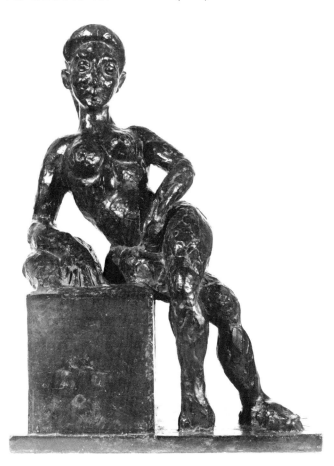

Bronze, AÔUT/1908/HM 2, Height: 28⅜ in.
Collection Mr. and Mrs. Wilfred P. Cohen, New York.
Colorplate on page 24

Fig. 42 Matisse, *La Coiffure*, 1907. Staatsgalerie, Stuttgart.

Decorative Figure was modeled during the summer of 1908 at Collioure.[1] It was Matisse's largest sculpture since *The Serf*. The obvious effort he invested in this piece sets it apart from the modest earlier bronzes — for the most part small, rapidly executed private studies — just as its scale suggests a greater public ambition. As we shall see, *Decorative Figure* may be interpreted as a response to the latest developments on the Parisian art scene.

The sculpture was developed from a pose seen in the 1907 painting *The Hairdresser* (Fig. 42).[2] The full, sensuous forms of the nude have been transferred naturally into three dimensions. Matisse took full advantage of the volumes of breasts, buttocks, and thighs, reinventing their proportions, enlarging, exaggerating, and making them more expressive and assertive. This transformation, inspired by African art, helped to create one of his most voluptuous and daring works to date.

Although Matisse used *The Hairdresser* as a starting point

for *Decorative Figure*, the pose was radically transformed — a transformation indicative of Matisse's new concern for formal order. The figure no longer sits on a chair but rather on the edge of a cube, legs extended to the side. The head and torso are now erect and frontal. The limbs do not dangle or float unsupported in space; the feet are firmly rooted to the ground, securely anchoring the figure on the base. One arm is strategically positioned on the thigh while the other acts as a buttress, carrying the weight of the upper body.[3] Matisse fashioned a carefully balanced system of parallel lines and right angles which plays about the major diagonal defined by the torso and right leg.[4] The architectonic quality of the figure is reinforced by the cube, which at once contrasts with the vivacious curves of the body and underscores the strict geometry of the composition. Body and cube have been positioned to obtain the optimum sense of balance. The head and neck are aligned with the cube's center, and this alignment is paralleled by the vertical axis of the left leg. Matisse extended the figure laterally through the placement of the right leg but pulled the composition back into balance by aligning the figure's left side with the edge of the cube, thus equally distributing the forms.

The extraordinary combination of the pose's formal structure with its unabashed physical appeal reflects Matisse's answer to the early phases of Cubism. During the first half of 1908, he saw his position as leader of the avant-garde slowly erode as the group of Fauve painters came under the influence of Picasso and his *Les Demoiselles d'Avignon* (Fig. 35).[5] Picasso's large canvas represented a complete break from contemporary styles. Its abstraction of the figure, its treatment of space, its overt primitivism, and its conceptual approach to painting heralded a new era in western art.[6] Those who saw the *Demoiselles* in Picasso's studio could not ignore the issues it raised. Georges Braque was profoundly impressed and, recognizing the importance of Picasso's innovations, abandoned fauvism to work on a large figure study in the new mode, *Large Nude* (1907-08, Fig. 43).[7]

Picasso continued to explore this new mode in several paintings from the summer and autumn of 1907. The influence of African sculpture became increasingly evident, and the schematization and faceting of the body was intensified in paintings such as the Hermitage's *Nude with Drapery* (summer 1907, Fig. 44). As already noted, Matisse was not immune to these developments. *Standing Nude* (Fig.

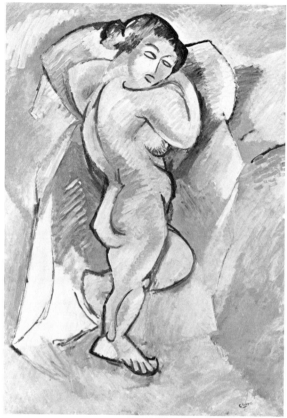

Fig. 43 Georges Braque, *Large Nude*, 1907-1908. Private Collection, Paris.

36), with its bold angular outlines, has been interpreted as a response to Picasso's innovations.[8]

Through the winter and spring of 1908, Picasso's nudes evolved toward an increasingly abstract, solid geometry which defined the figure by an interlocking system of angles and planes. The faceted, triangular forms of the two figures in *Friendship* (early 1908), or the equally abstract, though less angular, surface geometry of the Boston Museum of Fine Art's *Standing Nude* (spring 1908),[9] were undoubtedly foreign to Matisse's ideas concerning the integrity, unity, and expressive purpose of the human body. *Decorative Figure* may have been conceived, therefore, in response to the new aesthetic. Matisse formulated his own figural alternative, sublimating the external geometry of Picasso's figures while

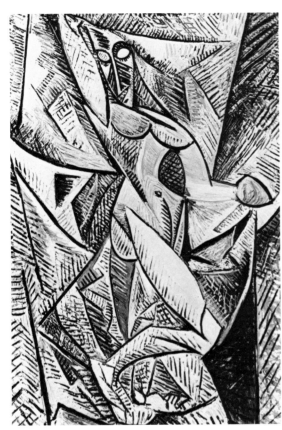

Fig. 44 Pablo Picasso, *Nude with Drapery*, 1907.
The Hermitage, Leningrad.

serenity, devoid of troubling or depressing subject matter..."[12] Matisse's vision of a new Golden Age was, of course, drawn from a long tradition of western imagery. From 1906, however, it was gradually infused with a primal dynamism deriving from his interest in African art.[13] This vision revolved around the human figure — specifically the female nude — the integrity of whose form (though never measured in terms of anatomical exactitude), was a key to his expressive ends.

Picasso's severe formal distortions, therefore, not only ran counter to Matisse's aesthetic sensibilities, but also to the deepest meaning of his art. The forbidding and menacing African-masked women on the right of the *Demoiselles d'Avignon*, or the equally frightening *Nude with Drapery* (Fig. 44), were hardly conducive to the serene aura of peace and tranquility he was striving to obtain. The disturbing, even threatening, quality of these females expressed Picasso's own ambiguous attitude toward women — a love/hate dichotomy which informs much of his art during these years.[14]

Matisse, however, suffered from no such phobia, as the appearance of *Decorative Figure* readily suggests. The face of *Decorative-Figure* — the almond shaped eyes, outturned ears, simplified features, and archaic smile — is reminiscent of the placid expression of certain Etruscan heads.[15] The exaggerated anatomy may reveal the influence of African art, but, if so, it is an influence strained through the many levels of Matisse's western cultural heritage and stripped of the malefic overtones it possessed in Picasso's art. Perhaps quieter than *Reclining Nude I*, *Decorative Figure* is no less insistently sensual. Matisse has created an archaic goddess. Frontal and hieratic, yet informally posed; voluptuous and curvacious, yet rigidly organized; revealing the abundance of her form, yet concealing it as well, *Decorative Figure* was Matisse's most skillful synthesis to date of the modern and primitive — an image evoking the sensual fullness of Matisse's ideal world.[16]

maintaining a voluptuous allure and rigorous formal order.

The affirmation of his artistic norms involved questions not only of form but also of content. Beginning with *Luxe, calme, et volupté* (1904-05) and *Bonheur de vivre* (1906), Matisse developed a personal iconography based on a serene, idyllic world of luxury and pleasure, one where woman occupied the symbolic center as a complex sexual emblem.[10] In two paintings of late 1907 and early 1908, *Le Luxe I* and *Le Luxe II*, Matisse concentrated on three monumental nudes (Figs. 40, 41). The standing figure at the left is the focus of attention, a modern-day Venus Anadyomene stepping from the sea to be greeted by her handmaidens.[11] The erotic aura of these paintings and the Venusian form of this quasi-mythological nude embodied his ideal of "an art of balance, of purity, and

Notes

1. The piece was first seen publically in 1913 at Matisse's exhibition at Galerie Bernheim Jeune; see Paris 1975, no. 197. Elderfield, *Matisse*, 190, n. 3, notes that it was made at Collioure.

2. Elsen, *Matisse*, 87.

3. Elsen, *Matisse*, 87, 91.

4. Barr, *Matisse*, 100.

5. Barr, *Matisse*, 86-87.

6. Cooper, *Cubist Epoch*, 22.

7. Golding, *Cubism*, 62ff; Cooper, *Cubist Epoch*, 27ff.

8. Golding, "Matisse and Cubism," 5. The painting was completed before his departure for Italy in July, see No. 12, n. 6.

9. For illustrations, see William Rubin (ed.), *Pablo Picasso, A Retrospective*, New York, 1980, 106, 113.

10. On the iconography of these paintings, see Elderfield, *Matisse*, 38-39; and Elderfield, "The Garden and the City," 13ff.

11. The iconography of these paintings and of Matisse's art in general is the subject of a forthcoming book by Jack Flam.

12. Matisse, "Notes of a Painter, 1908," as quoted by Flam, *Matisse on Art*, 38.

13. The question of influence of African art during the period is considered by Jack Flam in, "Matisse and The Fauves."

14. For the most recent discussion of this aspect of the *Demoiselles* with earlier references, see William Rubin, "From Narrative to 'Iconic' in Picasso: The Buried Allegory in *Bread and Fruitdish on a Table* and the role of *Les Demoiselles d'Avignon*," *The Art Bulletin*, LXV, 1983, 628-636. Rubin interprets Picasso's use of African-like masks for the two women on the right as an expression of his fear of women, a view which departs from Leo Steinberg's earlier interpretation of the "African" figures as embodiments of sexual energy and the life force; Steinberg, "The Philosophical Brothel," *Art News*, 1972, September, 22-29 (Part I), October, 38-47 (Part II).

15. An Etruscan connection was earlier advanced by Jean Laude, *La Peinture francaise (1905-1914) et "L'Art nègre,"* 2 vols., Paris, 1968, I, 215. Compare, for example, the heads illustrated in Emeline Richardson, *The Etruscans, Their Art and Civilization*, Chicago, 1964, plates XXI-XXIII.

16. *Decorative Figure* would appear to be one of the only bronzes Matisse dated to a specific month, a fact which may indicate its importance to him.

17. TWO NEGRESSES (1908)

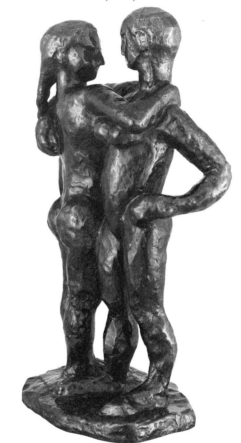

Bronze, *Henri Matisse 2*, Height: 18½ in., Private Collection, New York.

Two Negresses was exhibited at the Salon d'Automne[1] and so probably dates to the spring or summer of 1908. Unlike *Decorative Figure*, this sculpture was not developed from a painting but had as its source a magazine photograph (Fig. 45).[2] Matisse must have been attracted by the subject matter — he had earlier treated embracing females in the *Bonheur de vivre* and *Music (Sketch)* — as well as by the formal qualities of the composition. He was remarkably faithful to the photograph, modifying only small details, such as the fusion of the legs, the joining of the torsoes, and the slight widening of the stance.[3] The greatest departure from the source was, however, also the most telling, for by shortening the legs and

Fig. 45 Magazine photograph used by Matisse as the source for *Two Negresses*.

composition and added to the horizontal rhythms set up by the alignment of the feet, knee joints, buttocks and pelvis, and the breasts."[5] Arranging the figures back to front on the same plane created, in essence, a sculpture with two "fronts," a fact which forces us to view the piece from both sides in order to experience it fully.

Two Negresses and *Decorative Figure* were Matisse's first major sculptural efforts since *Reclining Nude I* of the previous year. They may have been inspired, in a way, by the opening of the so-called "Académie-Matisse" early in 1908. The importance of the figure was paramount in this curriculum, for Matisse insisted that his students achieve a full understanding of the body through drawing and modeling after ancient sculpture and from life.[6] His pedagogical efforts paralleled, though obviously on a different level, his own attempts to redress what he considered the excessive color and weak design of his fauve pictures. Two painted studies of the nude, *Seated Woman* and *Nude (Black and Gold)*, both of 1908, are remarkable for their sombre palette, sculptural modeling, and accentuated volumes,[7] although they are not nearly so innovative in their reorganization of form as *Two Negresses* and *Decorative Figure*.

thickening the proportions Matisse transformed the models' lithe bodies into broad, massive slabs. In this sense, *Two Negresses*, purged of the sensuous arabesque, surpasses the structural concerns of *Decorative Figure*.

The solid, almost masculine proportions of *Two Negresses* and the clearly defined and interlocking sections of the body recall Matisse's advice to his students of that year:

> Fit your parts into one another and build up your figure as a carpenter does a house. Everything must be constructed built up of parts that make a unit: a tree like a human body, a human body like a cathedral... You may consider this Negro model as a cathedral, built up of parts which form a solid, noble, towering construction... The lines between abdomen and thigh may have to be exaggerated to give decision to the form in an upright pose...[4]

Juxtaposing these figures allowed Matisse to exploit the formal interrelationships of the bodies' bulbous and flat forms. "The embracing gestures locked and squared off the

Notes

1. Paris 1975, no. 191; Elsen, *Matisse*, 83.

2. Published in Elsen, *Matisse*, 84, fig. 106.

3. Elsen, *Matisse*, 83.

4. Flam, *Matisse on Art*, 42-43.

5. Elsen, *Matisse*, 85-86.

6. No one was allowed to paint a figure clothed until the student had first studied it nude; Barr, *Matisse*, 116-118.

7. *Seated Woman* is signed and dated 1908. *Nude (Black and Gold)* has been dated to 1908 on the basis of its publication in that year as an illustration to Matisse's "Notes of a Painter," see A. Izerghina, *Henri Matisse, Paintings and Sculptures in Soviet Museums*, Leningrad, 1978, nos. 16, 17.

18. SERPENTINE (1909)

Bronze, *Henri Matisse 6*, Height: 22⅛ in.
Hirshhorn Museum and Sculpture Garden, Washington, D.C.

On March 31, 1909, the Russian collector Sergei Shchukin wrote Matisse to confirm a commission for two large paintings for his Moscow home. These two pictures, *Dance II* and *Music*, now in the Hermitage, represented Matisse's most ambitious project up to that date (Figs. 4, 5).[1] *Dance II* was preceded by an earlier version of the same theme,

Dance I, completed in March of 1909 (Fig. 46). [2] This full-scale "sketch" formed the basis for the Shchukin commission.[3] Matisse prepared for the second version during the summer of 1909 at Cavalière by making studies of the figure out of doors.[4] He continued work on the project in Paris during the fall; and it was at this moment that he embarked on one of his most remarkable sculptures, the *Serpentine*.

The sculpture was inspired by a photograph of a nude model leaning against a studio prop (Fig. 47). Matisse later wrote, "I had to help me a photograph of a woman, a little fat but very harmonious in form and movement."[5] The source is notable for its apparent distance from "high art" prototypes.[6] Some Greek, Roman, and Renaissance models have been suggested as sources, all of them related by the figure leaning against a support, or by the legs crossed at the ankles. Amusingly enough, one source which has not been noted is the *Farnese Hercules* type (Fig. 48). The resting posture, and especially the placement of the right arm behind the back, seem to derive directly from this famous ancient statue. Matisse certainly knew the statue, or one of the countless replicas of it, and may have been attracted by the burlesque of it which the photograph suggested. However, one is hardly prepared for the drastic reshaping which the woman's stout body has undergone. Edward Steichen's photograph of an early stage of the *Serpentine* shows a figure, though somewhat slimmer, still close to the original source photograph and yet far from the work which, in its final form, would deeply shock both the public and the art world (Frontispiece).[7] The final solution for the *Serpentine* represented at that point Matisse's most radical reformulation of the human body.[8]

Work on this piece went forward at the same time that work progressed on *Dance II*, and it reflects Matisse's efforts to devise an appropriate figure style for that painting. Significantly, both the *Serpentine* and *Dance II* had similar starting points: the thick-thighed, waistless girl in the photograph finds sisterly counterparts in *Dance I*, particularly the two figures placed frontally (Figs. 46, 47). According to Hans Purrmann, the earlier composition was entirely painted in only one or two days.[9] The figures are summarily rendered, with contours loosely drawn and often reworked; the modeling is unaccented, with only the barest indication of interior forms on any one figure — a circle or semicircle for breasts, a short line for buttocks or a spine.

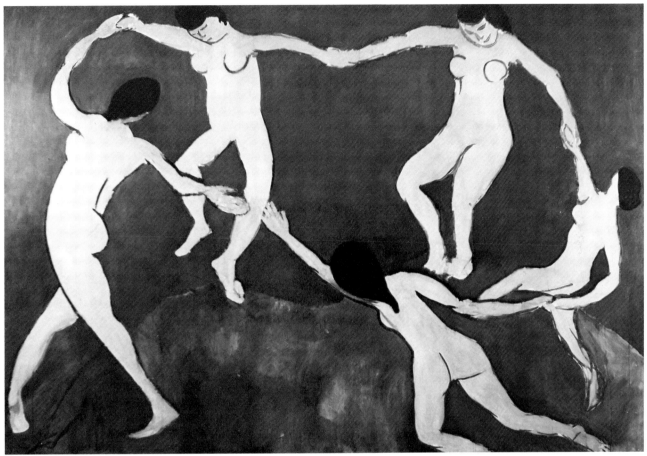

Fig. 46 Matisse, *Dance I*, March 1909. The Museum of Modern Art, New York.

The rapid execution and Matisse's interest in the overall conception rather than in details may account for the tentative drawing of *Dance I*.[10] In *Dance II* Matisse concentrated on individual figures, tightening the forms with strong, clear contours. Bodies are given greater resilience and relief by the definition of interior musculature — abdomen, back, shoulders, breasts, and knees are boldly indicated with dark lines. Limbs now taper emphatically at the joints, stressing the individual parts of the body and creating a rhythmic pulse, as forms contract and expand across the surface of the canvas. These dancers are no longer the fat paper dolls of *Dance I* but have a lean, sculptural quality.

An analogous restructuring and tightening of form was achieved at the same time in the *Serpentine*. Matisse attacked the mass of the body until its forms were condensed into the rope-like limbs and torso. The body itself was elongated, and its mass was directed to the huge feet, calf, and forearms. That calf, as wide as the thigh is narrow, is one of the *Serpentine*'s most distinguishing features. It reappeared in the second figure to the left in *Dance II* (Fig. 4).[11] Indeed, the dancer's posture has been compared to the sculpture's,[12] and it provides additional evidence of the clarifying role that the *Serpentine* played in the evolution of the painting.

Lessons learned from the *Serpentine* went beyond the

Fig. 47 Magazine photograph used by Matisse as the source for
Serpentine.

Fig. 48 *Hercules at Rest* (Farnese Type).
Louvre, Paris.

formulation of individual figures in a painting to an analysis of
the existence of the sculpted figure in space and its
relationship to the space around it. Matisse wrote of the
bronze: "I thinned and composed forms so that the
movement would be completely comprehensible from all
points of view."[13] A walk around the bronze reveals how
carefully Matisse exploited its linear volumes and full shapes:
the arcs of the torso, arms, and leg when seen from the side;
the play of the pearshaped buttocks and curving contours of
the hair from the back;[14] the constantly changing spatial
relationships defined by the limbs — all these demonstrate

Matisse's sensitivity to the formal demands of a figure in the
round. In this sense, too, the *Serpentine* was part of Matisse's
struggle to clarify and unify the figures of *Dance II* within their
own ambiance. Each whirling dancer, presenting a slightly
different aspect and angle to the viewer, benefitted from the
concentrated effort which helped formulate the motionless
pose of the *Serpentine* in three dimensions. For all of the
audacity of this work, none of its dramatic innovations was
developed further in Matisse's sculpture, a fact which
underscores the specificity of purpose it served at this time
for Matisse's painting.[15]

Notes

1. For color reproductions and the most recent bibliography, see Izerghina, *Matisse*, nos. 29, 30.

2. For which, see Elderfield, *Matisse*, 54-58.

3. Elderfield, *Matisse*, 55, has suggested that Matisse quickly painted *Dance I* "after preliminary discussions with Shchukin, in order to clinch the commissions before Shchukin left Paris."

4. Elderfield, *Matisse*, 60.

5. Barr, *Matisse*, 139.

6. The Greek, Roman, and Renaissance prototypes are listed by Barr, *Matisse*, 139.

7. Barr, *Matisse*, 139 has assembled some of the outraged public response.

8. Elderfield, *Matisse*, 62.

9. Elderfield, *Matisse*, 54.

10. A similarly undefined treatment of the figures occurs in the Hermitage's, *Fruit, Flowers, and 'The Dance'* (1909), where *The Dance* appears as a painting within a painting, see Izerghina, *Matisse*, no. 27.

11. Jean Guichard-Meili, *Matisse*, New York, 1967, 168.

12. William Tucker, in "The Sculpture of Matisse," 26, noted that the dancer's posture "is almost an exact inversion of the sculpture's."

13. Barr, *Matisse*, 139.

14. This relationship recalls Matisse's advice to his students on the making of sculpture: "The hair of the model describes a protecting curve and gives a repitition that is a completion," "Sarah Stein's Notes, 1908," as quoted by Flam, *Matisse on Art*, 44.

15. This point was noted by Carl Goldstein in his review of Elsen's book on Matisse, for which see *The Art Quarterly*, XXXVI, 197, 421.

19. BACK I (1909)

Bronze, *Henri Matisse, HM 0/10, Georges Rudier, Fondeur, Paris*
74⅜ x 44½ x 6½ in., The Anne Burnett and Charles D. Tandy Foundation.
Colorplate on page 25

Matisse's four bronze reliefs generally known as the *Backs* represent one of the artist's most distinctive achievements. This set of imposing, life-sized reliefs, executed at intervals between 1909 and 1931, are Matisse's largest works in sculpture as well as his most ambitious sculptural undertaking. The special position they occupy in Matisse's oeuvre is, however, largely a posthumous phenomenon, for the *Backs* were not conceived as a series and were never exhibited together until after Matisse's death.[1] They are nonetheless united by the penetrating analysis of a single motif, and

Fig. 49 Photograph of *Back 0* taken in 1909 by Georges Druet.

Cavalière (Fig. 49).[3] George Druet photographed it that autumn in preparation for its transfer to Matisse's new studio in the suburb of Issy-les-Moulineaux.[4] It seems likely that *Back 0* was transformed into *Back I* that fall.

Matisse's venture into an area which he had never explored before — life-sized sculpture — can only be understood in relation to Sergei Shchukin's commission of March 1909 for the large, multi-figured decorative panels *Dance* and *Music*. *Back 0* is contemporary with *Dance I*, and *Back I* was executed in conjunction with *Dance II* and a third subject proposed to Shchukin, *Bathers by a River*.[5] *Dance I*, the rapid, full-scale sketch which Matisse prepared for Shchukin's approval, provided a firm basis for the composition of *Dance II*, but it was only a starting point for the development of the figural style ultimately employed in the finished work. Matisse was obviously concerned about the dancers' flatness as well as their lack of structure and weight; thus, he undertook a figural study in clay. That he chose to do this in a life-sized relief betrays the pictorial origins of the impulse. To have modeled a statue or statuette would not have served his purposes so well, for Matisse sought to analyze the relationship of the figure's mass to the flat ground as well as to experiment with the expressive organization of its forms. This pursuit paralleled the task at hand in paintings unlike any he had ever done. In a strict sense, however, neither *Back 0*, nor any of the *Backs*, is a direct study for a particular figure in a painting, yet all of them relate to immediate pictorial issues and reflect Matisse's struggle to "put order into my feelings and find a style to suit me."[6]

Back 0 displays a degree of anatomical fidelity absent in the subsequent versions. As the starting point of Matisse's exploration, this is understandable and consistent with his working method. The tight, controlled modeling is reminiscent of such early paintings as *La Coiffure* (1901) and *Carmelina* (1903, Figs. 23, 25), works in which the artist turned to Cézanne as a guide for structural solidity.[7] The ample frame, the weighty proportions, and a surface which is united by the easy, even flow of one form into another created a solid figure whose grace is derived from its *contrapposto* pose and its balancing of masses on either side of the softly curving spine.

When Matisse reworked *Back 0* into *Back I* during the fall of 1909, the changes that he made were in the interest of a greater anatomical expressiveness. He cut away the fleshy portions of the body while building up the relief. The form

together they afford vivid insights into the artist's mind at critical moments as he wrestled with new pictorial problems. That the reliefs subsequently have enjoyed the status of major public masterpieces is incidental to their original role as private studies related to paintings in progress.

Back I was not the first in the series. It was preceded by another relief of the same scale and subject, *Back 0*.[2] This work, known only from a photograph, was modeled in the spring of 1909, before Matisse left Paris to summer at

was broadened at the right so that the thumb was absorbed into the hip. Matisse enlarged and unified the left upper arm and shoulder into one massive, bulging form. Similarly, the neck and muscles of the right shoulder have been joined and raised in high relief; the left contour of the neck was defined by the excavation of a large piece of clay. The surface topography of *Back I* varies considerably, giving it the appearance of an aerial photograph of rugged terrain. The upper back is the high ground which drops to lower levels as forms roll along on either side of the incised, meandering spine. The body itself rises steeply from the background plain — like a mountain island from the sea — an effect which was emphasized when Matisse took a knife and trued the left side from hip to ankle. Excavation of the background at various points near the figure also emphasized the body's weight and volume. The physical distortions and exaggerated forms of *Back I* recall the restless dynamism of *Reclining Nude I* and *Blue Nude* of 1907.[8]

There is a parallel development in style between the first two backs and *Dance I* and *Dance II*. Both *Back 0* and *Dance I* have comparatively bland, unexpressive surfaces; *Back I* and *Dance II* have surfaces that are more assertive. Through his work on *Back I* and the *Serpentine*, also done during that autumn, Matisse prepared the way for *Dance II*. The invigorated bodies of the dancers are at once slimmer, tauter, and more three-dimensional than their predecessors and reflect indirectly the influence of the *Serpentine*'s expressive linearity and *Back I*'s heightened anatomical articulation. A connection between the poses of the second figure on the left in *Dance II* and the *Serpentine* has already been noted.[9] This figure, the most sculptural of all the dancers, is also related to *Back I* in the hunched muscles of the neck and shoulder.[10] But Matisse may have realized that the muscular distortions of *Back I* were inconsistent with the effect of lightness and movement that he wanted to achieve; thus he restricted them to this dancer. He did, however, enhance the relief of all the dancers through the use of short, bold lines to define the muscles of the body.

As noted above, Matisse's original plan for the Shchukin commission called for a third subject, a bathing scene. He described it in an interview published in April 1909: "...finally on the third floor there is complete calm and I paint a scene of repose: some people reclining on the grass, chatting or daydreaming..."[11] Matisse prepared a watercolor sketch, the

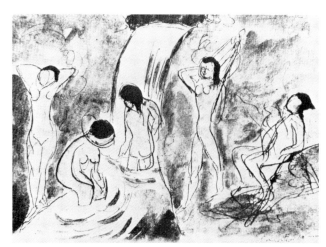

Fig. 50 Matisse, *Composition II*, a watercolor and ink sketch for *The Bathers*. Pushkin Museum, Moscow.

first idea for the composition, which he sent to Shchukin (Fig. 50).[12] For various reasons, the proposal for a third painting was not accepted, but Matisse continued to develop the subject on his own.[13] In fact, the *Backs* may be directly related to the bathing theme, as the sculpted figure can be understood as standing in a shallow pool of water — a motif present in the sketch.[14] In selecting a bathing theme, Matisse reflected a tendency common among artists in the period 1907-1909 to turn to Cézanne's paintings of bathers for inspiration.[15] Indeed, his own Cézanne has frequently been cited as an important source (Fig. 2). So, Matisse's decision to focus on the back of a figure standing in water may have derived from his involvement with the bathing theme, perhaps even as a study for a specific figure. The sense of quiet and repose which he sought in the painting is certainly achieved in the *Backs*, and the fact that *Back II* and *Back III* are related directly to later versions of the bathing theme might indicate a similar specificity of purpose for *Back 0* and *Back I*.[16] More broadly considered, however, the reliefs anchored Matisse's sensations in the figure, transferring the Cézannesque concern for structure into three dimensions. In effect, Matisse distilled from *Back I* the sculptural sensations of relief, line, and volume, adapted and simplified them, in the process of accomodating the sculptural to the pictorial.

Notes

1. The *Backs* were only exhibited together as a series in 1956 at the Tate Gallery, London. *Back I* was first exhibited in London in 1912 at the Second Post-Impressionist Exhibition, organized by Roger Fry, and the following year at the New York Armory Show. *Back II* was forgotten by Matisse and discovered in a Nice warehouse after his death. *Back III* and *Back IV* were not shown publically until 1949 and 1950 respectively; see Paris 1975, nos. 202, 210, 212, 225.

2. First published by Elsen, *Matisse*, 182-185.

3. Elderfield, *Matisse*, 72.

4. Elsen, *Matisse*, 182.

5. Elderfield, *Matisse*, 72, has correctly noted that neither Matisse's move to the larger studio at Issy nor his improved financial condition are sufficient alone to explain the new sculptural venture.

6. See Introduction, p. 18.

7. Flam, "Matisse's *Backs*," 354, connected these two paintings to *Back I* before the existence of *Back 0* was well known.

8. Flam, "Matisse's *Backs*," 354.

9. For the *Serpentine*, see No. 16.

10. For the pencil sketch of 1910 for this figure, see Elderfield, *Matisse*, Fig. 34.

11. Charles Estienne's interview with Matisse, April 1909, as quoted by Flam, *Matisse on Art*, 49.

12. This sketch is discussed by Neff, "Matisse and Decoration," 44-45.

13. *Ibid.*, 47.

14. Elderfield, *Matisse*, 76.

15. For example, Friesz, Derain, and Vlaminck: see Elderfield, *Fauvism*, 121-122.

16. See Nos. 27, 30.

20. STUDY OF A FOOT (1909)

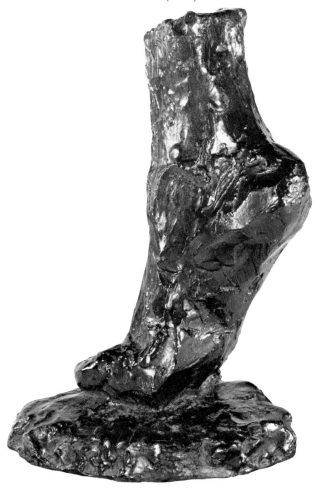

Bronze, *HM 4*, Height: 1 1¾ in., Collection Regina Slatkin, New York.

Study of a Foot, like the *Serpentine*, was executed in the fall or winter of 1909 in connection with *Dance II*. It is one of the few cases in which a sculpture can be securely identified as being a direct study for a painting.

Matisse sculpted a right foot balanced on its toes and pushing off the ground, an action which links it to the left-most figure in *Dance II* (Fig. 4).[1] His concern for tightening the organization and formal structure of his figures has been discussed in relation to the *Serpentine*, and that concern is

certainly evident in this work.[2] The fact that he concentrated on this sole motif indicates, however, the signal importance that it had for him. The feet in *Dance I* are either hidden, barely indicated, or very generalized, with the exception of the right foot of the figure on the left (Fig. 46). Here Matisse took some care with the anatomy, emphasizing the heel and defining the arch by dark underpaint covered with a scumbling of light fleshtones. In modeling this foot, Matisse studied its flexion as well as its form, stressing the hollow of the arch by paring away the clay with the knife. His focus on the motif of the foot suggests its importance as a pivot point, at once anchoring and elevating the body as it changes direction. Marcel Sembat recognized the significance of this figure in the painting: "At the left [of *Dance II*] a grand figure draws along the entire chain. What frenzy! What a baccante!"[3] The feeling of lightness and motion that Matisse sought to capture in *Dance* is readily expressed in the bronze.[4] We also know that, while working on the theme, Matisse is reported to have "crouched ready to leap as he had done some years before on the beach at Collioure in a round of Catalan fishermen."[5] His concern with personally feeling the sensations of dance — the physical tensions and stresses — helps us to understand this study.[6]

Notes

1. Izerghina, *Matisse*, 188, with three full-scale photographs.

2. See No. 18.

3. Sembat, *Matisse*, 9.

4. See the newspaper interview given to Charles Estienne in April 1909; Flam, *Matisse on Art*, 49.

5. Barr, *Matisse*, 135.

6. Our understanding is also aided by Matisse's advice to his students to feel the stresses and strains of the model's pose; Flam, *Matisse on Art*, 43; Elsen, *Matisse*, 110.

21. TORSO WITHOUT ARMS OR HEAD (1909)

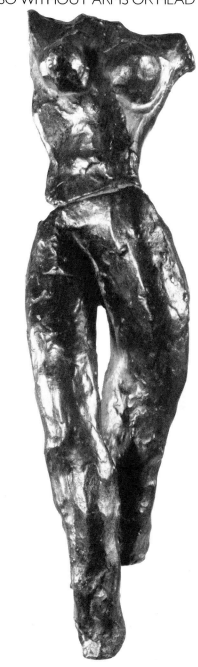

Bronze, *HM 3*, no foundry mark, Height: 9¾ in. Collection Mr. and Mrs. I. C. Deal, Dallas.

Torso without Arms or Head was modeled between the spring and winter of 1909 as part of Matisse's research for the dance panel of the Shchukin commission.[1] Although the bronze is not a study for a particular figure in *Dance II*, it was surely motivated by the same impulse — the desire to capture the motion, speed, and lightness of the dancing figure. In a newspaper interview published in April 1909, Matisse spoke of the new project for Sergei Shchukin: "I have to decorate a staircase. It has three floors. I imagine a visitor coming in from the outside. There is the first floor. One must summon up energy, give a feeling of lightness. My first panel represents the dance, that whirling round on top of the hill."[2] In this respect, *Torso without Arms or Head* reflects Matisse's first thoughts on the type of vigorous action he wanted to express in *Dance II*. Its source, indeed, provides a clue to the painting's meaning.

The trim figure leaps forward on her right leg while the trailing leg, cut below the knee, floats freely (Fig. 51). The back is arched, and the now truncated arms originally were thrown high into the air. A narrow waist and slender limbs contribute further to the impression of litheness and bouyancy. Although it is only a partial figure, broken and mended at the waist, the torso nevertheless has tremendous vitality. There is a feeling of abandon to the pose which is reminiscent of ancient bacchic revellers who run, jump and dance in a state of ecstatic frenzy. A dancing figure in a nearly identical pose was used by Derain in the center of his 1905 painting *L'Age d'or* (Fig. 52).[3] Matisse and Derain both turned to classical sources for this motif: their figures were ultimately inspired by dancing Maenads of the type familiar from Greek vases and sculpture (Fig. 53).[4]

That Matisse looked to images of the devotees of Dionysis who dance in celebration of bacchic rites is not surprising. According to the artist's friend Marcel Sembat, *Dance II* was conceived as a kind of ancient bacchanal.[5] But Matisse was interested not only in the dancers' poses but also in the transcendent state of mind expressed through the dance. During the summer of 1910, he spoke to the American critic Charles Caffin about *Dance II*. Caffin later wrote of "the primitive, elemental, one might almost say rudimentary expression of the whole. For the rhythms of these dancing figures are those of instinct and nature...And in the case of the *Dance*, organization and simplification were schemed to produce an expression of purely physical abandonment of

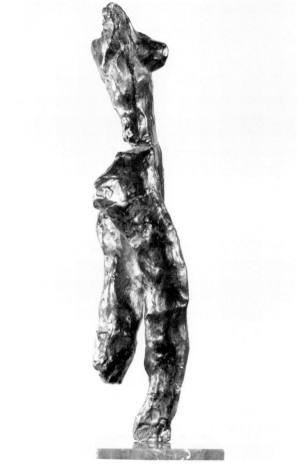

Fig. 51 Matisse, *Torso without Arms or Head*, side view.

lusty forms to sense intoxication."[6] In *Torso without Arms or Head*, Matisse sought to express the ability of the dance to raise sensations to a higher, more ecstatic level. In 1913, Marcel Sembat said as much of Matisse's intentions for *Dance II*: "He raises himself toward the eternal, toward the sublime and he intends for you to ascend with him. If you do not rise, then there will have been a misunderstanding. You may tear out your hair, or even abuse him because the faces have neither noses nor eyes. [If you do] it is because you have remained earthbound, too close to the ground."[7] The bronze is, in essence, an emblem of the elemental power of the dance.

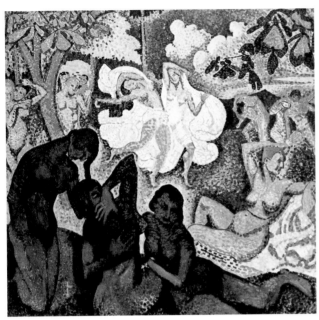

Fig. 52 André Derain, *L'Age d'or*, 1905.
Teheran Museum of Contemporary Art.

Fig. 53 *Dancing Maenad*, after Skopas, 4th century B.C.
Albertinum, Dresden.

Notes

1. The bronze has been dated generally to 1909; see Zurich 1959, no. 37; Elsen, *Matisse*, 110; Legg, *Matisse*, 25.

2. Interview with Charles Estienne, as quoted by Flam, *Matisse on Art*, 49.

3. For a discussion of this painting, see Elderfield, *Fauvism*, 102. Matisse's cut-out, *Nude with Flowing Hair* (1952), also employs the same ecstatic pose; see Tucker, *Language of Sculpture*, 106.

4. Compare, for example, the dancing maenad on a vase by the Kleophrades Painter, illustrated in John Boardman, *Athenian Red Figure Vases, The Archaic Period, A Handbook*, London, 1975, fig. 136. For a consideration of this ancient type, see G. E. Rizzo, *Thiasos, bassoriliesi greci di soggetto dionisiaco*, Rome, 1934, and

Giacomo Caputo, *Lo scultore del grande basso-relievo con la danza delle menadi in Tolemaide*, Roma, 1948. A particularly interesting comparison can be made with a small bronze, *Dancing Satyr with Thyrsus*, in the Museo Nazionale, Naples, for which see Margarete Bieber, *The Sculpture of the Hellenistic Age*, New York, 1961, fig. 560.

5. Marcel Sembat, *Matisse et son oeuvre*, Paris, 1920, 9.

6. Charles H. Caffin, *The Story of French Painting*, New York, 1911, 215.

7. Sembat, "Henri Matisse," 193. The French text reads: "Il s'élève vers l'éternal, vers le sublime, et il entend que vous y montiez avec lui. Si vous n'y mentez pas, alors entre vous et lui il y aura malentendu. Vous vous arracherez les cheveux, ou bien vous l'invectiverez parce que les visages n'ont pas de nez, ni d'yeux. C'est que vous êtes resté par terre, trop au ras du sol."

22. SEATED FIGURE, RIGHT HAND ON GROUND (1908)

23. SEATED NUDE, OLGA (1910)

Bronze, *HM 2/10*, Height: 7½ in.
Collection Mrs. M. Victor Leventritt, New York.

Bronze, *HM 9/10*, Height: 17 in., Private Collection, New York.

Seated Figure, Right Hand on Ground is sometimes considered preparatory to the larger *Seated Nude, Olga* of 1910.[1] Although the poses are closely related, the earlier bronze is probably not a study but rather an independent work. Its source is a photograph of a crouching model which Matisse used at Collioure in the summer of 1908.[2] He also modeled two miniature bronzes after the same photograph: *Small Crouching Nude with Arms* and *Small Crouching Nude without an Arm*. Both of these are close to *Small Crouching Torso* (No. 15) in their closed, compact form and concentrated mass.[3]

 Seated Figure has a bodily torsion similar to that of the two

bronzes mentioned above, but, unlike them, has a more open pose. Its most noticeable difference, however, is in the rough handling of the medium. The arm is little more than a roll of clay pressed into the shoulder and pinched into shape. The surface bears traces everywhere of the artist's fingers and tools.[4] In working the medium so roughly, Matisse may have sought to distance himself from the photograph. More instinctively, however, he perhaps followed the inspiration of a different sensation.[5]

 Sometime in 1910 Matisse returned to the same pose in *Seated Nude, Olga,* a larger, more ambitious work than *Seated*

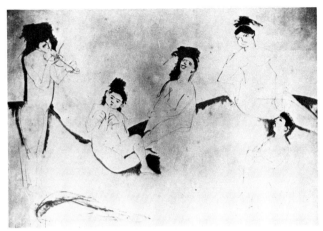

Fig. 54 Photograph of an early state of *Music*.

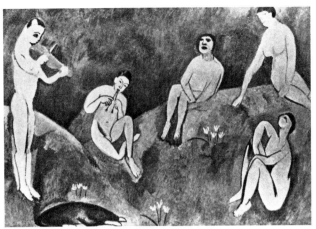

Fig. 55 Photograph of a later state of *Music*.

Figure. The model for this bronze has been identified as Olga Merson, a woman whose portrait Matisse painted in the same year.[6] The bronze's exact date is unknown. Matisse probably spent the summer in Issy. He was definitely in Germany in late September and early October and returned to Paris in mid-October for the Salon d'Automne and the furor generated by *Dance II* and *Music*. Shchukin reacted adversely to the hostile reception which the paintings received and refused to accept them. Matisse was so upset by this rejection that he was unable to work and, early in November, left Paris for Spain where he remained until January.[7] It is not likely that Matisse would have had the time or the inclination for a sculptural project in the few weeks between his return to Paris and his departure for Spain. It seems plausible, therefore, to date *Seated Nude, Olga* sometime between January and August 1910.

One might well ask why Matisse returned to a seated pose which he had studied in three small bronzes more than a year earlier and why he now chose to develop the work on a much larger scale and in such a deliberate manner. The sculpture can, of course, be understood on its own terms simply as a renewal of interest in a favorite pose. Yet it perhaps had an additional function in the artist's creative process. During the first half of 1910, Matisse was working on the Shchukin commission. *Dance II* and *Music* were probably completed by late spring or early summer.[8] *Seated Nude, Olga* may relate in a general way to *Music* (Fig. 5).

Indeed, *Olga* elaborated on forms seen in *Seated Figure* — the torsion of the body, the compression and intertwining of the legs versus the erect torso and head, the placement of the arm away from the side as a bracing element in the composition. Matisse tested these same features on a yet larger scale as he was developing the poses of the life-sized singers and musicians in *Music*. While no preliminary figural or compositional studies are known, photographs of the painting taken at two different stages in its evolution reveal a considerable development in the poses of the seated figures (Figs. 54, 55).[9] Each stage shows four distinct poses, ranging from the cross-legged pipe player to the three singers whose legs are either pulled tight to the chest, extend outward, or dangle down over the grassy incline. The variety of postures is noteworthy, as is the torsion of the figure with the extended arm in the second state, a feature seen in *Seated Nude, Olga*.

In *Olga*, Matisse explored a condensed *contrapposto*. It was precisely this complexity that he suppressed in the final version of *Music*. He undoubtedly felt that it was inappropriate for the effect of simplicity and calm he wanted, an effect ultimately achieved by standardizing the poses of the three singers. *Seated Nude, Olga* may have satisfied Matisse's need to experiment while at the same time helping to realize the form of the singers through its own density and compact silhouette.

Notes

1. Barr, *Matisse*, 138; Zurich 1959, no. 41; Paris 1975, no. 209.

2. See Elsen, *Matisse*, Fig. 126.

3. Illustrated in Legg, *Matisse*, 21; and Elsen, *Matisse*, Figs. 125, 127.

4. The piece is considered by Elderfield, *Matisse*, 61.

5. Elsen, *Matisse*, 99.

6. *Ibid.* For an illustration, see Barr, *Matisse*, 353. The portrait is now in the collection of the Museum of Fine Arts, Houston.

7. Barr, *Matisse*, 134.

8. *Ibid.*

9. All related material is assembled by Izerghina, *Matisse*, 153.

24 a-e. JEANETTE HEADS (1910-1913)

Los Angeles County Museum of Art
Presented by the Art Museum Council in Memory of Penelope Rigby.

24a. JEANETTE I (early 1910), Bronze, *HM 4*, 12⅞ × 11 × 11 in.

24b. JEANETTE II (early 1910), Bronze, *HM 5*, 10½ × 12 × 11 in.

24c. JEANETTE III (spring and fall 1911), Bronze, *HM 4*, 23½ × 12 × 12 in.

24d. JEANETTE IV (spring and fall 1911), Bronze, *HM 4*, 24 × 11 × 11 in.

24e. JEANETTE V (spring-summer 1913), Bronze, *HM 1/10*, 22⅞ × 8½ × 9¼ in.

The five heads of Jeanette are often considered Matisse's sculptural masterpiece. Executed at intervals over a period of two and a half years, they represent a serial analysis of a single motif, each one becoming progressively more abstract. Like the *Backs*, the Jeanette Heads were not intended at the outset as a series but evolved naturally in relation to the overall development of Matisse's art.[1] Each head, though linked to its predecessor conceptually (and in some cases physically, since plaster casts were sometimes used as the starting point) is an autonomous work conceived independently of any preexisting plan and is understandable on its own terms. This is not to say that Matisse did not ever think of them as a group. He first exhibited heads I-III in New York and London in 1912 and in Paris the following year. Heads I-IV were shown in New York in 1915.[2] However, all five were not seen together publically until the Paris retrospective of 1950, and so the full impact of the series was not apparent until late in the artist's life, an indication of the private purpose and personal character of Matisse's sculpture.

The model for *Jeanette I* and *Jeanette II* was a young woman named Jeanne Vaderin who was staying at Issy-les-Moulineaux while recovering from an illness. She also posed for a painting, *Girl with Tulips* (Fig. 56), which was exhibited at the Salon des Indépendents in March, so both sculpted heads should probably be dated to the early months of 1910.[3] Like the *Backs*, the *Jeanette Heads* began in a naturalistic mode. *Jeanette I* was the first life-sized portrait Matisse had sculpted in a decade,[4] and he may have been somewhat unsure of himself and anxious to master this relatively unfamiliar genre. The bronze is a conservative work, intent on an accurate

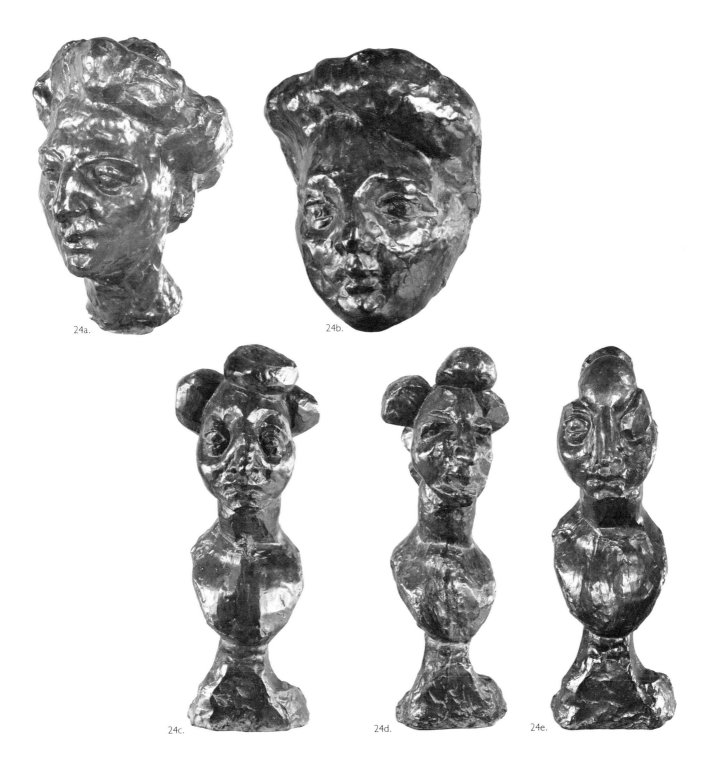

24a.

24b.

24c.

24d.

24e.

Fig. 56 Matisse, *Girl with Tulips*, 1910.
The Hermitage, Leningrad.

Matisse worked over the surface with his fingers, rubbing away the ridgelike eyebrows, straightening the bridge of the nose, reshaping the cheeks and coiffure, and adding a small right ear. He also removed the topknot and used the knife to slice away a portion of the head on the left side. This left a large triangular plane (not visible from the front), something that adumbrated his radical use of the knife in *Jeanette V.*

Jeanette I and *II* form a pair linked by their relative realism and their dependence on the model. With *Jeanette III* and *IV*, we see a sudden shift, as Matisse moved from observation to invention, freeing his imagination and separating himself from the model.[5] It is hard to explain the impulse behind this transformation, and the uncertainty of dating makes the sources of the new form unclear. It would seem, however, that *Jeanette III* and *Jeanette IV* were begun at different times during the spring of 1911 and were completed in the fall, after Matisse's return from Tangier.[6] Those spring months at Issy also saw Matisse embark upon a new group of pictures, the so-called "Symphonic Interiors" of 1911.[7] The large and elaborate works (*The Painter's Studio, The Painter's Family,* and *Interior with Eggplants*) are distinguished by their rich colors, complex decorative patterns, and subtle spatial constructions. The flattening of space through the use of abstract pattern, observable in the last two of these works, is particularly strong, and Matisse may have sought to balance this effect by modeling in clay. Sculpture, in fact, is depicted in all of the paintings, introducing accents of mass and weight. But aside from the general tendency toward abstraction, nothing in these paintings prepares us for the busts which followed.

With *Jeanette III* Matisse started afresh, working from memory and, above all, following his imagination. As he told his students: "To one's work one must bring knowledge, much contemplation of the model or other subject, and the imagination to enrich what one sees. Close your eyes and hold the vision, and then do the work with your own sensibility."[8] He augmented the simple head format of *Jeanette II* by adopting the form of an ancient bust with the head supported on a socle, or abstract base cast with the head. The result was an increase in scale and mass, a presence considerably more potent than that of its predecessor. In keeping with this assertiveness, the facial features have also been exaggerated, especially the large, staring eyes which bulge from widened eyesockets. The nose has been enlarged and thickened, and the hair has been

reading of facial features. The head is crowned by an upswept wreath of hair; the eyes, nose, and lips are softly modeled, with contours blurred and blended. The only hints of future developments are the emphatic delineation of the eyelids, the built-up eyebrows, and the general emphasis given to the orbit of the eyes by the high cheekbones. The overall treatment is restrained; the effect gracious and tranquil.

Jeanette II was modeled from a plaster cast of *Jeanette I.* Matisse significantly altered the head, however, by cutting away the neck along a diagonal line from the base of the chin to a high point on the back of the head where he also excavated a hollow. This operation focused attention on the face and gave the work the fragmented quality of a Roman bust (Fig. 57). The features were generalized and flattened.

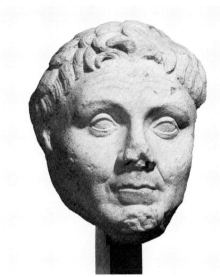

Fig. 57 Mask-like fragment of the face of Pompey the Great, Roman, mid-1st century B.C. Yale University Art Gallery, Lent by Frank Brown.

rearranged into separate rolls that are reminiscent of *Seated Figure, Right Hand on the Ground* of 1908 (No. 22).

These characteristics were carried over to *Jeanette IV* but were treated in an even more schematic manner. The head is no longer pearshaped but is rather lozengelike, with temples trimmed and cheeks excavated with the knife. The nose is long and pointed; the eyes are removed, and a heavy, broad ridge defines the upper occulus. The hair is raised above and behind the head in shapes that resemble partially filled balloons.[9] In general, the head is more animated than *Jeanette III* and, with its birdlike features, is more of a caricature than a portrait.[10]

Jeanette V probably dates from the spring and summer of 1913, a period of great change in Matisse's art.[11] Synthetic and radically restructured, *Jeanette V* embodies a new experimental mood generated by the influence of Cubism.[12] Although not a Cubist sculpture, *Jeanette V* is nonetheless unthinkable without reference to Cubism's liberating role. The artist now felt free to reorganize the motif in all its parts and all its aspects — probing, dissecting, restructuring, creating a totally new vision.

Matisse began working on *Jeanette V* from a plaster cast of *Jeanette III*. He sliced away the decorative rolls of the coiffure,

digging into the head itself. The nose, now large and tubular, directly joins the bulbous mound of the forehead. The left eye was filled in then planed flat. Above the left ear, a hole delves deep into the very core of the head, the structure of which has been simplified to one condensed form. The same kind of cutting, planing, and excavation is visible in the other great sculpture of 1913, *Back II*.[13] The experience gained in *Jeanette V* aided Matisse as he developed in his painting a style both simpler and more austere.

Notes

1. The most thorough discussion of the series is found in Elderfield, *Matisse*, 64-71; and Elsen, *Matisse*, 122-136. The dates given here are those proposed by Elderfield.

2. Paris 1975, nos. 204-207.

3. Barr, *Matisse*, 140; Elderfield, *Matisse*, 64.

4. Elsen, *Matisse*, 124.

5. Elderfield, *Matisse*, 64.

6. *Ibid.*, 65-66. This dating squares with Matisse's recollection of undertaking the first four busts within a year, see Barr, *Matisse*, 140.

7. See Barr, *Matisse*, 151 ff., 373-375.

8. Flam, *Matisse on Art*, 43.

9. Barr, *Matisse*, 141.

10. Goldwater, "Sculpture of Matisse," 43.

11. Jack Flam dates *Jeanette V* to 1916 on the basis of Pierre Matisse's recollection that it was contemporary with *Back III* (1916) and because of its depiction in the Barnes Foundation's *Still Life with Plaster Bust* which also dates from 1916 (and not, according to Flam, 1912 — the date usually given); see Flam, "Matisse and The Fauves," n. 105.

12. On the importance of Cubism to this series, see Tucker, *Language*, 94-98; and Elderfield, *Matisse*, 68-69.

13. See No. 27.

25. PURPLE CYCLAMEN (1911)

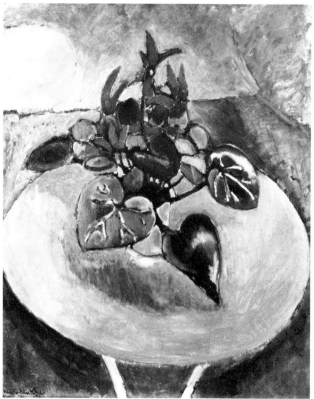

Oil on canvas, *Henri Matisse*, 28¾ x 23¼ in.
Mr. and Mrs. William R. Acquavella, New York.

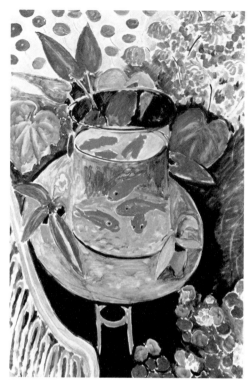

Fig. 58 Matisse, *Goldfish*, 1911. Pushkin Museum, Moscow.

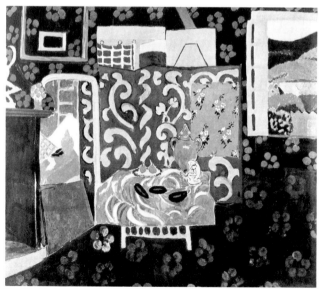

Fig. 59 Matisse, *Interior with Eggplants*, 1911.
Musée de Peinture et de Sculpture, Grénoble.

Purple Cyclamen was painted at Issy-les-Moulineaux in 1911.[1]
The painting is related to the Pushkin Museum's 1911
Goldfish, in which the artist depicted the same table from a
similarly high perspective and in a centralized composition
(Fig. 58). The two paintings are, however, quite different.
Goldfish is distinguished by an abundance of surface pattern
which contributes to an allover design, much like the
contemporary *Interior with Eggplants* from the summer of
1911 (Fig. 59).[2] Toward the end of the year, Matisse moved
away from the arabesque surface and began to concentrate
on uncluttered compositions with coloristic boldness. These
effects are especially evident in *The Red Studio*, an important
painting to which *Purple Cyclamen* is formally related and
which, like it, must date from the fall of 1911 (Fig. 6).[3] A

further sign of the relationship of the two paintings is that *Purple Cyclamen* is depicted on the rear wall of *Red Studio*.

 Purple Cyclamen has been stripped of the decorative foliage seen in *Goldfish*. Matisse reduced the visual components to the essential elements, clarifying and sharpening the image by placing the circular tabletop and plant in the center of the canvas. The background is similar to that in *Goldfish* but is unobstructed by any other element. It is divided into two broad zones — the purple band providing a backdrop for the blue tabletop, and the blue one complementing the purple flowers of the cyclamen. A harmonious coloristic effect is thus obtained by balancing the saturated hues. The only other compositional elements are the green circular shapes at the upper corners — abstracted plant forms which force the eye toward the center of the composition. This abstracting tendency was also seen in *Jeanette III* and *Jeanette IV* in which the coiffures were reorganized and reduced to a few bulbous shapes.[4] As seen in these works, simplicity of design and economy of means — a purging of the decorative — had become a basic feature of Matisse's art which would last until the beginning of the Nice period.[5]

Notes

1. Paris 1970, no. 108.

2. The dating of the Pushkin *Goldfish* is somewhat problematic. Barr, *Matisse*, 376, dates it generally to 1911; Madame Duthuit suggested a date in the spring or autumn of that year. Elderfield, *Matisse*, 197-198, n. 4, based on the correspondence of Shchukin, has suggested a date of 1912. It is dated 1911 in Paris 1970, no. 107.

3. For the *Red Studio*, see Elderfield, *Matisse*, 86-89.

4. See No. 24. A plaster version of *Jeanette IV* also appears in the *Red Studio*.

5. Barr, *Matisse*, 195.

26. DANCE (1911)

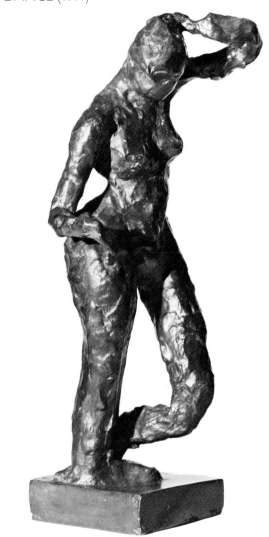

Bronze, *HM 4/10*, Height: 16⅛ in., Private Collection, New York.

The title of this bronze has seemed incongruous to at least one observer.[1] The static posture suggested a variation on the beauty pose used frequently by Matisse rather than a figure in motion. Yet the sculpture does express Matisse's interest in the dynamics of dance and it is, in fact, related to *Torso without Arms or Head* of 1909, a bronze that also

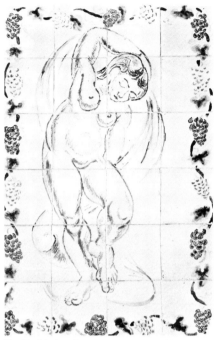

Fig. 60 Matisse, *Dancer*, ceramic tile, 1907.
Musée Matisse, Nice-Cimiez.

embodies the idea of dancing, although in a profoundly different way.[2]

It has been noted by Elsen that "the counterpart to this sculpture [*Dance*] is not the big paintings of *The Dance* nor their sketches on paper but rather the painted ceramic dancer of 1907 (Fig. 60). Having finished his commissions for this theme and perhaps tired of its enactment in painting, Matisse may still have felt the need to extend once more his ideas into sculpture."[3] It may well be true that the source for this pose can be traced back to the ceramic dancer; although Matisse had completed *Dance II* by 1910, he had by no means lost interest in the motif of the dancing figure. In fact, he painted two more versions of *The Dance* as pictures-within-pictures in the Leningrad and Worcester *Nasturtiums and "The Dance," I* and *II* (Figs. 61, 62).

It would seem that Matisse was dissatisfied with what he called the "frenzy"[4] of *Dance II*, since he told Marcel Sembat that after completing *Music* "he regretted that *Dance* was not more sublimated, more at rest, more nobly calm."[5]

"That whirling round on top of the hill,"[6] as he earlier had described the effect he sought to achieve, was now troubling. Matisse first sought to rectify the problem in a large charcoal drawing datable to 1911 and subsequently in the two versions of *Nasturtiums and "The Dance,"* probably done later the same year.[7] The figures in these paintings were simplified. The limbs were straightened, and the undulating ground line was eliminated in favor of a simple arc (in the case of the Leningrad picture, he used no groundline at all). Matisse's restrained handling of the figure style and setting created an impression of calm in which, as Sembat wrote in 1913 of the charcoal sketch, "movement is of a solemn dignity."[8]

Dance should be seen in light of Matisse's search for a calmer, more refined statement. The pose recalls that of the *Satyr* in the Uffizi's famous *Invitation to the Dance* group, a work which Matisse undoubtedly saw while he was in Florence in 1907 (Fig. 63).[9] Here, unlike the bacchic frenzy of the ancient sources which inspired *Torso without Arms or Head*, the satyr does not leap through the air but stands firmly on the engaged leg. The right leg of Matisse's bronze functions in a similar way. It is robust and straight, with neither thigh, knee, nor calf articulated. It is planed on the front and inside with a knife, creating an almost pier-like quality, while, in contrast, the free leg appears boneless and amorphous. Matisse's interest in the limb's structural, weight-bearing function is also visible from the rear. The exaggerated right buttock was built up by a large mound of clay, while the left buttock is practically non-existant. The full proportions, the balanced position of the arms, and the downward turn of the head contribute to the sense of measured, restrained movement. The tempo has been changed from allegro to adagio. Matisse has chosen to represent a moment of stasis, the pause between beats before the dancer resumes her deliberate steps. In this sense, *Dance* recalls the arrested motion of Degas' dancers. It also calls to mind Matisse's comments on movement in *Notes of a Painter* (1908):

> There are two ways of expressing things; one is
> to show them crudely, the other is to evoke
> them through art. By removing oneself from the
> literal representation of movement one attains
> greater beauty and grandeur. Look at an
> Egyptian statue: it looks rigid to us, yet we sense
> in it the image of a body capable of movement

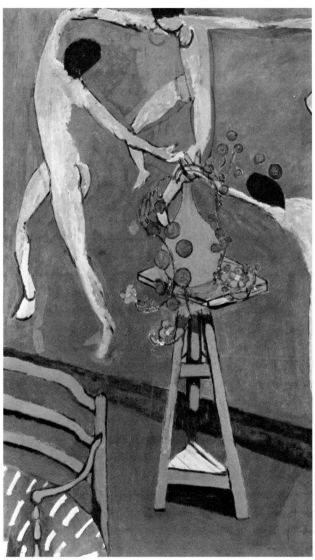

Fig. 61 Matisse, *Nasturtiums with "The Dance" I*, 1911.
The Hermitage, Leningrad.

Fig. 62 Matisse, *Nasturtiums with "The Dance" II*, 1911.
Worcester Art Museum, Worcester, Massachusetts.

and which, despite its rigidity, is animated. The Greeks too are calm: a man hurling a discus will be caught at the moment in which he gathers his strength, or at least, if he is shown in the most strained and precarious position implied by his action, the sculptor will have epitomized and condensed it so that equilibrium is re-established, thereby suggesting the idea of duration. Movement is in itself unstable and is not suited to something durable like a statue, unless the artist is aware of the entire action of which he represents only a moment.[10]

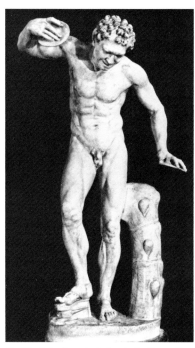

Fig. 63 Satyr from *Invitation to the Dance* Group.
Uffizi, Florence.

Notes

1. Elsen, *Matisse*, 103.

2. See No. 21.

3. Elsen, *Matisse*, 103.

4. Letter to Alexander Romm, February 14, 1934, as quoted in Neff, "Matisse and Decoration," 44.

5. "Après la *Musique*, il regretta que la *Danse* ne fût pas plus sublimée, plus reposée, plus noblement calme!"Marcel Sembat," Henri Matisse, "*Les Cahiers d'Aujourd hui*, April, 1913, 193. See also, Sembat, *Matisse et Son Oeuvre*, Paris, 1920, 9: "A peine achevée, Matisse la jugea [*Dance II*] trop matériellement passionnée, trop dionysiaque, trop agitée."

6. "Interview with Charles Estienne, 1909," as quoted by Flam, *Matisse on Art*, 49.

7. The charcoal sketch is illustrated and the chronology discussed by Neff, "Matisse and Decoration," 44.

8. Sembat, "Matisse," 193: Et je connais un fusain de la *Danse* telle qu'il la voit maintenant où le mouvement est d'une solennelle ampleur." See also, Sembat, *Matisse et Son Oeuvre*, 9: "Un fusain nous montre une danse ample, solennelle et calme."

9. For this sculpture, see Guido A. Mansuelli, *Galleria degli Uffizi: Le Sculture*, Rome, 1958, I, 80, no. 51; and Margarete Bieber, *The Sculpture of the Hellenistic Age*, New York, 1961, figs. 562-564.

10. Flam, *Matisse on Art*, 37.

11. Sembat, *Matisse et Son Oeuvre*, 9.

A comparison of the right legs of the figures on the left in both versions of *Nasturtiums and "The Dance"* shows that the leg in the Hermitage picture tapers at the knee and ankle (Figs. 62, 63), while the knee in the Worcester version is undefined, giving the leg the appearance of the engaged leg of *Dance* (Fig. 63, No. 26). This is the figure which leads the entire chain in all the versions of the *Dance* and for which Matisse prepared the *Study of a Foot* (No. 20). Its dithyrambic energy, as Sembat called it, animated the orgiastic frenzy of the entire composition of *Dance II*.[11] Interestingly, this foot is still elevated in *Nasturtiums and "The Dance," I* but is flat on the ground in the second version. Here the right foot and leg no longer launch the body but buttress it, arresting forward motion as the figure turns the corner. Although the bronze is not a study for this figure, it is nonetheless related as part of the new, more restrained and expressive mode that Matisse sought to obtain as he rethought the dance motif. The statuette, therefore, may be contemporary with *Nasturtiums and "The Dance," II*.

27. BACK II (1913)

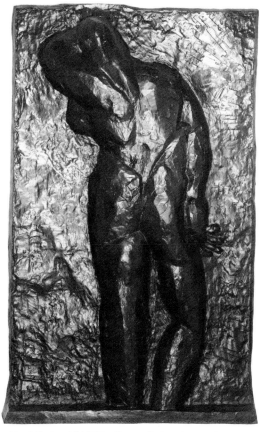

Bronze, *Henri Matisse, HM 0/10, Georges Rudier, Fondeur, Paris*
74¼ × 47⅝ × 6 in., The Anne Burnett and Charles D. Tandy Foundation.
Colorplate on page 26

Fig. 64 Photograph showing an intermediate state of *Bathers by a River*,
1912 or 1913.

Matisse seems to have spent most of the summer of 1913 working in his studio at Issy-les-Moulineaux.[1] Sometime during this period he began another relief, *Back II*. He wrote to his friend Charles Camoin on September 15, 1913: "I worked, however, on but a few things this summer; but I advanced my large painting of bathers, the portrait of my wife as well as my bas relief."[2] The bas relief was *Back II*; the large painting was the Art Institute of Chicago's *Bathers by a River* (Fig. 68). The connection between these two works is more than co-incidental and can be traced to the commission for *Dance* and *Music*. In 1909, Matisse proposed an additional

subject to Shchukin, a group of bathers which would have formed the third and culminating panel in the series for his house. As we have seen (No. 19), that suggestion was not accepted by the Russian, but Matisse pursued the idea on his own and produced a third painting now generally held to be the monumental work in Chicago.[3]

A photograph of *Bathers by a River*, which was taken while the painting was in progress in 1912 or 1913, shows that Matisse's initial conception, as seen in the watercolor sketch prepared for Shchukin, was considerably modified (Figs. 50, 64).[4] The number of figures was reduced, their scale enlarged, and their form schematized. A formal relationship between the standing bather at the left, seen from behind, and *Back II* is evident in the flexed right knee, the columnar left leg, the contrast of rounded and flattened buttocks, the lines running upward and outward from the base of the spine, and the suppression of subsidiary accents in favor of the definition of large areas of the body. We know that Matisse worked on the painting and the sculpture concurrently, even placing the two side by side in the studio at Issy.[5] Both the painting and the sculpture reveal the liberating influence of Cubism in the fearless analysis of the body's structure and the rearrangement of form.

The reductive thinking and tectonic approach to form evident in the bather was undoubtedly aided by Matisse's work on *Back II*. Compared to *Back I* No. 19), *Back II* is simplified and streamlined. The "valleys" have been filled in,

and the surface smoothed. Gaps between the right side and the arm and between the left arm and the head were eliminated. The head, neck, and hair were subsumed in one long V-shaped form. Contours were straightened, and the legs' width and mass increased in response to the torso's broadened proportions. Verticality was stressed by straightening the spine and aligning it with the inner edge of the engaged leg. Matisse told his students: "To feel a central line in the direction of the general movement of the body and build about that is a great aid."[6] He also noted that a sculpture "must have a spinal column. One can divide one's work by opposing lines (axes) which give the direction of the parts and thus build up the body in the manner that at once suggests its general character and movement."[7] The diagonal lines running upward from the base of the spine like branches on a tree at once reinforce the vertical movement and create wedge-shaped forms linking the outer parts to the center. "Fit your parts into one another and build up your figure as a carpenter does a house," Matisse said. "Everything must be constructed — built up of parts that make a unit — a tree like a human body, a human body like a cathedral."[8]

Notes

1. Barr, *Matisse*, 177.

2. "J'ai travaillé pourtant à peu de chose cet été; mais j'ai poussé mon grand tableau des baigneuses, le portrait de ma femme, ainsi que mon bas relief," as quoted in Paris 1970, 86. See also Danièle Giraudy, "Correspondance Henri Matisse-Charles Camoin," *Revue de l'Art*, no. 12, 1971, 16, for the full text.

3. Neff, "Matisse and Decoration," 45.

4. The photograph is dated 1912 by Neff, "Matisse and Decoration," 46; and 1913 by Elderfield, *Matisse*, 195, n. 26.

5. A communication from Pierre Matisse to Elderfield, see Elderfield, *Matisse*, 195, n. 26.

6. "Sarah Stein's Notes , 1908," as quoted by Flam, *Matisse on Art*, 43.

7. *Ibid.*, 45.

8. *Ibid.*, 42-43.

28. STILL LIFE WITH LEMONS (1914)

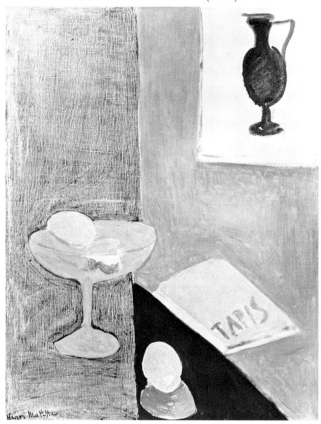

Oil on canvas, *Henri Matisse*, 27¾ x 21¾ in.
Museum of Art, Rhode Island School of Design, Gift of Miss Edith Wetmore.
Colorplate on page 27

During the period from late 1913 to early 1917, Matisse's art grew increasingly formal, austere, and architectonic.[1] These years are generally referred to as Matisse's "Experimental Period," and they witnessed the production of some of his greatest works. Throughout this time, the influence of Cubism was an important factor,[2] although its effect was a subtle one. It is most notable in such paintings as *Tête blanche et rose* from the end of 1914 or early 1915.[3]

Still Life with Lemons, which has been dated early in 1914[4] is, as Barr noted, "as flat as any of the most abstract pictures of 1911."[5] Unlike those earlier works,

however, it responds to the geometric compositions, vertical format, and tendency toward flatness that are characteristic of Cubism, but without the fracturing of form. A simple, abstract geometry defines the structure of the painting and asserts the planarity of its surface. Matisse flattened space by juxtaposing the green wall with the textured blue tabletop turned on end and the red ledge, also a horizontal surface tilted upward. He exploited the diagonal, recessive thrust of this red triangle in the foreshortened form labeled *TAPIS*, a form which lies not on the receding surface with which it is aligned but rather on the flat green of the vertical wall. This establishes an incongruous spatial relationship. Matisse also experimented with the contrast between two and three dimensional objects: the black vase, an interpretation of a drawing of a vase by his son Pierre, is juxtaposed with the rounded lemons below.[6]

It is easy to imagine the seriousness with which Matisse undertook this confrontation with Cubism. Matisse wrote in November of 1913 that he was at the beginning of a "very painful endeavor."[7] The effort must have caused some disquiet, like his struggle with Neo-Impressionism during the summer of 1904, when the painter Henri-Edmond Cross wrote of "Matisse the anxious, the madly anxious."[8] In any case, he was interested enough in the comments of Gris and Metzinger to show them the painting in his studio shortly after it was completed. They said nothing to Matisse who, as Barr remarked, "would have welcomed some commendation or at least a comment from his juniors."[9] Matisse subsequently learned that they had praised the "'extraordinary concordance' between the forms of the vase and the fruit,"[10] an observation which he later chose to stress when he devised a fulsome new title for the painting, *Still Life with Lemons which Correspond in their Forms to a Drawing of a Black Vase upon the Wall*.[11]

Notes

1. Barr, *Matisse*, 177ff.; Elderfield, *Matisse*, 92.

2. Elderfield, *Matisse*, 92.

3. See No. 29.

4. Elderfield, *Matisse*, 203, n. 9.

5. Barr, *Matisse*, 187.

6. The same vase appears in the Museum of Modern Art's *Woman on a High Stool* of 1914 and in the 1918 *Vase of Anemones*. See Elderfield, *Matisse*, 94, 203, n. 9.

7 Letter to Camoin of November 1913, as quoted in Elderfield, *Matisse*, 92.

8. As quoted in Barr, *Matisse*, 53.

9. *Ibid.*, 187.

10. *Ibid.*

11. *Ibid.* Matisse appears to have devised the title in response to one of Barr's Questionaires, which possibly reflects his desire to perpetuate this positive recollection of the painting. See also the Introduction by Lawrence Gowing for *Matisse (1869-1954): A Retrospective Exhibition at the Hayward Gallery* (The Arts Council of Great Britain, 1968), London, 1968, 34; and Pierre Schneider, "Matisse: 'Faire duex choses à la fois,'" *Tel Quel*, 1978, no. 77, 88 and no. 78, 87, 91.

29. HEAD OF MARGUERITE (1915)

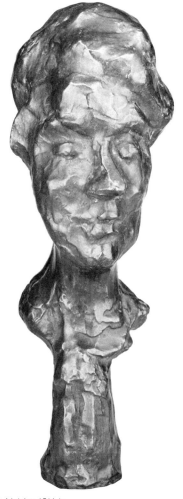

Bronze, *HM 7/10*, Height: 12½ in.
The Minneapolis Institute of Art, Gift of the Dayton Hudson Corporation.

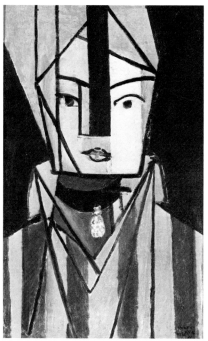

Fig. 65 Matisse, *Tête blanche et rose*, 1914-1915.
Musée National d'Art Moderne, Paris.

During the summer of 1914 at Collioure, Matisse met Juan Gris, the third great figure of Cubism. Matisse found Gris sympathetic, and the two men were soon engaged in passionate theoretical discussions on the nature of painting. Gris wrote to his dealer, D. H. Kahnweiler: "We argue so heatedly about painting that Marquet can hardly sit still for boredom."[1] Although Matisse's interest in Cubism predates his friendship with Gris, the contact perhaps intensified his

involvement.[2] One painting begun in 1914 and completed in 1915, the cubist *Tête blanche et rose*, reveals the direct influence of Gris in the strong linear grid superimposed on the head and torso (Fig. 65).[3] The painting was one of Matisse's most direct confrontations with the Cubist idiom.

Tête blanche et rose was preceded by a more naturalistic version of the composition, *Jeune femme au chapeau corbeille* (Fig. 66).[4] The sitter — who wears a striped, V-necked blouse and choker with a pendant, the dominant motifs in the second version — was Matisse's daughter Marguerite. The bronze bust of Marguerite catalogued here may be contemporary with work on one or both of these paintings. The more or less realistic rendering of the features, the head's slight tilt off axis, and the quiet mood call to mind *Jeune femme au chapeau corbeille*. At the same time, the rather conservative modeling and realistic handling are far from the severe, abstract forms of *Tête blanche et rose*. The tentative, experimental quality of the painting has been noted frequently,[5] and it is not impossible that Matisse undertook

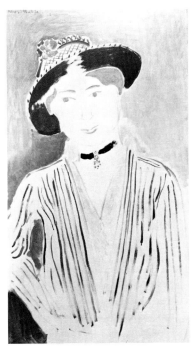

Fig. 66 Matisse, *Jeune femme au chapeau corbeille*, 1914.
Bridgestone Museum of Art, Ishibashi Foundation, Tokyo.

Fig. 67 Matisse, *Mlle. Yvonne Landsberg*, etching, 1914.
The Museum of Modern Art, New York.

the bust in order to counterbalance the flattening and abstraction of Marguerite's features seen in *Tête blanche et rose*.

The bust may have been motivated as well by a desire to capture a certain mood, an expressiveness missing in the painting. Each profile has a unique aspect,[6] a serene, almost dreamy state reminiscent of his portrait etching of Yvonne Landsberg made the year before (Fig. 67).[7] Matisse reacted to his models in different ways, being attracted to a particular aspect or mood.[8] The dual nature of his thought in 1915 — experimental and austere, as well as sensuous and emotional — is perhaps nowhere seen more clearly than in the relationship of *Tête blanche et rose* and the *Head of Marguerite*.[9]

Notes

1. As quoted in Barr, *Matisse*, 178.

2. Elderfield, *Matisse*, 100.

3. Golding, "Matisse and Cubism," 15.

4. For the former, see Isabelle Monod-Fontaine, *Matisse, oeuvres de Henri Matisse (1869-1954): Collections du Musée National d'Art Moderne*, Paris, 1979, no. 9, p. 38.

5. Barr, *Matisse*, 188; Golding, "Matisse and Cubism," 15.

6. Elsen, *Matisse*, 136.

7. Elderfield, *Matisse*, 99.

8. Matisse discussed his approach to portraiture and his relationship to the sitter in the introduction to the folio, *Portraits* (1954). The text is reproduced in Flam, *Matisse on Art*, 150-153.

9. Golding, "Matisse and Cubism," 4, noted this dual tendency in Matisse's art over the period 1907-1917.

30. BACK III (1916)

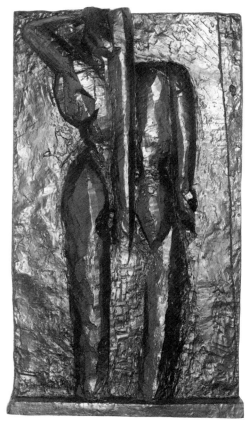

Bronze, *Henri M. HM 0/10, Georges Rudier, Fondeur, Paris*, 74½ x 44 x 6 in.
The Anne Burnett and Charles D. Tandy Foundation.
Colorplate on page 28

This remarkable relief was probably begun in the summer of 1916 during the final stages of work on *Bathers by a River* (Fig. 68).[1] As Matisse had done with *Back II*, he placed *Back III* alongside the painting in the studio at Issy, and worked on both contemporaneously.[2] Indeed, stylistic affinities between the sculpture and the bather on the left in the painting have often been cited. The division of the body into narrow vertical segments, the bold central axis, and the trunk-like legs are obvious points of similarity. In fact, *Back III* is the closest of all the *Backs* to Matisse's contemporary painting and reflects his ongoing interest in Cubism. Although the

relief is no more a Cubist sculpture than *Bathers by a River* is a Cubist painting,[3] it is clear that both works owe a considerable debt to the new movement.[4] Matisse assimilated certain Cubist principles between 1914 and 1916, adapting them in order to fashion his own Cubist morphology related to, but distinct from, the orthodox images of Picasso, Braque, and Gris. The audacious formal reconstruction seen in *Back III* can only be understood within the context of this period of intense reflection and experimentation.

Back III is defined by "a series of broad vertical zones of light and dark tonalities that carry the eye across the surface."[5] This system of organization, possibly inspired by the compositions of Juan Gris,[6] is seen in the wide, flat compositional slabs of *Bathers by a River* and in *Goldfish* (1914).[7] In these paintings, the vertical compartments function to lock the figures or still life elements tightly into the overall composition. In *Back III*, they have become the architectonic essence of the figure itself. The strong vertical axis created by the braid-spine, which at once dominates and demarks the center of *Back III*, recalls Matisse's dictum concerning the importance of the spine in a sculpted figure.[8] However, the boldness with which it is realized here, especially when compared to *Back I* and *Back II*, has more in common with the centralized black verticals in *Goldfish* and *Variation on a Still Life by de Heem* (1915).[9]

The dissection of the figure into vertical zones fractured the form, flattened and spread it across the surface. The impression of volume was diminished, a slimming effect achieved by the elongated proportions and the extension of the head above the top edge of the relief. The weightiness of the figure was also vitiated by the encroachment of the ground into the body at the waist and inner thighs, an interaction which was seen in *Woman on a High Stool* (1914) and in two paintings of 1916, *The Italian Woman* and *Portrait of Greta Prozor*.[10]

The flattening impulse is also signaled by the triangular faceting of the shoulder and by what remains of the once rounded breast. In *Back I* and *Back II*, the sideward thrust of the breast is understandable as a result of its being pressed against the backplane (Nos. 19, 27). The spatial implication, of course, is that the figure is standing in front of a solid wall. In *Back III*, most of the breast's mass has been sliced away, leaving only a flat, semicircular arc, thus removing a major indication of the solidity and proximity of the backplane.

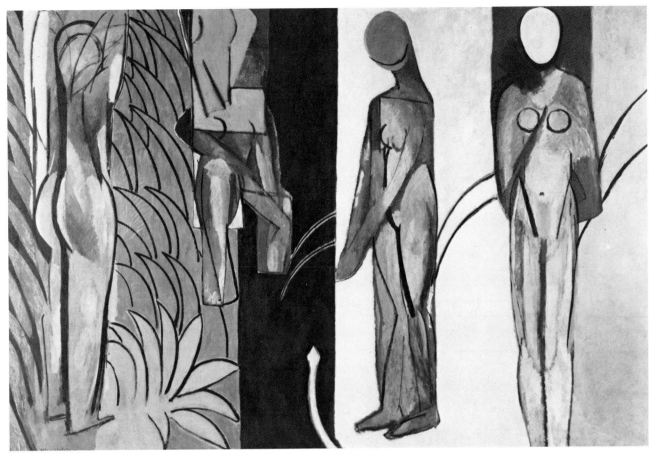

Fig: 68 Matisse, *Bathers by a River*, 1916, The Art Institute of Chicago.

Apart from this change, the removal of the grasping fingers of the left hand at the upper edge of the relief in *Back I* and *Back II*, tends to make the backplane in *Back III* seem "transparent" and to locate the figure in an atmospheric realm. We can almost interpret the figure as gazing far into the distance, with the left wrist on the brow. Matisse may have been reacting against this spatial illusionism in adding the incised diagonal line at the right edge. Elsen suggested that this line might be an aesthetic counterweight to the verticals of the figure or a "'breach' to encourage reworking."[11] However, it seems more likely that it is a device to reassert the materiality of the backplane and so eliminate any sense of illusory spatial depth which might arise from the loss of the grasping hand and the compression of the breast against the background.

In making *Back III*, Matisse began with a plaster cast of *Back II*, working in soft plaster to add mass, carving it away to subtract. The striated grooves, seen most clearly on the left shoulder, the breast, and along the outside of the right leg, resulted from the downward pressure of the knife as it cut away the hard plaster. This textural effect, unique to *Back III*, finds a parallel in the Cubist-inspired paintings, *Goldfish* and *Variations on a Still Life by de Heem*, in which paint has been scraped away in several areas, producing a scored surface. Indeed, the surface of *Back III* bears many more working marks than its predecessors. Matisse gouged, cut, excavated,

scored, planed, and squared the figure, objectifying it, while
reducing the form to its structural and expressive essentials.

Notes

1. Elderfield, *Matisse*, 78. Elderfield discusses the dating of the
painting and *Back III* in detail on p. 195, n. 30.

2. Elderfield, *Matisse*, 195, n. 26.

3. Only two of Matisse's paintings could be considered Cubist even
under the broadest definition of the term, the *Tête blanche et rose*
(1915) and the *Variation on a Still Life by de Heem* (1915); Golding,
''Matisse and Cubism,'' 17.

4. Golding, ''Matisse and Cubism,'' 18.

5. Elderfield, *Matisse*, 78.

6. Lyons, ''Matisse 1914-1917,'' 75.

7. On the importance of the latter painting in Matisse's study of
Cubism, see Golding, ''Matisse and Cubism,'' 16; and Elderfield,
Matisse, 100-102.

8. See No. 27.

9. For the latter, see Elderfield, *Matisse*, 105.

10. Flam, ''Matisse's *Backs*,'' 356.

11. Elsen, *Matisse*, 192.

31. BOWL OF APPLES ON A TABLE (1916)

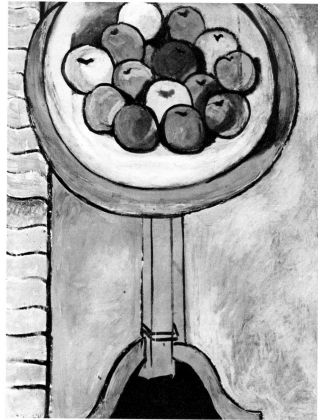

Oil on canvas, *Henri Matisse*, 45¼ x 35¼ in.
The Chrysler Museum, Norfolk.
Colorplate on page 29

During the winter of 1916, Matisse worked in Paris on his
great composition *The Moroccans*. In the spring, he moved to
the studio at Issy and started a new group of paintings.[1]
Writing on June 1 to Hans Purrmann, Matisse reported that
he had completed a large painting of an interior with a table
and flowers, several still lifes, including a study of oranges, and
that he was beginning anew ''a five meter-wide painting
showing bathing women,'' the *Bathers by a River* (Fig. 68).[2]
 The Chrysler Museum's *Bowl of Apples on a Table* must have
been undertaken in the weeks immediately following this
letter to Purrmann; it relates to another still life simply
entitled *Apples* in the Art Institute of Chicago (Fig. 69).[3] Both

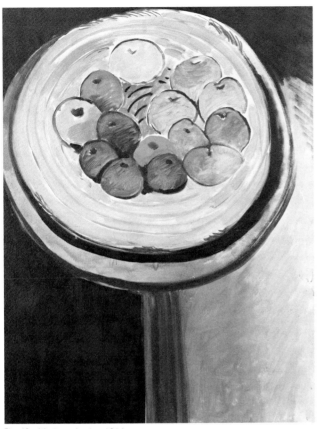

Fig. 69 Matisse, *Apples*, 1916.
The Art Institute of Chicago.

Fig. 70 Matisse, *The Window*, 1916.
The Detroit Institute of Arts.

pictures study the same subject and use the same table seen in another major picture of 1916, *The Window* (Fig. 70), but now in dramatic close-up. The Chrysler picture, severe and formal in its architecture, may post-date *Apples*, which is more freely painted and loosely defined.[4] This tightening of form in successive versions was characteristic of Matisse's development and also parallels stylistically what one can observe in *Bathers by a River* and *Back III*.

The connections with the latter two works are especially illuminating inasmuch as they suggest a broad range of Cubist influence: the linearity and simplified geometry focusing on the round tabletop; the strong vertical axis established by the table pedestal; the flattening of space caused by tipping the tabletop forward, the elimination of the third leg, and the folding out the right side of the pedestal. The resulting "effect of monumental dignity and colossal size,"[5] finds echoes in the rigorous, formal principles that were shaping *Back III* and *Bathers by a River*.

At the same time, Matisse was examining the relationship of circular forms — apples, bowl, tabletop, and curved legs — with the rectilinear elements of the composition, even tempering the strong vertical of the louvered door with gently curving, horizontal lines. This formal interplay addressed issues which Matisse faced as he reworked *The*

Moroccans.[6] The still lifes he produced at this time "showed Matisse a way of using organic forms such as he had been struggling with in *The Moroccans*, in a monumental fashion that was compatible with the rectilinear geometry of his preceding paintings."[7]

Notes

1. Elderfield, *Matisse*, 110-111.

2. As quoted in Barr, *Matisse*, 181.

3. For the literature and exhibition history of the painting, see *Veronese to Franz Kline: Masterworks from the Chrysler Museum at Norfolk* (selected by Denys Sutton, catalogue by Mario Amaya and Eric Zafran), New York, 1978, p. 31, no. 29.

4. The fact that neither painting is mentioned in Matisse's letter to Hans Purrmann among the works which "are the important things in my life" also argues for a later date.

5. Barr, *Matisse*, 189.

6. For a discussion of the history of *The Moroccans*, see Elderfield, *Matisse*, 110-113.

7. *Ibid.*, 112.

32. BOUQUET OF FLOWERS (1917)

Oil on canvas, *Henri Matisse*, 55 x 40½ in., San Diego Museum of Art. Colorplate on page 30

Bouquet of Flowers is one of many paintings of 1916 and 1917 which are difficult to date precisely. The period was one of the most productive and experimental in Matisse's career, bearing witness to great works like *The Moroccans* and *The Piano Lesson* (Fig. 7).[1] But also from this period are paintings more relaxed and realistic in handling, such as *Laurette, turban blanc* and *The Music Lesson*, paintings which indicated a new direction in Matisse's style.[2]

Bouquet of Flowers has been dated to 1916,[3] but a letter of 1917 from Matisse to his friend Camoin indicates that it was painted in that year instead.[4] On the basis of the flowers —

daisies, zinnias, carnations, peonies, and dahlias — it would appear to have been painted at Issy during the summer.[5] At first glance, the painting might seem to have little in common with the still lifes of 1916, such as *Apples* and *Bowl of Apples* (Fig. 69, No. 31). It is informal and vibrant, without any of the severe geometric qualities that characterize those two paintings. Here he simply reveled in painting the loosely arranged flowers. Paint was freely and rapidly applied, imparting the freshness and vivacity of a sketch. The central bouquet is crowned by three long, thin-stemmed carnations which fill the upper third of the canvas and lend a light and airy quality to the composition.

To find a similarly decorative still life on this scale, one would have to look back to *Azure Vase with Flowers*, painted in Tangier in 1913, or to the Pushkin *Goldfish* of 1911 (Fig. 58).[6] Both of these paintings, however, have rich, patterned backgrounds. *Bouquet of Flowers* has a background which is unadorned and fluidly brushed. The gray wall provides a muted backdrop for the bouquet. In this respect, *Bouquet of Flowers* is similar to the still lifes of 1916. It also relates to them in the centralization of the image, the subtle stress placed on the vertical axis through the alignment of the flowers along it, the balancing of stems and blossoms on either side, and the absence of the rear stool leg, which tends to flatten the space. These features, as well as the large scale, were legacies of Matisse's Cubist experimentation, which conditioned his vision and helped to create in this bouquet a composition at once natural and ordered.

Notes

1. Barr, *Matisse*, 189ff.

2. For the former, see No. 33. The significance of *The Music Lesson* and the *Piano Lesson* in Matisse's change of style during this period is discussed by Jack D. Flam, "Matisse in Two Keys," *Art in America*, July/August, 1975, 83-86.

3. Information supplied by Pierre Matisse to the San Diego Museum of Art. For exhibition history and references, see Margaret Fairbanks Marcus, *Catalogue of the Fine Arts Gallery*, San Diego, 1960, 48.

4. "Je viens de faire aussi une toile de fleurs de 80 ainsi que beaucoup d'autres toiles de moindre importance," Danièle Giraudy, "Correspondance Henri Matisse-Charles Camoin," *Revue de l'Art*, 1971, no. 12, 20. The term "de 80" refers to a standard canvas size, Figure Format 80, not a measurement in centimeters. The dimensions of Figure Format 80 are exactly the size of *Bouquet of Flowers*. This is the only painting of this size done in 1916 or 1917 and, therefore, must date to 1917. This information was kindly provided by Jack Flam.

5. I would like to thank Foster Clayton and Erika Esau for identifying the flowers.

6. For these works, see Izerghina, *Matisse*, no. 49, 37.

33. LAURETTE, TURBAN BLANC (1916)

Oil on panel, *Henri Matisse*, 13¾ x 10⁷/₁₆ in., Galerie Rosengart, Lucerne.
Colorplate on page 31

34. THE RED JACKET (1916 or 1917)

Oil on panel, *Henri Matisse*, 18¼ x 14¼ in.
Columbus Museum of Art, Ohio, Gift of Ferdinand Howald.

Laurette was an Italian model who posed for Matisse from 1916 to 1917.[1] She was the subject of numerous pictures, beginning with the severe *The Italian Woman* of early 1916 and culminating with the large *Three Sisters, Triptych* in the Barnes Foundation which was completed the following year.[2] Many paintings of Laurette were done in the intervening period, ranging from reclining nudes and full figure studies to bust-length portraits such as *The Red Jacket*.[3] The frontal pose and the framing of the body by the edges of the straight-backed chair relate this painting to the austere, geometric compositions in which Laurette also appears: *The Studio, Quai St. Michel* (Philips Collection, Washington, D. C.)

and *The Painter in his Studio* (Musée National d'Art Moderne, Paris).[4] In *The Red Jacket*, however, Matisse moved away from the abstracted and generalized treatment of the body seen in the two studio pictures, a trend continued in *Laurette, turban blanc*. This picture, a three-quarter length study of the model seated in a high-backed armchair, was probably painted in Paris during the fall or winter of 1916.[5]

Compared to the rectilinear, vertical, and flattened forms of *Back III* and *Bathers by a River*, which were completed that fall, *Laurette, turban blanc* is remarkable for its informality and the realistic treatment of form and volume. The sinuous movement of the body, the outward thrust of the hip, and

the crosslegged pose are reminiscent of the bronze *Decorative Figure* of 1908 (No. 16). The arabesque-like form holds the full, sensuous volumes in balance, as seen in the bronze. Laurette's languid pose, however, lacks the internal tensions of the sculpture.

The relaxation of the taut geometry of the canvases of 1916 has achieved a softer, more decorative style. The flat, austere surfaces of the earlier paintings have yielded to a richer application of paint which models the form in broad, curving strokes. The surface is sensuous, with a luminous harmony in the restricted palette of whites, blacks, flesh and rose tones. A hint of a new direction is given by the white turban, an exotic element prescient of the odalisque themes that would occupy Matisse for the next ten years.

Notes

1. Elderfield, *Matisse*, 108.

2. For the redating of *The Italian Woman* to early 1916, see Elderfield, *Matisse*, 108.

3. Barr, *Matisse*, 227, 410, 412-417. For provenance, exhibition history, and bibliography on *The Red Jacket*, see *Catalogue of the Collection* (Columbus Museum of Art, Columbus, Ohio), Columbus, 1978, 81-82.

4. Both of these were begun in 1916; see Monod-Fontaine, *Matisse*, 45, no. 11.

5. Laurette is shown seated in the same chair in the left panel of the *Three Sisters, Triptych*. This panel was probably painted in Paris in the autumn of 1916; see Barr, *Matisse*, 193, n. 6, 416.

35. SEATED NUDE, BACK TURNED (1918)

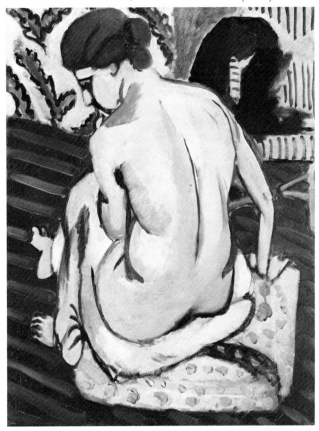

Oil on canvas, *Henri Matisse*, 24½ x 18½ in.
Philadelphia Museum of Art
The Samuel S. White, III, and Vera White Collection.
Colorplate on page 32

In this painting, Matisse returned to the motif of the back — now, however, in a way far removed from the strenuous formality and geometry of *Back III* (No. 30).[1] The model is located in a clearly defined foreground space, her body realistically rendered, carefully modeled, and shaded in tones of gray to emphasize its volume. The paint is richly applied and contributes to the image's substantiality and relief, as does the bounding of the body by strong, dark contour lines. The naturalistic, tightly drawn forms evoke the firm handling of *La Coiffure* (1901) and *Back O* (1909), works that were concerned with the body's inherent solidity (Figs. 23, 49).

The reintegration of form and the more realistic treatment of the figure reflect Matisse's move away from the experimental works of 1914-1917. The relaxation of style and resurgence of the decorative impulse were part of a general tendency in Matisse'e art beginning about 1917.[2] Other evidence of this trend is apparent in *Seated Nude, Back Turned*. Matisse abandoned strict frontality by placing the model on line with the receding diagonal of the floor boards. The pitch of the floor itself deepens the space and avoids the emphatic horizontal thrust that would have resulted from its alignment with the picture plane. This was a departure from the flattened, abstract spaces of the earlier works. Matisse also used the flooring as part of the overall decorative patterning of the surface, which is further embellished by the vertical stripes of the yellow chair, the spotted cushion, and the blue and white fabric with the branching motif. This material is the *toile de Jouy* textile which Matisse used ten years earlier as the organizing motif for the stylized and flattened *Harmony in Red*.[3] Its reappearance signaled the return of the decorative arabesque, albeit modestly, in the small section of canvas behind the model's head. The following year, the fabric's curving branch forms would dominate the backgrounds of several other paintings.[4]

Notes

1. For this painting, see Paris 1970, no. 154.

2. Barr, *Matisse*, 195ff. See also, Flam, "Matisse in Two Keys."

3. Barr, *Matisse*, 124, 345.

4. See No. 38.

36. RECLINING NUDE WITH BOLSTER (1918)

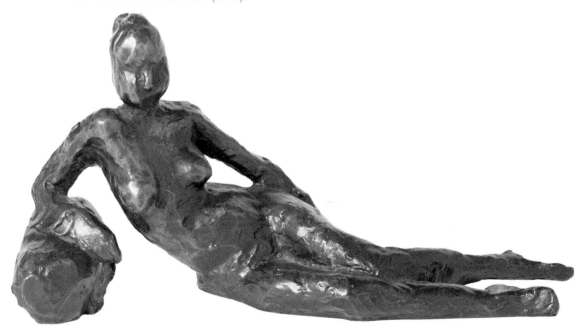

Bronze, *Henri Matisse 3/10*, Height: 5½ in., The Rosenbach Museum and Library, Philadelphia.

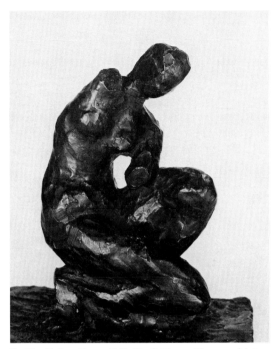

Fig. 71 Matisse, *Venus*, 1918. The Baltimore Museum of Art.

In December 1916, Matisse left Paris for the French Riviera, a migration that he repeated almost every winter for thirty years.[1] The trip initiated a change in style (the so-called Nice Period), which lasted until 1929.[2] *Reclining Nude with Bolster* and *Venus* (Fig. 71), both of 1918, are among the works that express the move away from the austere, ascetic style of the experimental period.[3]

Exactly when in 1918 the bronzes were modeled is unclear. Matisse was in Nice during the winter of 1917-18 and returned again in November 1918. While there, he developed a work routine which included drawing and modeling from plaster casts of ancient and Renaissance sculpture at the École des Arts Decoratifs, a practice he apparently did not engage in during the previous years.[4] He may have worked from a plaster cast of the antique crouching Venus type in Nice, or from the marble *Crouching Venus* in the Louvre.[5] It has been suggested that the figure in *Reclining Nude with Bolster* leans on a bolster from Matisse's hotel room, which would support the idea that the sculpture was executed in Nice.[6]

Matisse's return to the study of ancient and Renaissance sculpture is significant in itself and is indicative of a general revival of interest in the Old Masters. Picasso had developed, from 1915, a graphic style that was strongly influenced by Ingres, a style epitomized in the masterful, multifigured drawing of nudes on the beach done at Biarritz during the summer of 1918.[7] Matisse was no less open to the influence of Ingres. Some years earlier, when Ingres' *Grand Odalisque* and Manet's *Olympia* hung side by side in the Louvre, he had preferred the former because, according to Jean Puy, "the sensual and willfully determined line of Ingres seemed to him to conform more to the needs of painting."[8] Indeed, the relaxed pose, smoothly flowing contours, thinned proportions, languid limbs, and easy air of *Reclining Nude with Bolster* seem indebted to this appreciation of Ingres' indolent *Grand Odalisque* (Figs. 72, 73).

The *Venus*, essentially a bathing theme, has a subdued, classical feeling. That Matisse chose the crouching Venus as a model suggests his interest in its compressed pose and the play of volumes. Unlike his crouching figures of 1908, however, which are condensed in form and three dimensional in their many aspects,[9] *Venus* has basically a flat pose. It is almost relief-like in its presentation of the figure from one major viewpoint, and in this respect it also resembles the viewpoint for this ancient crouching Venus type.[10] In a way, *Venus* mediates between the flatness of his abstract style and the more volumetric figures of the 1920's.

Notes

1. Barr, *Matisse*, 195.

2. *Ibid.*, 195ff, 203ff.

3. A third sculpture dates from 1918, a *Seated Venus*, for which see, Elsen, *Matisse*, 138-141.

4. *Ibid.*, 195.

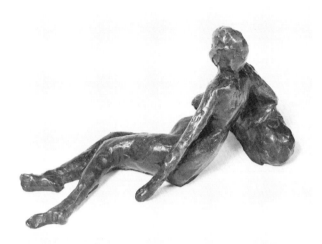

Fig. 72 Matisse, *Reclining Nude with Bolster*, back view.

5. Elsen, *Matisse*, 138.

6. *Ibid.*, 144.

7. Roland Penrose, *Picasso: His Life and Work*, London, 1958, 191-193; 208-9. The drawing is in the collection of the Fogg Art Museum and is reproduced in William Rubin (ed.), *Pablo Picasso, A Retrospective*, New York, 1980, 205.

8. As quoted in Barr, *Matisse*, 191.

9. See Legg, *Matisse*, 28, for illustrations.

10. The statuette is based on the *Prado Venus* type, a type which has one major side, see Selma Holo, ''A Note on the Afterlife of the *Crouching Aphrodite* in the Renaissance,'' *The J. Paul Getty Museum Journal*, VI-VII, 1978-1979, 28.

Fig. 73 J.-A.-D. Ingres, *Grand Odalisque*, 1814. Louvre, Paris.

37. PLASTER TORSO AND BOUQUET (1919)

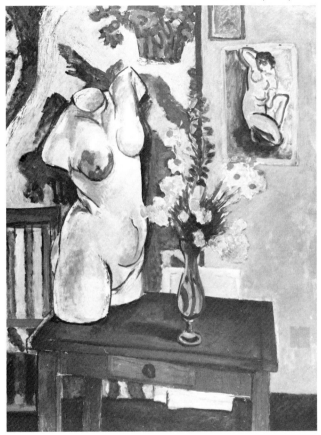

Oil on canvas, *Henri Matisse*, 44½ x 34½ in.
Museu de Arte de São Paulo, Brazil.
Color reproduction on cover

Plaster Torso and Bouquet was painted at Issy probably during the summer of 1919. It is one of several interior still lifes done at this time, including *The Chair with Peaches* and *Bouquet for the 14th of July*.[1] These are related by the use of the blue and white pattern of the *toile de Jouy* fabric in the background, signaling Matisse's return to the decorative as a major feature in his compositions.[2] In *Plaster Torso and Bouquet*, Matisse placed on the table a large, limbless and headless torso and a vase of flowers. On the plain blue wall, hangs a sketch of a model in the pose of the ancient crouching Venus.[3]

This still life, with its unusual juxtaposition of torso and bouquet, presents a rich series of complementary contrasts: the natural, three dimensional forms on the table are opposed to their two dimensional counterparts on the wall. The flat, patterned fabric provides a foil to the full volumes of the torso but also echoes its sinuous rhythms.[4] Similarly, the curving forms of abdomen and buttocks repeat the vase's elegant, undulating contour.

Matisse was introducing elements into his art which had been largely excluded from the 1913-1917 works. These included: the flattening effect of decorative pattern in illusionistic space; the realistically modeled body whose volumetric quality is very strong; the linear arabesque in figure and fabric. All four of the main compositional elements of the still life are, in a way, emblems of artistic principles which concerned Matisse: the *toile de Jouy* textile, the decorative arabesque; the torso, volume infused with linear grace; the bouquet, the color and variety of the natural world; the crouching Venus, the order and repose of antique art. All four of these elements are linked together visually by the flowers, which overlap each one of them, creating a rich series of formal relationships.

In *Plaster Torso and Bouquet* Matisse was rediscovering the sensuous aspects of painting which had been largely purged during the austere experimental period. In an interview granted in June of 1919, Matisse spoke of "finding a new synthesis." He realized that in his experimental paintings, he had sacrificed "substance, spatial depth, and richness of detail. Now I want to reunite all that, and think I am capable of it in the course of time."[5]

Notes

1. For illustrations of the *Bouquet for the 14th of July* and *The Chair with Peaches*, see Barr, *Matisse*, 431; and John Elderfield, *European Master Paintings from Swiss Collections—Post-Impressionism to World War II* (Museum of Modern Art, 1976), New York, 1976, 74; and Zurich, 1982, no. 60.

2. In *Bouquet for the 14th of July*, the fabric covers all but about one-fifth of the background, while in *The Chair with Peaches* it fills the entire rear plane of the wall.

3. For the crouching Venus, see No. 36.

4. The plaster torso is neither a cast after a classical statue nor a modern work but rather a cast made from life which Matisse probably purchased about this time. This information was generously provided by Pierre Matisse.

5. Interview with Ragnar Hoppe, "Pä visit has Matisse," in Fourcade, "Autre Propos de Matisse," *Macula I*, Paris, 1976, 94; and as quoted by Elderfield, *Matisse*, 212.

38. NUDE WITH GREEN SHAWL (1921-22)

Oil on canvas, *H. Matisse*, 34⅞ x 45¾ in., Kimbell Art Museum, Fort Worth.

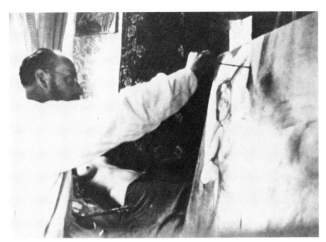

Fig. 74 Photograph of Matisse and the model in his Nice studio while working on *Nude with Green Shawl*, 1921-1922.

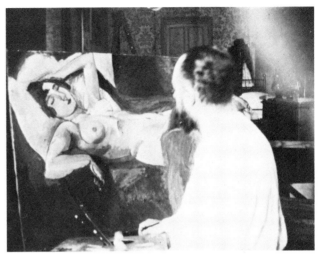

Fig. 75 Photograph of Matisse in his Nice studio working on *Nude with Green Shawl*, 1921-1922.

Nude with Green Shawl was painted in Matisse's Nice studio during the period 1921-1922.[1] The model is seen three-quarter length, reclining on red drapery and a blue-gray pillow decorated with a line and dot pattern. A light green shawl is draped over her thighs. The red fabric backdrop is embellished with a sketchy flower motif, and a portion of a yellow and white background fabric is visible just above the model's left elbow.

The painting's grandeur derives from the placement of the figure so close to the foreground plane that it almost fills the entire canvas. The figure itself is richly painted, its substantiality conveyed by the dense application of paint. The body — full, soft, and rounded — faithfully expresses the voluptuous forms of the model, who is visible in the background of a photograph taken while Matisse was at work on the painting (Fig. 74).

This photograph is notable not solely because of the presence of the model. On the wall, above the artist's head, is what appears to be a small oil painting of a woman in an identical pose, indicating that the artist had studied the composition earlier. Although this small painting is blurred in the photograph, the full, rounded forms of the reclining nude — especially the abdomen — seem to be a faithful representation of the model. The fact that Matisse hung the

painting above the reclining girl so that both were within his field of vision as he worked on the larger version at his easel suggests that the small painting acted as a control, a reminder of his initial reaction to the model in this pose.

Matisse may have been dissatisfied with the first version's realism. This possibility is suggested by a previously unpublished photograph, probably taken at the same time as Figure 74, in which the figure in the painting is clearly visible (Fig. 75). The photograph reveals a figure style both linear and angular. The lower edge of the rib cage is sharply defined by shaded planes leading to a flattened abdomen. The left arm is formed by straight, parallel lines which rise almost vertically to the upper edge of the canvas. This geometric quality is even expressed by the triangular lock of hair on the forehead.

Matisse was consciously working away from the realism of the first, small version. That he did so before the model is especially interesting. He had frequently made two versions of the same theme: the first realistic and analytic, the second independent of the model, more abstract and synthetic.[2] The presence of the model here, however, seems to have had a decisive impact, for Matisse eventually reworked the body, painting over the angular forms of the abdomen, fleshing out and elongating the arms and torso, and

smoothing the interior forms and contours with sweeping brushstrokes. The numerous pentimenti bear witness to his extensive revisions. As we have seen, the final result is quite close to the model's full, sensual forms seen in Figure 74.

This dualism of linear abstraction and voluptuous realism occured repeatedly in the paintings and sculptures of the Nice period. In the case of this painting, an early stage in the evolution of Matisse's thought has been preserved only in a photograph, a document that shows us how complex was his creative process. That dual impulse later found simultaneous expression in the sculpture *Reclining Nude II* (No. 44).

Notes

1. This information is based on family records. The exact nature of those records is unknown, however. See *Kimbell Art Museum, Catalogue of the Collection*, Fort Worth, 1972, 220, n. 1. See the same source for exhibition history and references.

2. Compare, for example, *Madeleine I* and *Madeleine II* (Nos. 3,4); *Young Sailor, I* and *Young Sailor, II* (1907), Barr, *Matisse*, 334-335; or *Henriette II* and *Henriette III* (Nos. 42, 43).

39. LARGE SEATED NUDE (1923-25)

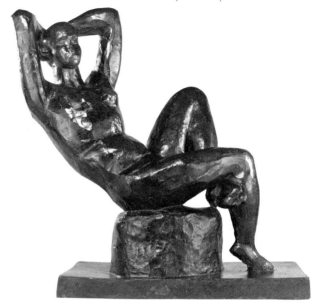

Bronze, *HM 9/10*, Height: 33 in.
Collection Mr. and Mrs. Raymond D. Nasher, Dallas.
Colorplate on page 33

Large Seated Nude was the first sculpture Matisse had undertaken since completing the three small bronzes of 1918.[1] He had used the pose in a number of earlier paintings, lithographs, and drawings — perhaps nowhere more nearly the same as in *Nude with Blue Cushion* (1924, Fig. 76), painted at about the same time.[2] Although the poses are alike, the effect is totally different. In the painting, the model reclines comfortably in an armchair, while in the sculpture she is cantilevered into space, unsupported by anything but her own abdominal muscles. Matisse even accentuated the outward thrust of the body by elongating the torso and increasing the angle of inclination.

Like many of Matisse's sculptures, this bronze went through several phases before it was completed. Photographs taken while work was in progress indicate at least two previous stages.[3] They show the figure growing in size from a rather diminutive plaster to the grand scale of the bronze. They also show Matisse moving from the smooth, rounded forms of the first version to a tighter, more articulated anatomy in the

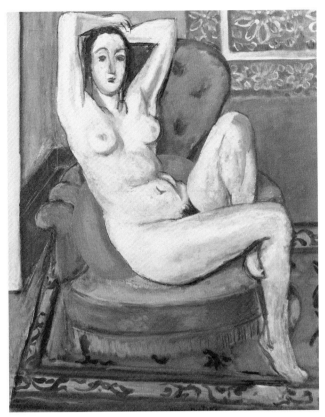

Fig. 76 Matisse, *Nude with Blue Cushion*, 1924.
Collection Mrs. Sidney F. Brody, Los Angeles.

Fig. 77 Michelangelo, *Ignudo*, 1511. Sistine Chapel, Rome.

second, particularly around the abdomen.[4] In the final version, Matisse abstracted the figure, planing and paring it with the knife, working away from rounded, flowing forms toward a broadly faceted surface with strong planar accents. The knife was used liberally on the back, hips and right thigh, and on the inner surface of the right arm where the artist sliced away the clay to create a long, vertical plane. He pared away the soft flesh of the stomach area, segmenting the abdomen and accentuating the abdominal crease seen in *Nude with Blue Cushion*. Taut planes now define the abdominal muscles which hold the body up and express the innate internal stress of the pose, a stress, though, which is curiously disguised by the informal quality of the pose.

The roots of *Large Seated Nude* have been traced to Matisse's study of Michelangelo's *Night* from the tomb of

Giuliano de'Medici in the Medici Chapel, S. Lorenzo, Florence.[5] In 1918, Matisse drew and modeled from a plaster cast of *Night* at the École des Arts Decoratifs in Nice, as well as from a plaster of Michelangelo's statue of *Lorenzo de'Medici*. He wrote in a letter of that year, ''I hope to understand the clear and complex structure of Michelangelo.''[6] This interest in ancient and Renaissance masters, as we have seen, was part of a larger, classicizing trend which affected many artists.[7]

It has been suggested that ''the modeled form based on Michelangelo's tomb figure [*Night*] may have been the first plaster version of the *Large Seated Nude*.''[8] It seems unlikely, however, that Michelangelo's *Night* played such a direct role in the formation of Matisse's bronze, for the poses are quite different. Even the poses of the reclining nudes in Matisse's

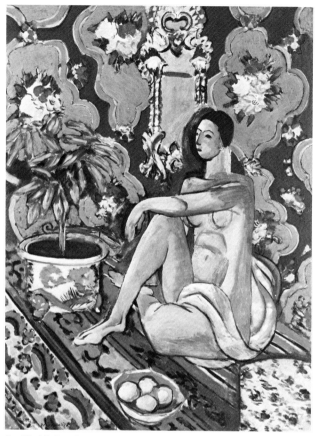

Fig. 78 Matisse, *Decorative Figure on an Ornamental Background*, 1925-1926. Musée National d'Art Moderne, Paris.

interest in Michelangelo suggests that he studied more of the master's work than the statues in the Medici Chapel.

Monumentality and gravity were reintroduced into Matisse's art in *Large Seated Nude*. These qualities would gradually reinfuse his paintings of the following years, most immediately in the remarkable *Decorative Figure on a Ornamental Background* (1925-26, Fig. 78).[10]

Notes

1. It has been variously dated as follows: 1922-25, Zurich 1959, no. 54; 1923-25, Paris 1975, no. 216; 1924 or 1925, Elsen, *Matisse*, 144; 1925, Barr, *Matisse*, 213.

2. Those related examples are listed in Elderfield, *Matisse*, 215, n. 2.

3. Elsen, *Matisse*, figs. 196-198; see also Monod-Fontaine, *Matisse*, no. 17, figs. b, d, for photographs of what may be an enlarged state of the first version.

4. Matisse stressed the pose's inherent muscular tension in the second state by schematizing the abdominal muscles. He also acknowledged the impossibility of holding the pose with the muscles of the abdomen alone by the device of the large foot, firmly rooted to the ground, which serves as an anchor. In the bronze, Matisse abandoned this massive foot, eliminating the toes, slimming the proportions, and touching the ball of the foot lightly to the ground.

5. Elsen, *Matisse*, 144 ff.

6. As quoted in Elsen, *Matisse*, 146.

7. See No. 36.

8. Elsen, *Matisse*, 146.

9. The lithograph *Day* is reproduced by Legg, *Matisse*, 35. For *Night*, see Elsen, *Matisse*, fig. 195.

10. Monod-Fontaine, *Matisse*, no. 17.

1922 and 1924 lithographs *Day* and *Night*, which are direct postural prototypes for the bronze, bear no clear relation to Michelangelo's sculpture.[9] The influence of Michelangelo is, nonetheless, evident. A much closer source for the pose of *Large Seated Nude* is found in one of the ignudi on the Sistine Ceiling (Fig. 77). The pose of the lower body, although reversed, is exactly the same, and the figure is similarly perched on a small support. But beyond a postural prototype, Matisse found in this ignudo a sense of physical power, scale, and grandeur — an heroic quality — which had been missing in his work of the 1920's. It is not inconceivable that a reproduction of this ignudo served as a source of inspiration for *Large Seated Nude*. Indeed, Matisse's avowed

40. ODALISQUE COUCHÉE, (1925)

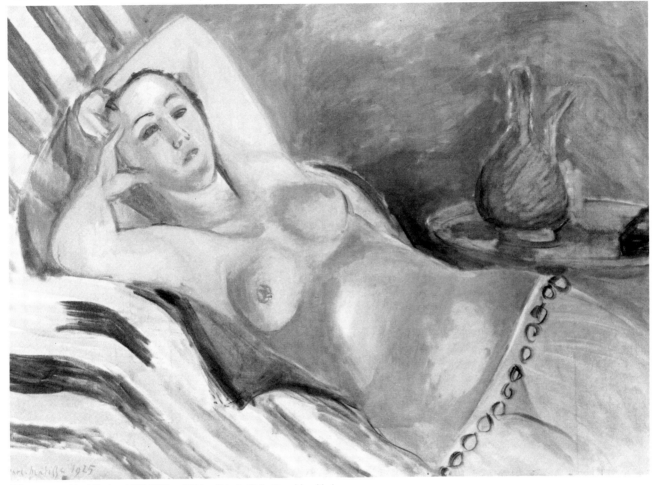

Oil on canvas, *Henri Matisse 1925*, 31⅞ x 45⅝ in., Private Collection, New York.

The odalisque was regularly the subject of Matisse's art during the Nice period, a figure type evoking the indolent sensuality of the luxurious, exotic world of the houri. When asked why he painted odalisques, Matisse replied:

> I do odalisques in order to do nudes. But how does one do the nude without it being artificial? And then because I know that they exist. I was in Morocco. I have seen them. Rembrandt did Biblical subjects with real Turkish materials from the Bazaar, and his emotion was there. Tissot did the life of Christ with all the documents possible, and even went to Jerusalem. But his work is false and has no life of its own.[1]

Matisse's Nice paintings do have a life of their own, one which conveys a relaxed aura of pleasure and a languid, dreamlike state of perpetual reverie. The Nice period paintings, far from being an aberration or a moment when his art suddenly went slack, are consistent with his avowed desire to create a

soothing art which would be a refuge from the normal stresses of life.[2]

Odalisque Couchée was painted in 1925, the same year that *Large Seated Nude* was completed.[3] It develops the three-quarter length reclining pose with arms raised which is seen in a number of paintings of these years. The model wears a tulle skirt slung low on her hips and lies on a green and yellow striped coverlet with a red, gray, and purple pillow. The unadorned background allows the viewer's attention to be focused on the model's torso, which nestles into the divan; the yellow and green stripes repeat the sinuous contours of her body. The waterpipe echoes the ample shapes of the breasts and thighs. The forms of the body are freely brushed and fully rendered. Matisse's simplification of the shape of the head to an oval and the linear rendering of the left forearm offer hints of the more structured *Decorative Figure on an Ornamental Background* of 1925-26. However, the overall effect is both supple and sensuous. Paint is applied freely and thinly, giving the picture the vibrant quality of a sketch.

Notes

1. ''Statement to Tériade, 1929,'' as quoted by Flam, *Matisse on Art*, 59.

2. See Introduction, p. 17.

3. The painting belonged to Marguerite Duthuit before entering the collection of its current owner. It was exhibited previously in Strasbourg, May-September 1970, *L'Art en Europe autour de 1925*, no. 129 and, in Tokyo, Mitsukoshi, 1982, *The Minotaure*, no. 72.

41. HENRIETTE I (1925)

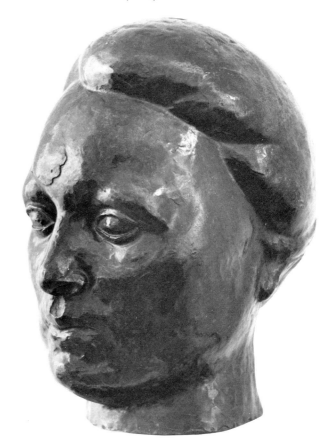

Bronze, *HM 2/10*, Height: 11½ in.
Collection Stephan Hahn, New York.

Between 1925 and 1929, Matisse produced three portrait heads of Henriette Darricarrère, a model who posed for many of his paintings and drawings during the 1920's.[1] *Henriette I* was his first sculptural portrait since the *Head of Marguerite*, completed ten years earlier. It is a sensitive, realistic portrait carefully studying the sitter's gentle features. Its evenly textured surface is marked only by a lump of clay on the forehead, which according to Matisse's family, was a ''pastille'' or ''breach'' through which he addressed the work anew at each session.[2]

Henriette II represents a considerable revision of the form.

42. HENRIETTE II (1927)

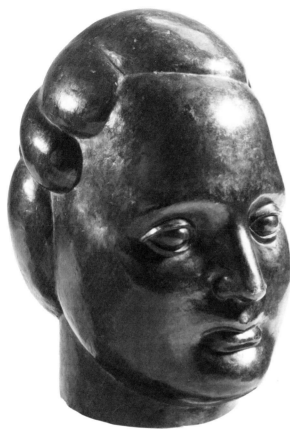

Bronze, *HM 6/10*, Height: 12½in.
San Francisco Museum of Modern Art, Bequest of Harriet Lane Levy.

43. HENRIETTE III (1929)

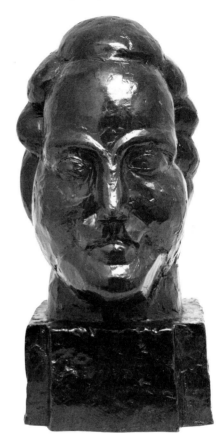

Bronze, *HM 4/10*, Height: 15¾ in.
Collection Mr. and Mrs. I. C. Deal, Dallas.

Its greater mass and bulk give the bronze a monumental, classic quality.[3] The placid features, grave and dignified, are enhanced by the impressive scale and volume. The surface is taut, seemingly stretched smooth by a pneumatic pressure from within. Sleak and slick with no trace of modeling, *Henriette II* is one of Matisse's most sculptural heads in a traditional sense,[4] manifesting the artist's delight in the perfection of the forms and the relationship of shapes and volumes. The carefully defined features are arranged symmetrically,[5] and the stylized, undulating ''curls'' echo the volume and swelling contour of the cheeks. The coiffure itself

— a series of full, bulbous forms — wraps around the head like an abstract helmet. The round head, the pear-shaped face, and the oval eyes are pure forms which express themselves independently of their representational function. When *Henriette II* is viewed from the sides, the contours of the head may be connected to form a near perfect circle (Fig. 79). The reduction of the cranium to a simple shape recalls Matisse's advice on the study of the model: ''Don't hesitate to make the head round and let it outline itself against the background. It is round as a ball and black.''[6] *Decorative Figure on an Ornamental Background* (1925-1926) provides an

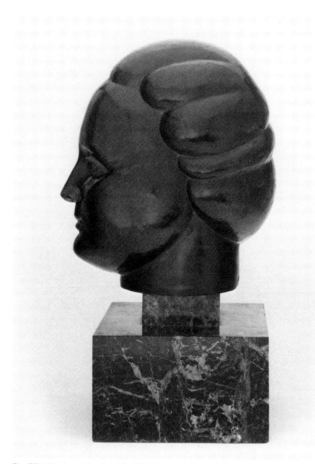

Fig. 79 Matisse, *Henriette II*, side view.

The surface has also been roughened, textured, and made more expressive, a stylistic progression similar to that from *Back O* to *Backs I* and *II*. The changes were not made as a result of Matisse's direct reaction to the model, who had left in 1927, but rather reflect a reorientation of his own sensibilities. He sought to invigorate the work sculpturally, a process indifferent to the sitter's personality. The large square base which Matisse added to *Henriette III* presents the head in a form reminiscent of medieval head reliquaries and stresses its "objectness." Indeed, somewhat removed from the realm of portraiture, the object takes on an independent status as a kind of contemporary reliquary of modern art, enshrining in its very form the autonomous sensibilities of the artist.

Notes

1. Paris 1975, no. 218. Henriette worked with Matisse between 1920 and 1927.

2. Elsen, *Matisse*, 161.

3. Barr, *Matisse*, 217.

4. Tucker, *Language of Sculpture*, 98.

5. Monod-Fontaine, *Matisse*, no. 56.

6. "Sarah Stein's Notes, 1908," as quoted by Flam, *Matisse on Art*, 43. These comments were made in relation to a Negro model.

additional illustration of this dictum in the model's oval head, a pure form sitting atop a pedestal of a neck (Fig. 78). One connection between Matisse's painting and sculpture at this juncture is found, therefore, in the impulse toward geometric purity which guided him in the realization of both heads.

Henriette III was based on a plaster cast of *Henriette II*. The cool formality of the earlier bust was radically altered. Matisse took the natural lines of the face as a starting point for reshaping the head. He emphasized those lines around the mouth, nose, and eyes — excavating, planing, and faceting the chin with bold slicing cuts. Eyebrows were raised and joined to the bridge of the nose in outward-arcing ridges, and the eyes filled in and incised with the point of the knife.

44. RECLINING NUDE II (1927)

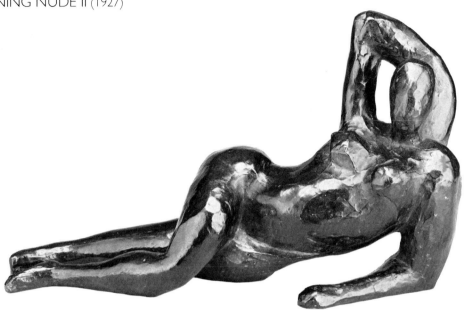

Bronze, 8, Height: 11¼ in., The Minneapolis Institute of Arts, Gift of The Dayton Hudson Corporation.

45. RECLINING NUDE III (1929)

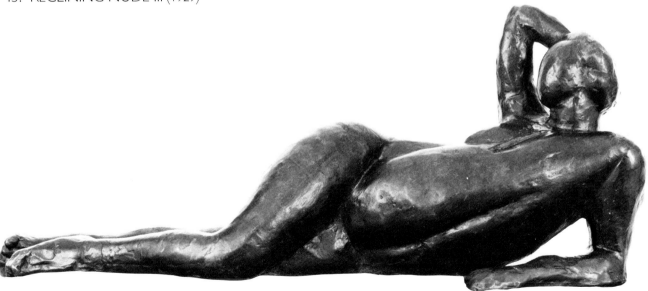

Bronze, HM 6/10, Height: 7¼ in., Collection Mr. and Mrs. I. C. Deal, Dallas.

Matisse's renewed sculptural activity in the last half of the 1920's was associated with his struggle to reformulate his style. The effort was begun with *Large Seated Nude* (No. 39) and continued in *Decorative Figure on an Ornamental Background* (Fig. 78), in which the contrasting impulses of arabesque pattern and rectilinear figure style are startlingly apparent.[1] Matisse's oscillation in these years between the voluptuous and the tectonic is also evident in *Reclining Nude II*, a reprise of the 1907 *Reclining Nude I* (No. 11).[2]

The exotic, recumbent nude, whose pliant forms exude an erotic somnolence redolent of forbidden pleasures, was a staple subject of the 1920's. In returning to *Reclining Nude I* as a postural prototype, Matisse found all the voluptuous possibilities of his contemporary odalisques, plus the expressive qualities inherent in *Reclining Nude I*'s powerful physical distortions. Undoubtedly, the most surprising feature of this bronze — one not apparent in the front and back views usually reproduced — is the tremendous barrel chest (Fig. 80). The massive build of the upper body is all the more striking in contrast to the thin right leg. The head itself — though oval when viewed from the front — is a solid slab which tapers to merge with hand, forearm, and neck in one unified form. The weight of the body is paramount, a fact which Matisse stressed by enlarging the left arm in order to carry the great mass of the chest. Yet, when viewed from the front, *Reclining Nude II*, tempered as it is by the relaxed mood of the Nice period, is not quite so exaggerated or dramatic as the 1907 *Reclining Nude I*.

Matisse was aiming to strike a balance between the sensual and the structural. The languid lines of *Reclining Nude II* are hardly distorted by the faceted breast. On the back, however, Matisse's experimental urges prevailed (Fig. 81). He pared the upper portion of the left buttock and thigh and cut a wedge into the back — an incision that continues the horizontal thrust of the extended leg, but in a manner totally independent of the back's anatomy. The back and side of the right arm also were trued with the knife. This front/back contrast is one of curve and volume versus line and plane, an opposition seen earlier in *Decorative Figure on an Ornamental Background*, but which is here resumed within the figure itself. None of Matisse's painted odalisques was as audacious as this sculpture.

In *Reclining Nude III*, that conflict was resolved in favor of the sensuous curve. This bronze is lower, sleeker, and

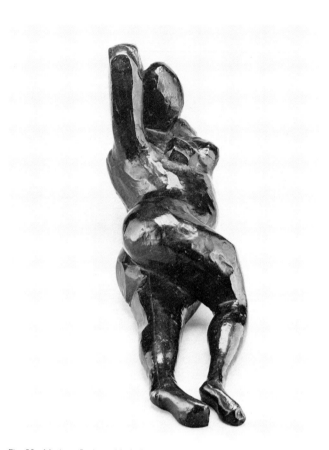

Fig. 80 Matisse, *Reclining Nude II*, view from the feet.

altogether more streamlined than its predecessor, whose raised hip has here been smoothed and whose mesa-like breast absorbed into the chest. The incised parallel lines on the torso are modest compared to the broad, bold cuts into the back of *Reclining Nude II*. They contain the swollen form of the distended abdomen and enhance the downward rhythm of the forms from head to toe. However, the suppression of the architectonic is nowhere clearer than from the rear view. A thin spinal depression curving gently up the

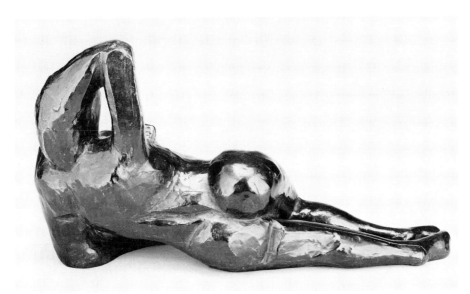

Fig. 81 Matisse, *Reclining Nude II*, back view.

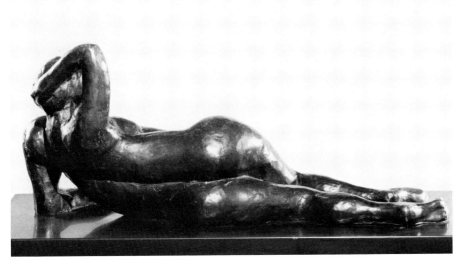

Fig. 82 Matisse, *Reclining Nude III*, back view.

center of the back (Fig. 82), replaces the bold slicings and abstract wedge cuts into the back of *Reclining Nude II*. Matisse paid little heed to the severe tone of his previous Nice sculptures, opting instead for the supine elegance and sensuality of the 1928 odalisques.

Notes

1. See No. 39.

2. Barr, *Matisse*, 217-218; Elsen, *Matisse*, 157.

46. SMALL TORSO (1929)

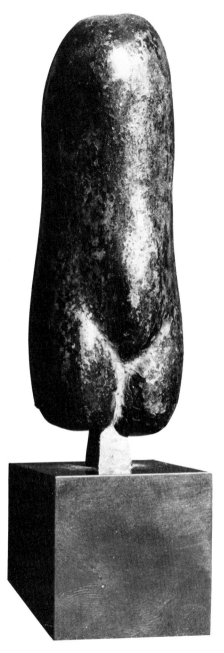

Bronze, *HM 4*, Height: 4 in.
Marion Koogler McNay Art Institute, San Antonio.

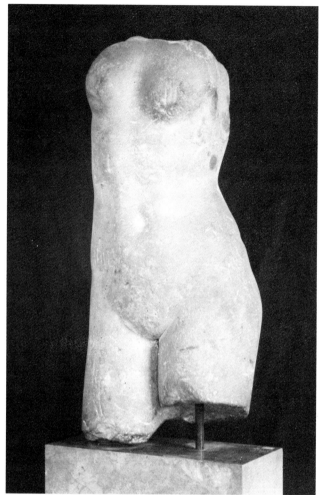

Fig. 83 Roman copy of a Greek torso owned by Matisse.
Musée Matisse, Nice-Cimiez.

The movement toward a simple, reductive figural volume, such as that seen in *Reclining Nude III,* was continued in another sculpture of 1929, *Small Torso*. This tiny bronze and a companion piece, *Small Thin Torso*, were developed from a marble Roman copy of a Greek torso some 24 inches high which Matisse owned (Fig. 83).[1]

Matisse's turn to an ancient sculpture for inspiration as he was working toward a new formal purity is not surprising. Some twenty years before he had expressed to his students

the importance of antique sculpture in realizing the fullness of form. "I see this torso [Greek or Roman] as a single form first," Matisse said in 1908. "Without this, none of your divisions, however characteristic, count."[2] The formal purity achieved in *Small Torso* was anticipated by *Small Thin Torso*, which follows the fragmented form of the Roman copy fairly closely in its inclusion of breasts and thighs. In *Small Torso*, on the other hand, Matisse reduced and simplified the form even more, creating what has been called "the most daring contraction of the body in Matisse's art."[3] The breasts were eliminated, and the diminutive torso was tapered and rounded, subsuming the form of the female body in that of a phallus. Its miniature size demands that the piece be held in the hand to enjoy fully the sensuous form and volume. That Matisse chose to sculpt this torso on such a small scale is in itself significant, for its speaks, literally and figuratively, of what he called "that state of condensation of sensations"[4] which he tried to reach in an earlier period of crisis in his art.

Notes

1. Elsen, *Matisse*, 159.

2. "Sarah Stein's Notes, 1908," as quoted by Flam, *Matisse on Art*, 42.

3. Elsen, *Matisse*, 160.

4. *"Notes of a Painter, 1908,"* as quoted by Flam, *Matisse on Art*, 36.

47. GRAY NUDE, LOULOU (1929)

Oil on canvas, *Henri Matisse 29*, 40 × 33½ in.
E. V. Thaw and Co., Inc., New York.

Gray Nude was one of only a few paintings which Matisse produced in 1929.[1] In general, these works were larger and simpler in format than his earlier Nice paintings. As Barr noted, *Gray Nude*, "a fluently drawn figure posed diagonally against a simple background of seagreen tiles, seems as remote as it can be from the busy, brilliant odalisques of the previous year."[2] The increase in size and the move from the odalisque to the studio nude as the subject reflect Matisse's efforts to reformulate his style and distinguish *Gray Nude* as a special effort.

The change is perhaps most evident when this painting is compared to an odalisque of 1928, now in the Barnes Foundation Collection, which depicts a model in the same setting (Fig. 84). The figure is richly painted in tones of gray,

Fig. 84 Matisse, *Odalisque*, 1928.
©The Barnes Foundation, Merion, Pennsylvania.

pink, and blue, but the squat proportions, the thick impasto, and schematic face give the body a heavy quality.

By 1929, Matisse was again seeking the monumentality he had explored earlier in *Large Seated Nude*. In an interview granted while he was painting *Gray Nude*, Matisse remarked: "I want today a certain formal perfection and I work by concentrating my ability on giving my painting that truth which is perhaps exterior but which at a given moment is necessary if an object is to be well carried out and well realized."[3]

Matisse was again striving to simplify his art as he searched for "a certain formal perfection." He achieved this end in *Gray Nude* in several ways. He eliminated the heavy impasto of the 1928 *Odalisque* in favor of a thinly brushed, freely painted surface. Matisse was reacting directly to the sensuous forms of the model. He focused on the supple, elegant body poised casually on the edge of the bed. He continually adjusted the position of the limbs, particularly the left leg, while stressing the volume of the body through the subtle modulations of the flesh tones. The model's head, resting on the shoulder, and her sweet expression create an air of informality and tenderness which is immediately appealing.

The tile background is an innovation of the Nice period

paintings which made its first appearance in the Barnes Foundation's *Odalisque* (Fig. 84). The tiles must have always been in Matisse's studio, but he only began to use them as a backdrop in 1928 and 1929 when he sought to simplify his compositions by abolishing the floridly patterned screens and wall hangings in favor of this regular, geometric pattern. In a way, the device is reminiscent of the grid in Juan Gris' Cubist paintings of 1912-1914, in that it provides a framework for the pictorial structure.[4] The only concessions to the decorative in *Gray Nude* are the yellow necklace and bracelet and the patterned pillow, but even this has been painted with a purely rectilinear design.

Notes

1. The other major picture is the unfinished *Portrait in the Moorish Chair*. For this painting, see Barr, *Matisse*, 453; and Zurich 1983, no. 76.

2. Barr, *Matisse*, 215.

3. Gowing, *Matisse*, 158; Flam, *Matisse on Art*, 59.

4. On the influence of Gris, see Lyons, "Matisse at Work: 1914-1917," 74-75; and Golding, "Matisse and Cubism," 15.

48. TIARI (1930)

Bronze, *HM 8*, Height: 8 in., Private Collection, New York.

in Matisse's sculpture for its punning ambiquity.''[2]

The abstract volumes which surmount the head and the egglike head itself look back to *Jeanette IV* and *Jeanette V*. The central mass is particularly close to the bulbous forehead and nose of *Jeanette V* — indeed, this sculpture would seem to be a closer source than was an actual plant form. In *Tiari*, however, shapes have been smoothed and simplified, and the masses of the ''hair'' are joined together in one flowing, organic form. ''The surfaces are almost neutral,'' Jacques Lipschitz noted, ''the volumes poetized to a sublime degree.''[3]

This development reflected Matisse's interest in geometric purity, seen in the rounded head of *Reclining Nude III* and in the reductive form of *Small Torso*.[4] *Tiari* is among Matisse's most formal works, sharing an exotic, sensual elegance with the other bronze of 1930, *Venus on a Shell I*.[5] Both were inspired by his Tahitian experience and both seem to express, as Matisse himself said of Tahiti, the charms of ''that isle of thoughtless indolence and pleasure which brings oblivion and drives out all care for the future.''[6]

Notes

1. Barr, *Matisse*, 218; Elsen, *Matisse*, 170.

2. Elderfield, *Matisse*, 137.

3. Jacques Lipschitz, ''Notes on Matisse as a Sculptor,'' *The Yale Literary Magazine*, CXXIII, Fall 1955, 12.

4. See Nos. 45, 46.

5. See No. 49.

6. Aragon, *Matisse*, I, 9, as quoted by Elderfield, *Matisse*, 137.

During the summer of 1930, after his return from Tahiti, Matisse modeled a sculpture inspired by his memory of the Tahitian women who wore in their hair the island gardenia known as the tiari.[1] He added to the bust form a conglomeration of bulbous shapes: the stalk of the central form approximated a nose, while the leaves or petals can be read as part of an elaborate hairstyle. ''It is an image unique

49. VENUS ON A SHELL I (1930)

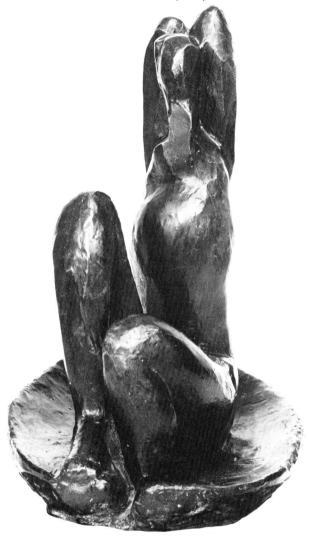

Bronze, *HM 2/10*, Height: 12¼ in.
The Museum of Modern Art, New York, Gift of Pat and Charles Simon, 1960.

Fig. 85 Matisse working on a later destroyed version of *Venus on a Shell*, 1929(?).

This sculpture was modeled in Nice during the summer of 1930.[1] Its most immediate source was a now lost sculpture of Venus on a shell which is known only from a photograph taken no earlier than 1929 (Fig. 85). This lost work was a reprise of the reclining nude with arms over head motif

traceable in various media during the 1920's.[2] What distinguished it from those prototypes, and what ultimately must have resulted in its abandonment, was the exaggerated zigzag pose. Neither classical nor contemporary treatments of the Venus on a shell theme were so mannered.[3] In his own

Fig. 86 Matisse, Etching illustrating Stéphane Mallarmé's *Poésies*.

of 1930.[5] While there, he saw and photographed a cloud formation which suggested a naked woman rising from a billowy cloud. Matisse used this photograph soon after his return to France when he was preparing etchings to illustrate the *Poésies* of Mallarmé.[6] His recollection of the cloud was inspired by Mallarmé's poem and by the poet Gautier's quatrain describing a sculpted cloud rising in the sky as a nude virgin emerges from the water of a lake.[7] The illustration for the line, "*la torse et native nue*," repeated very closely the pose of *Venus on a Shell I* (Fig. 86).

The image of the nude at the interface of sea and air suggests another possible explanation for the body's strict verticality, an explanation inherent in the theme itself of Venus on a shell. According to ancient myth, when the genitals of the castrated Uranus were hurled from the heavens into the sea, Venus was born, arising from the waves on a shell. The quasi-erotic erectness of the bronze may therefore allude to the watery birth of the Venus Anadyomene, the sculpture carrying within its sensual feminine form a sign of the male generative power which spawned it.[8]

Notes

1. Elderfield, *Matisse*, 138.

2. Elsen, *Matisse*, 197-198; Elderfield, *Matisse*, 138.

3. See Elsen, *Matisse*, 199-201, for a discussion and illustration of these sources.

4. See Nos. 45, 46.

5. Barr, *Matisse*, 219.

6. Much of the work on the *Poésies* was accomplished in the summer and fall of 1930; Barr, *Matisse*, 220. For the photograph, see Aragon, *Matisse*, 103, fig. 55.

7. Aragon, *Matisse*, I, 102-103; Elderfield, *Matisse*, 139-140. Gautier's lines read: "A l'horizon monte une nue/Sculptant sa forme dans l'azur!/ On dirait une vierge nue/ Emergeant d'un lac au flot pur."

8. *Venus on a Shell I* is much less cloudlike than the etching, a fact which suggests the presence of another concept.

sculptures of 1929, Matisse concentrated on a reductive formal perfection, as seen in the two small torsos (No. 46).

Venus rises majestically from the smooth, flat, circular plane of the shellbase — her back straight, her arms parallel to the neck and head, forearms bent backward and blended together to extend upward the sweep of the back. The streamlining of the body which was seen in *Reclining Nude III* and *Small Torso* is continued: for example, in the swelling of the chest outward to absorb the breasts.[4] Judicious planing and the drawing of the right leg toward the chest reinforced the statuette's insistent verticality.

Matisse's redesign of the first *Venus on a Shell* from a supine to an erect pose is understandable in formal terms as part of his continual search for a purified style. The change can also be explained as a result of his trip to Tahiti during the spring

50. GIRL IN A YELLOW DRESS (1929-1931)

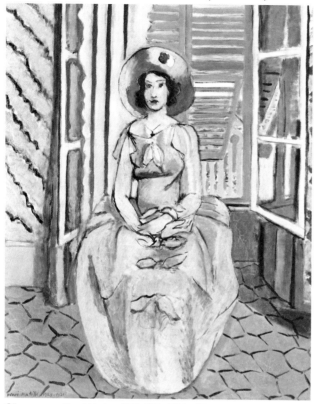

Oil on canvas, *Henri Matisse 1929-1931*, 39⅜ × 32 in.
The Baltimore Museum of Art, The Cone Collection.
Colorplate on page 34

Girl in a Yellow Dress has been called a "uniquely transitional work," as the lengthy period of its creation straddles the end of the Nice period and that of the first Barnes mural.[1] The picture combines the familiar elements of the Nice works — e.g. shuttered windows, patterned walls and floors — with a new pose and position for the model. Barr first noted this novel aspect of the picture: "The symmetrically frontal pose of the full-length model right in the center of the canvas is a device Matisse had very rarely, if ever, used since the Moroccan figures of 1911-13."[2]

The innovation was not achieved without difficulty. Matisse referred to his problems with the painting in an interview with Tériade published in October of 1930. In response to a question about the value of travel for a painter, Matisse said:

> In my Nice studio, before my departure for Tahiti, I had worked several months on a painting without finishing it [*Girl in a Yellow Dress*]. During my trip, even while strongly impressed by what I was seeing every day, I often thought of the work I had left unfinished. I might even say that I thought of it constantly. Returning to Nice for a month this summer, I went back to the painting and worked on it every day. Then I left again for America. And during the crossing I realized what I had to do — that is, the weakness in the construction of my painting and its possible resolution. I am anxious to go back to it today.[3]

This statement, taken in the context of Matisse's output in the months following his return from his travels, is particularly important for the light it sheds on the formulation of the figure. During the summer of 1930, he also began work on *Venus on a Shell I* (Fig. 49).[4] Whatever insight Matisse had into his painting on the transatlantic crossing would seem also to be related to this sculpture. The spare, streamlined form of *Venus on a Shell I*, its near symmetry, and especially its verticality foreshadowed the solution Matisse ultimately discovered for the painting.

In *Girl in a Yellow Dress*, Matisse stressed the verticality of the body by positioning the arms away from the sides and by the repetition of bows and the folded hands along the length of the central axis. By modeling the skirt so that the legs may be read as pressed together, he thus extended the torso's tubular core down to the lower edge of the dress. It is especially the skirt, which arcs outward from the lower back in a great oval plane, that recalls *Venus on a Shell I*. Matisse created an oval base diagonal to the picture plane — like the slanted shell of the sculpture — from which the slender torso rises. By adapting the sculpture's erect, seated pose of Venus for the painting and by enveloping the legs in the oval shape of the skirt, Matisse transformed his Tahitian experience through the sculpture to arrive at the final solution for *Girl in a Yellow Dress*.

Notes

1. Barr, *Matisse*, 216.

2. *Ibid.*

3. Flam, *Matisse on Art*, 60.

4. See No. 49. This sculpture was based on the recollection of a sculptural cloud formation which Matisse had seen in Tahiti, one which rose into the sky like a nude maiden rising from a lake.

51. BACK IV (1931)

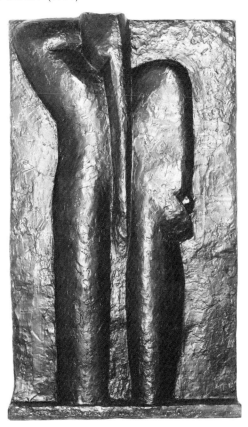

Bronze, *HM 0/10*, Height: 74 x 44¼ x 6 in.
The Anne Burnett and Charles D. Tandy Foundation.
Colorplate on page 35

Back IV, the last relief in the *Back* series, was executed some 15 years after the completion of *Back III*. Although it is chronologically distant from its three predecessors, *Back IV* nonetheless served the same basic function as did the others — the clarification and ordering of Matisse's thought at a crucial time in his career.

Back IV is usually dated 1929 or 1930 and is seen as part of the general movement away from the style of the Nice years.[1] Matisse's decision to return to the motif is understood best, however, in relation to the Barnes Foundation commission of 1931.[2] Matisse visited Dr. Albert Barnes in

Fig. 87 Matisse, *Dance Mural I*, 1931, 1932. Musée d'Art Moderne de la Ville de Paris.

Merion, Pennsylvania, late in the winter of 1930 in order to consider the request that he paint a large mural in the three lunettes high above the floor of the Foundation's main gallery. Matisse agreed to undertake the project in January of 1931 and returned to Nice to begin work (Fig. 87).[3] Free to choose his own subject, he selected the dance, a theme employed earlier in his first great decorative commission for Sergei Shchukin (1909).[4] Since *Back O* and *Back I* were undertaken on the occasion of the Shchukin order, it is not surprising that he again should have returned to a full-scale relief as he initiated a second large decorative project devoted to the dance theme.

Matisse already had begun to work out of the realistic mood of the Nice period when, early in 1930, he embarked on his trip to Tahiti. That voyage was crucial in "clearing the air," for, as Matisse implied in an interview with Tériade after his return, he had reached an impasse. "When you have worked for a long time in the same milieu it is useful at a given moment to stop the usual mental routine and take a voyage which will let parts of the mind rest while other parts have free reign — especially those parts repressed by the will. This stopping permits a withdrawal and consequently a reexamina-

tion of the past."[5]

The Barnes commission coincided with Matisse's retrospective frame of mind, a fact which may explain the selection of a subject treated twenty years earlier. This personal historicism represented a conscious effort on the artist's part to work through himself to maintain a continuity of thought as he sought a fresh vision and a renewed simplicity for his painting. That he may have initiated that process with *Back IV* rings true both in terms of the pattern of his own work and the pressing artistic task at hand.

Back IV is indeed startling in its simplicity. Working from a plaster cast of *Back III*, Matisse simply filled in the gaps and holes, reworking, smoothing, and unifying the surface. Essentially, the body has been fleshed out over the scarred, geometric skeleton. "The division of the back into vertical zones was eliminated so that the entire surface seems to flow together in one continuous, coherent image united by the homogeneous Cézannesque surface."[6] Proportions were enlarged and contours regularized to create a monumental figure of tranquil grandeur.

Ultimately, *Back IV* relates to the Barnes Foundation commission less in terms of the sculptural quality of some of

the preparatory sketches of 1931 than in the role it played in establishing the scale and, especially, the impression of volume of the dancers in the finished works.[7] Matisse wrote of the Barnes murals in 1934: "The expression of this painting should be associated with the severity of a volume of whitewashed stone, and an equally white bare wall."[8] The brilliance of Matisse's achievement in *Back IV* was that it harmonized the relationship between volume and ground, preparing the way for the massive yet flat figures on the walls of the Barnes Foundation. Likewise, its symmetry and simplicity anticipated developments in his paintings and cut-outs.[9]

Notes

1. Barr, *Matisse*, 218, dates it about 1929, as does Flam, "Matisse's *Backs*," 357. Zurich 1959, no. 62, dates it 1930, as do Elsen, *Matisse*, 192; Legg, *Matisse*, 29; and Paris 1975, no. 225.

2. This point was first made by Elderfield, *Matisse*, 78.

3. Barr, *Matisse*, 219-220. The mural was completed early in 1932, but, because of an error in measuring the pendentives of the lunette, the canvas was the wrong size. Matisse therefore began an entirely new composition in the fall of 1932. This was completed in April of 1933 and installed soon afterward by Matisse himself. The first version was purchased by the Musée d'Art Moderne de la Ville de Paris.

4. See Nos. 18, 19. The early sketches isolated one of the background figures from *Dance II* in each of the three lunettes, see Barr, *Matisse*, 242; and Jacobus, *Matisse*, 40, fig. 43, for the pencil sketches and colorplate 43 for the oil sketches.

5. "Statement to Tériade, 1930," as quoted by Flam, *Matisse on Art*, 60.

6. Flam, "Matisse's *Backs*," 357.

7. Flam, "Matisse's *Backs*," 358, noted Matisse's concern with form in the early oil sketches. For the sketches, see note 4.

8. "Letter to Alexander Romm, 1934," as quoted by Flam, *Matisse on Art*, 68.

9. Flam, "Matisse's *Backs*," 360.

52. VENUS ON A SHELL II (1932)

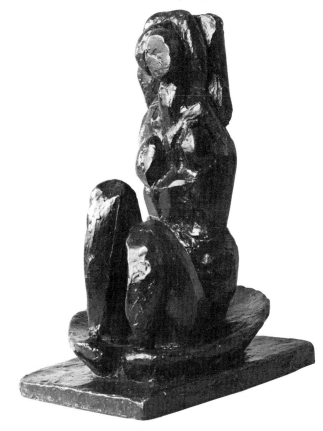

Bronze, *HM 4/10*, Height: 13⅜ in.
Collection Mr. and Mrs. I. C. Deal, Dallas.

Venus on a Shell II was made sometime in 1932, the year in which Matisse completed the first version of the *Dance* for the Barnes Foundation and began work on the second version.[1] In both murals, Matisse created colossal figures some 12 feet high. Their form was very flat, with no internal modeling, the color a light stone gray imitating the color of the architecture itself (Figs. 87, 88).[2] Against the unrelieved flatness of the Barnes murals, *Venus on a Shell II* appears as a sculptural antidote. Matisse had not produced such an insistently structural piece since *Back III* of 1916, when he was involved with another large figure painting, the Chicago *Bathers by a River*.[3]

Fig. 88 Matisse, *Dance Mural II*, 1933. ©The Barnes Foundation, Merion, Pennsylvania.

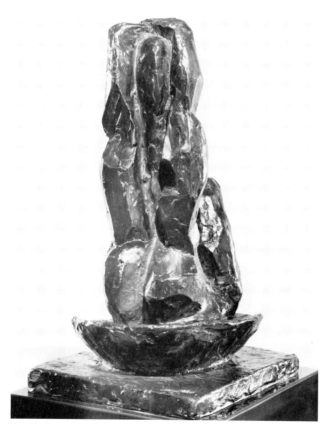

Fig. 89 Matisse, *Venus on a Shell II*, back view.

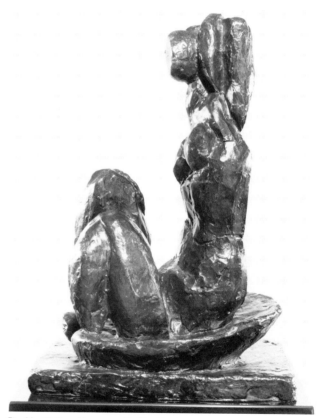

Fig. 90 Matisse, *Venus on a Shell II*, side view.

A plaster cast of *Venus on a Shell I* provided the starting point. Matisse excavated the chest to reveal the breasts, formerly hidden in a smoothly contoured casing. The arms were squared off and the head abstracted in a way which suggests the possible influence of Picasso.[4] His ministrations to the back were no less radical (Fig. 89). Matisse planed the surface and cut away large wedges of clay leaving an abstract geometric column to support the arms and head. The body has been reduced to a few components: torso, head, and arms were fused as one unit, while the legs have been almost severed from the body by two deep, wedge-shaped cuts (Fig. 90). This near amputation was intimated by the shallow groove in the left thigh of *Venus on a Shell I*, as well as in the pencil sketches for *Dance I*, in which several disembodied legs emerge from the upper edges of the composition.[5] The same effect was also suggested in the final versions of *Dance I* and *Dance II*, inasmuch as the pendentives penetrated through or into the legs of the seated figures (Figs. 87, 88). Yet, although fragmented, Venus is no more disrupted than the reclining revelers in the murals.

The angular facets, fragmented forms, and rugged surface counterbalance the flat, curvacious dancers of both murals. But the reprise of the sedate, static pose may indicate that the bronze was a kind of intermediary between the active, seated figures of the first version of the *Dance* and their more restrained self-contained counterparts of the second. This was the last bronze Matisse made until 1949.[6]

Notes

1. Barr, *Matisse*, 219-220, 243.

2. *Ibid.*, 242.

3. See No. 30.

4. Jacobus, *Matisse*, 56.

5. For illustrations of these sketches in the Musée Matisse, Nice-Cimiez, see Jacobus, *Matisse*, 40, fig. 43.

6. For that bronze, a crucifix for the Chapel of the Rosary for the Dominican Nuns of Vence, see Legg, *Matisse*, 45. Matisse produced only two more bronzes, a *Crouching Nude* (1949) and *Standing Nude, Katia* (1950); Legg, *Matisse*, 45-46.

53. WOMAN IN A PURPLE COAT (1937)

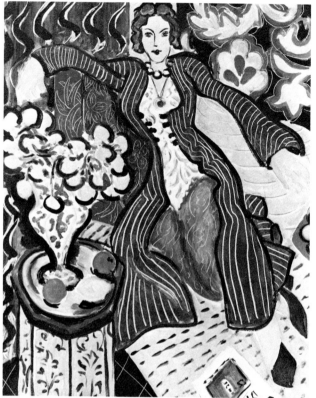

Oil on canvas, 31⅞ x 25¹¹/₁₆ in.
The Museum of Fine Arts, Houston
John A. and Audrey Jones Beck Collection
Colorplate on page 36.

Woman in a Purple Coat is one of a number of works from the 1930's which study the model seated in a long, flowing robe.[1] It was executed in 1937 along with several other paintings of models similarly attired. The sitter is Matisse's companion from 1935, Lydia Delectorskaya.[2]

The Persian robe seen in this painting contributes to an exotic flavor reminiscent of Matisse's Nice odalisques. The painting also recalls the Nice period in the taste for the decorative, especially in the background which is composed of two boldly patterned zones — a black on green strigil motif and a large red and white floral pattern on a black ground. Unlike the Nice period paintings, however, the figure has

been flattened and simplified with no interior modeling and the background more clearly defined and sharply drawn. Indeed, the entire composition is carefully thought out and highly structured. The figure is placed in the middle of the canvas on line with the central vertical axis. Her head is neatly framed by a narrow white band which also separates the two halves of the background into nearly equal zones. Although the model's legs pull the eye off to the lower right, Matisse counteracted the effect by the floral still life and table at the left.[3] The symmetry of the composition is ultimately indebted to Matisse's solution for *Back IV* which balances forms on either side of the central vertical axis.[4]

Matisse was also clearly interested in the decorative effect of line, as is evident from the patterned backgrounds. Yet he strove to obtain a "cleaner" effect than seen in the Nice paintings by using large or simple patterns, by edging the strigil motif in white, and by outlining the form of the flowers in the black ground, creating a linear exoskeleton for the soft petals. The robe itself is decorated with long white stripes — the unpainted canvas — whose sinuous character is reinforced by the bold black contours. Matisse even drew in the wet paint, scraping it away with the hard end of his brush to create decorative linear patterns from the white ground. The process is reminiscent of etching and may have been partly inspired by his experience with the Mallarmé etchings of 1932 and the six Ulysses etchings of 1935.[5] More broadly, the experience of working in pure line seems to have aided Matisse in strengthening the design of this painting.

Notes

1. See also three similar paintings from 1931, 1932, and 1933, Barr, *Matisse*, 468.

2. Prof. Bill Camfield, Rice University, kindly brought this new identification to my attention. Barr, *Matisse*, 251, identifies the sitter as the Princess Elena Galitzin.

3. The octagonal table is visible in a photograph of Matisse's studio published in Aragon, *Matisse*, I, figs. 113, 117.

4. See No. 51.

5. For these two projects, see Elderfield, *Matisse*, 140-142.

54. THE PINEAPPLE (1948)

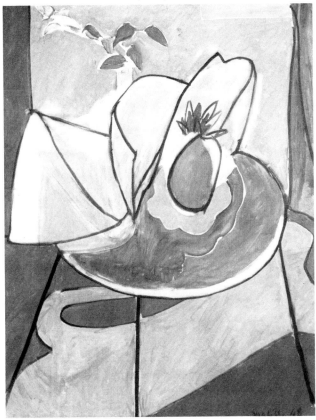

Oil on canvas, *Matisse 48*, 45¾ x 35 in.
The Alex Hillman Family Foundation., New York.

Fig. 91 Matisse, *Still life with Pineapple*, brush and ink, 1948.
Private Collection.

The Pineapple was one of a series of six large interior scenes which Matisse painted in 1948 and which were exhibited together the following year at the Musée national d'art moderne.[1] All six paintings are characterized by the exploitation of brilliant color and light and by their simple but bold design. *The Pineapple* is, however, unique among the series in its centralization of the image and its high degree of abstraction.[2]

Matisse placed on the center of a table with three thin metal legs a still life composed of a pineapple, a sheet of wrapping paper, and a vase with a sprig of greenery.[3] To the right is a green curtain, to the left a thin slice of the red wall, and in the center a broad, flat orange backdrop which may

be a door, curtain, or some other form. Even more puzzling is the strange orange shape underneath the table. In a brush and ink sketch of the same motifs, which probably immediately preceded *The Pineapple*, Matisse painted a large, amorphous, spotted form under the table (Fig. 91).[4] Too irregular to be a rug and too incomplete to be the flooring, this undefined shape remains perplexing in both works. A clue to the identification of the forms is provided by one of the other paintings of 1948, *Grand Intérieur Rouge* (Fig. 92).[5] Here, at the bottom margin, are what appear to be two dogs — one spotted, the other plain orange. This unusual form may, therefore, be an abstracted image of Matisse's dog stretching or sleeping, his tail curling up over his back, his

Fig. 92 Matisse, *Grand Intérieur Rouge*, 1948.
Musée National d'Art Moderne, Paris.

front and hind legs extended outward. The painting represented on the back wall of *Grand Intérieur Rouge* is, indeed, *The Pineapple*. Matisse may have presented this particular painting within a painting humorously to allow these more or less abstracted canines to play against one another.

Notes

1. Monod-Fontaine, *Matisse*, 99. The other paintings were, *Intérieur au rideau egyptien* (The Phillips Collection, Washington, D. C.); *Grand Intérieur Rouge* (Museum of Modern Art, Paris); *La Branche de prunier, fond vert* (private collection); *La Branche de prunier, fond ocre* (private collection); and *Interieur à la fougère noire* (collection Otto Preminger, New York). The first, second, third, and fifth of these paintings are illustrated in color in Zurich 1983, nos. 93-96. For the exhibition history of *The Pineapple*, see Paris 1970, no. 202.

2. Barr, *Matisse*, 277.

3. The same table was used in *Intérieur à la fougère noire*, see Zurich 1983, no. 93.

4. Paris 1970, no. 207. All the elements on the table are the same. The wall, however, is a square tile pattern.

5. For this picture, see Monod-Fontaine, *Matisse*, no. 28.

Selected Bibliography

The studies which have been most useful are compiled below. For a more detailed list, the reader should consult the bibliographies in the exhibition catalogues, Paris 1970; and Paris 1975.

Aragon, Louis. *Henri Matisse, Roman*. France, 1971.

Barr, Alfred. *Matisse, His Art and His Public*. New York, 1951.

Caffin, Charles H. *The Story of French Painting*. New York, 1911.

Cooper, Douglas. *The Cubist Epoch*. New York, 1971.

Cuno, James B. ''Matisse and Agostino Carracci: A Source for the 'Bonheur de Vivre'.'' *The Burlington Magazine*, CXXII (1980).

Elderfield, John. ''Matisse's Drawings and Sculpture.'' *Artforum*, X (September, 1972).

Elderfield, John. *The ''Wild Beasts'': Fauvism and Its Affinities*. New York, 1976.

Elderfield, John. *Matisse in the Collection of The Museum of Modern Art*. New York, 1978.

Elderfield, John. *The Cut-Outs of Henri Matisse*. New York, 1978.

Elderfield, John. ''The Garden and the City: Allegorical Painting and Early Modernism.'' *Bulletin, The Museum of Fine Arts, Houston* (Summer, 1979).

Elsen, Albert. *The Sculpture of Henri Matisse*. New York, 1972.

Escholier, Raymond. *Matisse from the Life*. London, 1956.

Flam, Jack D. ''Matisse's *Backs* and the Development of His Painting.'' *Art Journal*, XXX (1970/71).

Flam, Jack D. *Matisse on Art*. New York, 1973.

Flam, Jack D. ''Some Observations on Matisse's Self-Portraits.'' *Arts*, 49 (1975), no. 9.

Flam, Jack D. ''Matisse and The Fauves.'' *'Primitivism' in 20th Century Art: Affinity of the Tribal and the Modern*, New York, 1984.

Fourcade, Dominique (ed.). *Henri Matisse, Écrits et propos sur l'art*. Paris, 1972.

Fourcade, D. ''Autre Propos de Matisse.'' *Macula I*, Paris, 1976.

Giraudy, Danièle. ''Correspondance Henri Matisse-Charles Camoin.'' *Revue de l'Art* (1971), no. 12.

Golding, John. ''Matisse and Cubism.' (W. A. Cargill Memorial Lectures in Fine Art), University of Glasgow Press, 1978.

Golding, Carl. Review of Elsen, *The Sculpture of Matisse*, New York, 1972. *Art Quarterly*, 36 (1973).

Goldwater, Robert. ''The Sculpture of Matisse.'' *Art in America* (March, 1972).

Gowing, Lawrence. *Matisse*. London, 1980.

Guichard-Meili, Jean. *Matisse*. New York, 1967.

Izerghina, A. *Henri Matisse Paintings and Sculpture in Soviet Museums*. Leningrad, 1978.

Jacobus, John. *Matisse*. New York, 1973.

Kostenevich, Albert. ''*La Danse* and *La Musique* by Henri Matisse: A New Interpretation.'' *Apollo*, 100 (1974).

Kramer, Hilton. ''Matisse as a Sculptor.'' *Bulletin of the Boston Museum of Fine Arts* (1966).

Laude, Jean. *La Peinture française (1905-1914) et ''L'Art nègre.''* 2 vols., Paris, 1968.

Legg, Alicia. *The Sculpture of Matisse.* New York, 1972.

Lieberman, William S. *Matisse 50 Years of His Graphic Art.* New York, 1956.

Lipschitz, Jacques. "Notes on Matisse as a Sculptor." *The Yale Literary Magazine,* CXXIII (Fall, 1955).

Lyons, Lisa. "Matisse: Work, 1914-1917." *Arts,* 49 (May, 1975), no. 9.

Monod-Fontaine, Isabelle. *Matisse, oeuvres de Henri Matisse (1869-1954): Collections du Musée National d'Art Moderne.* Paris, 1979.

Neff, John Hallmark. "Matisse and Decoration: The Shchukin Panels." *Art in America* (July/August, 1975).

Purrmann, Hans. *Leben und Meinungen des Malers Hans Purrmann.* Wiesbaden, 1961.

Read, Herbert. "The Sculpture of Matisse." *Henri Matisse,* Berkeley and Los Angeles, 1966.

Reff, Theodore. "Matisse — Meditations on a Statuette and Goldfish." *Arts Magazine,* LI (November, 1976).

Rubin, William (ed.). *Pablo Picasso, A Retrospective.* New York, 1980.

Schneider, Pierre. "Matisse's Sculpture: The Invisible 'Revolution'." *Art News,* 71 (March, 1972).

Schneider, Pierre. "The Striped Pajama Icon." *Art in America,* 63 (July/August, 1975).

Schneider, Pierre. Review of Lawrence Gowing, *Matisse,* London, 1980. *The Burlington Magazine,* CXXII (1980).

Schneider, Pierre. "Matisse: 'Faire deux choses `a la fois'." *Tel Quel* (1978), nos. 77, 78.

Sembat, Marcel. "Henri Matisse." *Les Cahiers d'Aujourd'hui* (Avril, 1913).

Sembat, Marcel. *Matisse et Son Oeuvre.* Paris, 1920.

Trapp, Frank. "Form and Symbol in the Art of Matisse." *Arts,* 49 (1975), no. 9.

Tucker, William. "The Sculpture of Matisse." *Studio International* (July/August, 1969), no. 913.

Tucker, William. *The Language of Sculpture.* London, 1974.

Tucker, William. "Matisse's Sculpture: The Grasped and the Seen." *Art in America* (July/August, 1975).

Photograph Credits

Photographs of the works of art reproduced in this catalogue have been supplied, in the majority of cases, by the owners or custodians of the works. The following list applies to photographs for which a separate acknowledgement is due.

The Baltimore Museum of Art: No. 17.

Bibliothèque Nationale, Paris (Collection Druet): Fig. 49.

Bulloz: Figs. 2, 87.

John Denman, Fort Worth: Nos. 3, 16, 19, 20, 21, 27, 30, 39, 43, 45, 51, 52; Figs. 9, 15, 22, 37, 48, 50, 51, 54, 55, 64, 72, 77, 82, 89, 90.

Ifot-Grenoble: Figs. 30, 59.

Wanda de Guébriant, Paris: Figs. 45, 47.

Kimbell Art Museum, Fort Worth: Figs. 74, 75.

Pierre Matisse Gallery, New York: Fig. 91.

Amanda S. Merullo, Rhode Island School of Design: No. 28.

Musée Matisse (Cliché Maurice Berard): Figs. 60, 83.

The Museum of Modern Art, New York: No. 48; Frontispiece; Figs. 20, 52, 85.

Professor Theodore Reff, Columbia University: Fig. 31.

Sopraintendenza alle Gallerie, Firenze: Fig. 63.

Stanford University Libraries, Stanford: Fig. 86.

John Thomson, Los Angeles: Nos. 6, 9; Fig. 24.

Yale University Art Gallery, New Haven: Fig. 57.